One Flash!

Tilo Gockel earned his PhD in image processing and now teaches signal processing and photography at the Aschaffenburg University of Applied Sciences in Germany.

Over the years, he has written regularly for photography and imaging magazines, and he has published numerous books on various aspects of the image-creation process.

Tilo's blog, www.fotopraxis.net, offers a wealth of information and tips on flash photography, Photoshop, and photography in general, and he challenges his readers to break those bad old habits and get creative.

Tilo Gockel

One Flash!

Great Photography with Just One Light

rockynook

Tilo Gockel (kontakt@fotopraxis.net)

Editor: Ted Waitt
Translator: Jeremy Cloot
Layout: Cora Banek, www.corabanek.de
Cover Design: Helmut Kraus, www.exclam.de
Cover Photo: Tilo Gockel
Printer: WeSP through Four Color Print Group
Printed in Korea

ISBN 978-1-937538-71-2

1st Edition 2015
© 2015 by Tilo Gockel

Rocky Nook Inc.
802 East Cota St., 3rd Floor
Santa Barbara, CA 93103

www.rockynook.com

Copyright © 2015 by dpunkt.verlag GmbH, Heidelberg, Germany.
Title of the German original: Just one Flash!
ISBN 978-3-86490-209-3
Translation Copyright © 2015 by Rocky Nook. All rights reserved.

Library of Congress Control Number: 2015939103

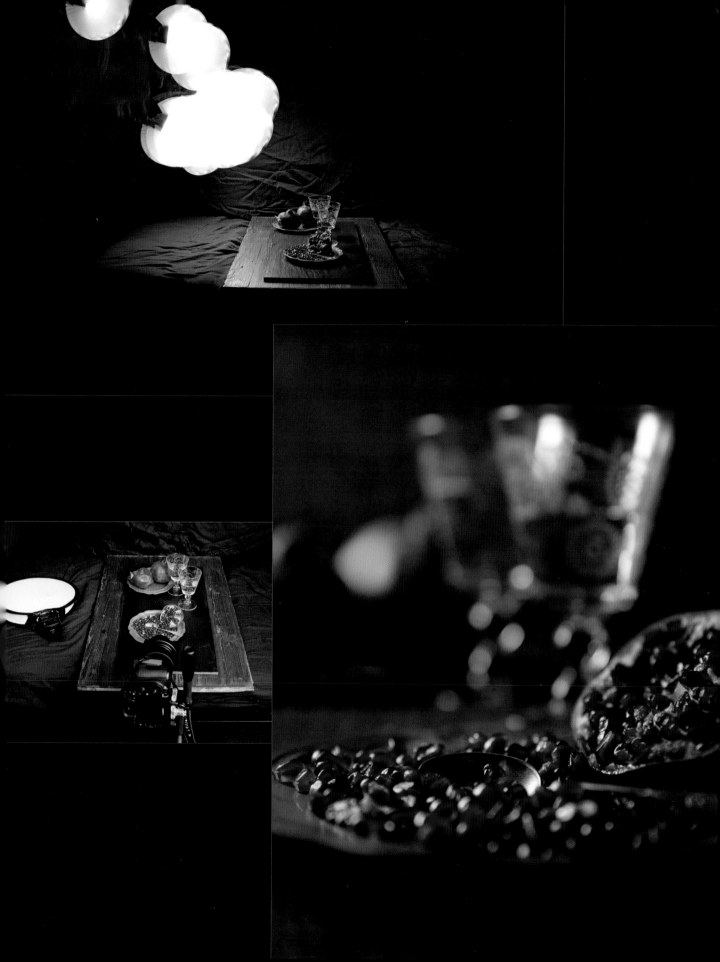

CONTENTS

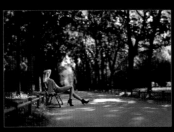

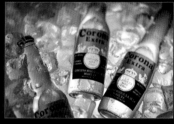

INTRODUCTION

Welcome to *One Flash!*, my newest bag of tricks with all the latest flash photography techniques. This book follows up on the amazing success of my first book on flash, *Creative Flash Photography*, which appeared at just the right time and filled a previously neglected gap in the market. In that book, I used as many as seven flashes for some of the setups I described, which might have verged on overkill but definitely showed what's possible with these often underrated marvels of technology.

But not all photographers own seven flashes, and others simply don't want to carry that much gear on a shoot. So why not use just one flash? After all, the sun is our sole, primary light source on earth, yet it still offers a huge range of lighting possibilities.

And that is the basic concept behind this book. All the setups described in the workshop chapters can be reproduced using just one flash—usually off-camera—and you will be amazed at what these fantastic devices can do. Not only can a flash illuminate a scene or subject, it can project colors and patterns, too. And, if a single light isn't enough for your photograph, I will show you how to produce multiple light sources using a single speedlight:

› The simplest way to double up the light is to combine *available light* with *flash*. For example, available light can be used to create an accent light produced by the sun or a highlight produced by a desk lamp.

› A different approach involves using *flags*, *reflectors*, and *mirrors* to split the light from your flash and send it in multiple directions.

› Last but not least, you can even fire a single flash multiple times in different places within the frame. This "flash composite" technique even works without darkening the space you are working in.

The most versatile way to use a single light source is to apply "light painting" techniques. The spectrum provided by xenon flashes is much better than that produced by LED flashlights, making them ideal for this type of work. Other features, such as stroboscopic flash and a modeling light, can transform a speedlight into a useful source of continuous light, too.

It is important to note that great photos and fascinating lighting don't always require a big budget. Even if some of today's high-end shoe-mount flash units cost more than a studio flash and offer sophisticated features like TTL, HSS/FP Sync, and built-in radio control for slave flash, you don't have to spend more than $50 on an inexpensive non-TTL flash to get enough power and high-quality light to create great images. Light modifiers such as flash umbrellas are also inexpensive; they can cost as little as $20. It is easy to put together a simple but effective flash kit for no more than the price of a quality camera bag.

Don't forget: your gear can grow with your needs and experience. On some shoots I use a 400-joule portable flash unit, and this book includes a guide that shows you how to build a powerful bare-bulb portable flash using two modified speedlights.

I hope you find this book and the workshops within it a great place to start with your flash photography. Things then get really interesting when you use your own creativity to combine and adapt the techniques explained here and begin to develop your own "lighting toolbox."

Wishing you a constant stream of great light!
Tilo "Gallo" Gockel

Note: Please send your comments, criticisms, and other feedback (including inquiries regarding the models shown in the photos) to *kontakt@fotopraxis.net*.

BASICS

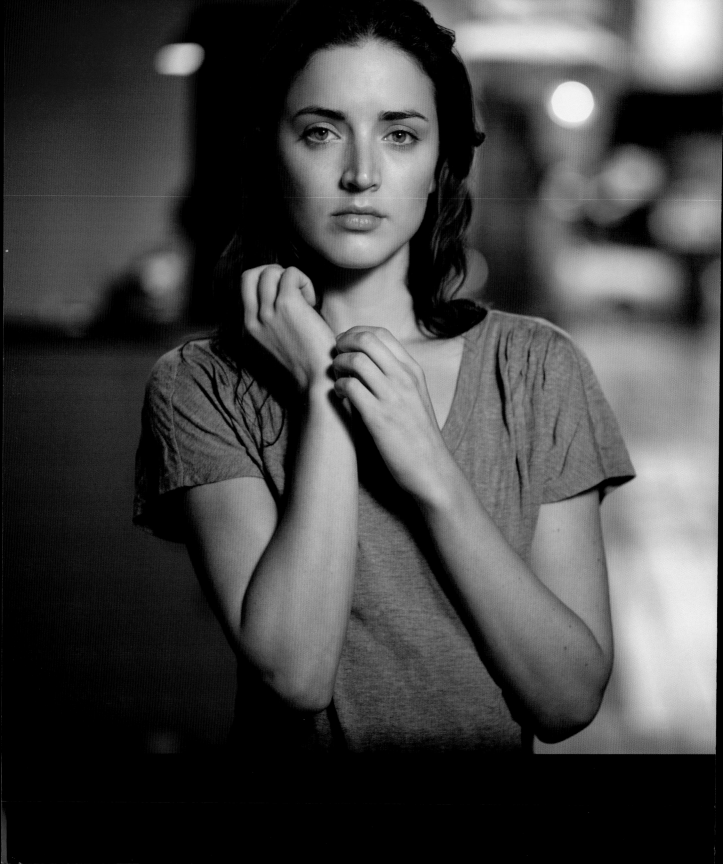

01

QUICK START GUIDE

Getting started in flash photography isn't easy.
Along with familiar metrics like aperture, ISO, and
shutter speed, using flash introduces additional
factors into the equation, such as flash power, flash-
to-subject distance, angles of incidence, and your
choice of light modifiers. The following three chap-
ters are intended to give you a head start and make
your first steps into the wonderful world of flash
easier than they were for me when I started out
many years ago. The next chapter,"Techniques in
Detail," goes into more depth on the topics
addressed here.

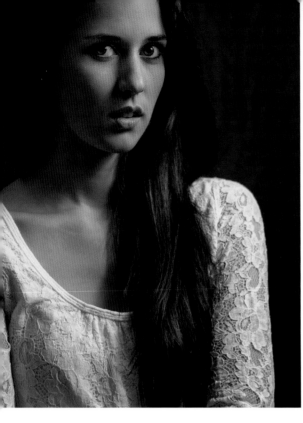

Introduction

The traditional but sometimes frustrating path to learning flash technique covers topics such as guide numbers, spectral curves, and flash duration curves. It is sure to have scared off quite a few hopeful beginners. At its essence, though, flash photography usually only involves either cutting out the ambient light or integrating it into your overall lighting for an image. If you keep this straightforward idea in mind, things suddenly become much simpler and quite logical. On the next few pages, you can look over my shoulder on two shoots and see exactly how I set up my camera and flash in the field.

The overall approach is always the same, and with a little practice, most of the basic settings become instinctive. More sophisticated techniques, such as second-curtain sync and the use of filters, are explained in the "Techniques in Detail" chapter and in the individual workshops that follow later in the book.

A simple portrait serves as our first example.
Canon EOS 5D Mark III · Canon EF 70–200mm f/2.8 II @ 105 mm and f/3.2 · M mode · 1/160 second · ISO 100 · JPEG · WB set to flash · Yongnuo YN-560 flash in a softbox, fired remotely using an RF-602 wireless trigger

Required Skills

You should be familiar with operating a DSLR, and you need to be able to quickly and reliably adjust exposure manually to suit the ambient light. You also need to be familiar with the relationships that exist among ISO, aperture, and shutter speed values. If you need to refresh your knowledge, check out some of the links listed in the "Online Resources" appendix, in particular my "Light Primer" article.

The Simplest Case: Cutting Out Ambient Light

Flash photography always involves two separate exposures: one for the flash and one for the ambient light. If the ambient light isn't too bright, you can choose to simply suppress it. You probably don't want to work in the dark in your studio, and your camera's autofocus is sure to work better if there is some light around, so you don't need to switch off the room lighting. But if you set the shortest possible shutter speed, the ambient light will no longer be visible in your photo and the flash will still fit into the time slot offered by the open shutter.

The "shortest possible" shutter speed is at least as long as your camera's flash sync speed plus a margin of error to allow the remote trigger to work its magic, which often equates to a value of 1/125 or 1/160 second (see "Techniques in Detail"). Set your aperture as you normally would in order to produce your desired

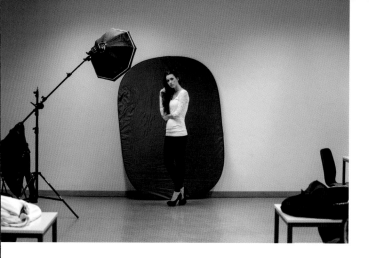

Our simple setup consisted of a Yongnuo YN-560 flash in a Firefly II softbox mounted on a homemade boom made from two light stands and a reflector holder. Later, we replaced the softbox with a white shoot-through umbrella. (Model: Sandra. Co-photographer: Thomas Christl)

A test shot revealed whether we had successfully suppressed the ambient light. Even though the room lighting was switched on, this test shot turned out almost completely black.

Canon EOS 5D Mark III · EF 70–200mm f/2.8 II @ 100 mm and f/3.2 · M mode · 1/160 second · ISO 100 · JPEG · WB set to flash · No flash

depth of field, and set your ISO value as low as you can but as high as necessary. Higher ISO values help to take pressure off the flash but can make the ambient light more visible than you might otherwise want.

In our first studio-based example, we used a simple setup with a boom-mounted softbox, which we later replaced with a shoot-through umbrella. I set the camera to M (manual) mode, 1/160 second, ISO 200, and f/3.2 for low depth of field. I took my first test shot without flash to check that my settings adequately suppressed the ambient light. Using such a wide aperture at ISO 200 allowed too much ambient light into the shot, but switching to ISO 100 had the desired effect, producing an almost completely dark background.

For the next shot, I mounted my remote trigger and set my Yongnuo YN-560 flash to 1/8 power. Given the wide aperture and the proximity of the light to the subject, this was actually quite a bit of flash power; however, it was necessary because the softbox "swallows" between 1.5 and 2 stops of light. I also used the built-in wide panel on the flash to ensure that the softbox was evenly filled with light. Using the wide panel automatically sets the reflector in the flash to its shortest focal length, which creates the widest possible spread of light.

Our lighting setup worked well right from the start, although this was a rare stroke of luck. I usually have

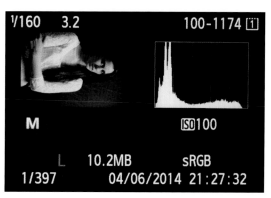

We checked the exposure of the initial shot on the camera monitor and referred to the histogram. We also checked the shadow produced by our model's nose and examined whether the catchlights in her eyes were effective enough. Everything was looking good so far.

15

Then I took some test shots and slightly varied the settings and the light (for more details on portrait lighting, see "The Aesthetics of Lighting" on page 37).

Canon EOS 5D Mark III · EF 70–200mm f/2.8 II @ 160 mm and f/3.2 · M mode · 1/160 second · ISO 100 · JPEG · WB set to flash · Yongnuo YN-560 in a softbox, fired using an RF-602 trigger

to adjust my settings after assessing the results of two or three test shots. The combined effects of the flash-to-subject distance, the light modifiers, the ISO value, and the aperture are complex, but in this case the only remaining variable was flash output, and we were able to quickly adjust it to suit the rest of our settings. When you are starting out, you will often need to take four or five test shots until you find the right settings, but with practice and the help of the camera monitor, histogram, and highlight-clipping display, you will soon be able to find the right settings using just one or two attempts. (For in-depth information on exposure metering and portrait lighting, see the "Techniques in Detail" chapter.)

The next step in our test setup was to try out our chosen settings and a few different poses before moving on to the second phase of the shoot, where we used a shoot-through umbrella and a new background. In this case, we used a crumpled emergency blanket, which, in combination with the wide aperture, produced nice bokeh bubbles. A second flash might well have increased the effectiveness of such a setup, but our single unit produced all the sparkle we needed.

As you can see, it is really easy to cut out ambient light and create your own effects on the "blank canvas" that results. In this case, the exposure parameters were determined by the camera's sync speed and the desired depth of field. Regarding the ISO value, we had to choose between two approaches: on the one hand, a low ISO would provide lower noise levels and suppress the ambient light, and on the other hand, a higher ISO would helpfully reduce the required flash power. A test shot without flash—which should be a standard prac-

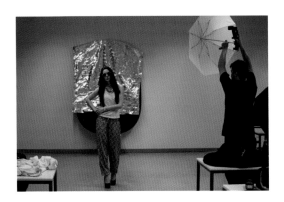

In this version of the setup, the softbox was replaced with a white shoot-through umbrella, and an emergency blanket was added to the background.

tice at every shoot—serves to check that you have fully suppressed the ambient light. Begin by setting the flash power to a medium level and adjust it from there as necessary.

Our example here is a portrait shoot, but the process is the same for product shots, too. The workshop chapters provide many examples of both.

The result of shooting against the emergency blanket background. The long lens and the wide aperture produced beautiful bokeh bubbles. We produced the turquoise color using two sets of RAW development settings—one for our model and one for the background.

Canon EOS 5D Mark III · EF 70–200mm f/2.8 II @ 170 mm and f/2.8 · M mode · 1/160 second · ISO 100 · RAW · WB set to flash · YN-560 flash in a white shoot-through umbrella, fired remotely using an RF-602 trigger

Including Ambient Light Isn't Much Trickier

I took the shots for the next example on location, which is why I wanted to keep the background visible. The procedure for setting the aperture, shutter speed, and ISO was similar to the one I used in the previous example, starting with a test shot without flash; in this case, I selected values that ensured that the background remained visible. I began by selecting an aperture of f/2 to provide shallow depth of field. I then selected the shutter speed and ISO value as follows.

> Useful ISO value range: 50–3200 (lower is better)

If your camera doesn't offer an ISO 50 setting, ISO 100 is the lowest available value. You will have to rely on your knowledge of your own camera's noise characteristics if you want to use higher ISO values. I don't mind a little noise and sometimes even add noise to my images during post-processing, but I always avoid camera shake.

Using a stabilized lens, I can shoot handheld at 1/60 second, but I find that longer shutter speeds are simply not practical, even with the best stabilization mechanisms, because the subject has to be stationary, too. A shutter speed of 1/200 second is the shortest practical shutter speed I use when shooting with conventional flash techniques (see "How to Outsmart Your Camera's Flash Sync Speed"). Depending on the camera and flash trigger you use, at 1/200 second and shorter, the gap between the shutter curtains starts to become visible in the form of a narrow black stripe across the frame. I'll explain this a bit later.

> Useful shutter speed range: 1/60–1/200 second (shorter is better)

This is where experience counts. On a cloudy afternoon when there is not quite as much light, I start shooting at ISO 400 to give myself some leeway and alter the shutter speed to fit the scene. In our example here, I ended up selecting f/2, ISO 400, and 1/200 second. I could have used f/2, ISO 200, and 1/100 second, although the 85mm lens I was using wasn't stabilized, and I wanted to make sure I didn't produce unwanted camera shake, which is impossible to correct later on.

At this stage, I hadn't yet taken any photos and was still busy making adjustments using the camera's dials while keeping an eye on the exposure meter display in the viewfinder. After dialing in the initial settings, it was time to make a test shot without flash and check whether the background (not the subject) required further exposure tweaks.

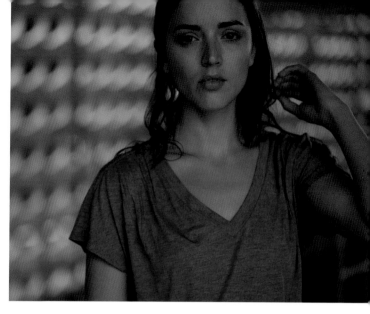

Use the viewfinder to judge the ambient light exposure. The green exposure meter display is still visible in M (manual) mode and, based on the display, you can easily zero out the exposure with the ISO and shutter speed dials. Slight underexposure of the background (in this case, by one stop) gives the image a more dramatic look and, when flash is added, the light will direct the viewer's gaze toward the subject.

This test shot showed that the settings for the ambient light were satisfactory and that the background looked good (this shot is the counterpart to the dark test shot I made previously). All that was missing was the flash lighting for the model.
Canon EOS 5D Mark II · EF 85mm f/1.8 @ f/2 · M mode · 1/160 second · ISO 400 · RAW · WB set to cloudy · Shot without flash

Once you have set up the exposure for the ambient light, you can add flash. I always begin by using medium, middle-of-the-road values, setting the flash output, distance, and angle according to the results of one or two test shots. In this example we used a Firefly II softbox as our light modifier.

As you can see, setting up a shot like this isn't rocket science. The most important thing to note is that you have to work methodically, setting each parameter in turn and taking your initial test shots without flash. If you work too fast or adjust more than one parameter at a time, you will quickly lose track of what you are doing.

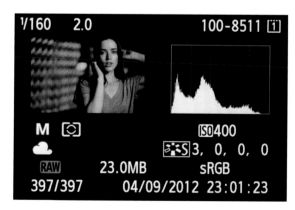

Checking the test shot with flash on the camera monitor and in the histogram showed that everything was fine. For this shot we used a remotely fired off-camera Canon Speedlite 580EX II set to manual mode and fitted with a Firefly softbox.

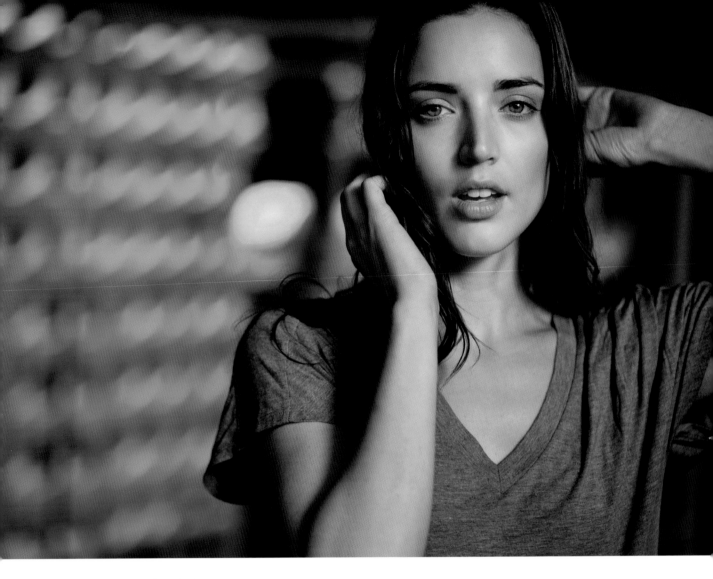

The final shot after a little subtle Photoshopping. (Model: Anelisa Durham)

Canon EOS 5D Mark II · EF 85mm f/1.8 @ f/2 · M mode · 1/160 second · ISO 400 · RAW · WB set to cloudy · Canon Speedlite 580EX II in a Firefly softbox

If you are asking yourself how it's possible to make the two exposures independently of one another, it is because the subject is not properly lit with only the ambient light. If that were the case, it would be impossible to add flash (you can't pour more liquid into a full glass!). Fortunately, this is not usually the case on location, as natural light normally comes from directly or diagonally above and leaves the subject's face in shadow.

You will need to use higher ISO values if you want to keep the background visible at a low-light location. The image on the opposite page (below right) comes from one of the workshop chapters later in the book, and it was captured in the evening at ISO 2000. I used my lens's maximum focal length and widest possible aperture to control focus, and then I adjusted the ISO value and shutter speed until I reached the limits of my usable parameters. Thanks to the great stabilizer built into the lens, I was able to shoot handheld at 1/100 second using a 200 mm zoom setting. My EOS 5D Mark III delivered image quality that I find perfectly acceptable for this type of low-light situation.

I had to dial the flash way down to compensate for the high ISO value and the wide aperture. In situations like this, I begin by taking test shots using flash power that is five stops less than full power (i.e., 1/32 output) and fine-tune the setting as necessary.

This technique works in bright sunlight, too, although it requires a slightly more sophisticated setup. The subject has to be in the shade with her back to the sun (see the "full glass" analogy above) and you need to use either a powerful flash or a short flash-to-subject distance to keep the sunlight in check.

For that kind of shoot, the flash sync speed makes life difficult, too, and you will usually have to use either a neutral density (gray) filter or HSS/FP Sync, or SuperSync/HyperSync techniques to shoot effectively with a wide aperture in sunlight. Details on these techniques can be found in the following chapter and in the workshop sections.

Two more sample shots from our shoot. A test shot for the ambient light doesn't require the presence of the model...

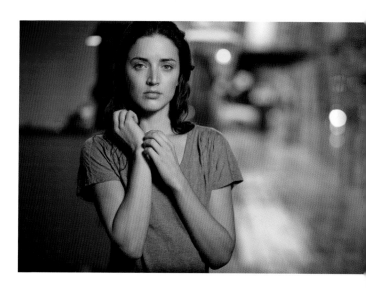

...who only needs to turn up when the flash comes into play! (Model: Anelisa Durham)

The technique described here also works well in low-light situations. This shot was taken at the main railway station in Frankfurt using a relatively high ISO setting. (Model: Mia Carma)

Canon EOS 5D Mark III · EF 70–200mm f/2.8 @ 200 mm and f/2.8 · M mode · 1/100 second · ISO 2000 · RAW · WB set to flash · Flash mounted in a Firefly II softbox

02

TECHNIQUES IN DETAIL

If you need to quickly determine flash power, a guide number, the degree of light loss for high-speed sync (HSS) flash, or the right neutral density (ND) or color filter to use, this chapter gives you all the background information you need to make the right decision. You can also read all about how to use a handheld exposure meter, how the inverse square law works, and what "Through the Lens" (TTL) flash is all about.

How to Calculate Flash Output and Guide Numbers

Because the flash duration—the length of time that the flash fires—usually "fits" within the exposure time (the shutter speed), studio flash output is expressed not in terms of electrical power (i.e., watts), but rather in terms of the energy released when the flash is fired. This energy release is expressed in terms of joules (J) or watt-seconds (Ws). Because the flash fires so quickly, the flash duration itself is generally irrelevant when calculating exposure parameters. Flash energy (E) is calculated using the capacity of the flash capacitor (C) and its charge voltage (U):

$$E = \frac{1}{2}CU^2$$

If you know something about electronics, you can easily measure the energy given off by the capacitor to the flash tube when it is fired. But be very careful, as the charge in a flash can be as much as several hundred volts!

Most speedlights are rated in terms of a "guide number" (GN). This is because, unlike studio flash—which produces omnidirectional light—speedlights have a built-in reflector whose behavior can be better defined by using a guide number that describes its maximum range. Compared to an average studio flash with a maximum flash energy of about 400 Ws, a powerful modern speedlight has a maximum flash energy of about 60 Ws.

The guide number (GN) is defined as the product of the maximum distance at which the flash can illuminate a subject (A) and the aperture (B):

$$GN = A \cdot B$$

Because aperture values have no units, guide numbers are expressed in terms of meters (m). The guide number can be used to calculate the maximum range of a flash using the following formula:

$$A = \frac{GN}{B}$$

Although guide numbers are a useful reference when using flash, they are not always meaningful, especially when you begin to compare flashes from different manufacturers. Manufacturers often include the reflector setting and the ISO value in their own calculations, so you need to allow for the ISO value you are using if it is different from the one used by the manufacturer:

$$A = \frac{GN}{B}\sqrt{\frac{E_F}{100}}$$

In this case, E_F represents the ISO value you are using and 100 stands for the standard value used in the manufacturer's own calculation. Refer to your unit's manual if you are not sure of the value used.

Let's look at a sample calculation. Assume that your camera's built-in flash has a *GN* of 12 m at ISO 100 and you have set an aperture of f/5.6. Maximum flash range is $GN/B = 12/5.6 = 2.14$ m.

If you then raise the ISO to 800, the maximum flash range will be $12 \text{ m}/5.6 \cdot \sqrt{(800/100)} = 6.05$ m.

You will rarely have to deal with guide numbers in everyday flash photography situations, as your flash performs all the necessary calculations automatically using the formulas described here. Modern TTL speedlights display the maximum current range according to these simple calculations above. However, the actual range can be greater, depending on the ambient light and if you use a longer shutter speed.

Care is required when using manufacturers' guide numbers, as these usually correspond to values measured using a speedlight's maximum focal length setting. This value is 105 mm for many Canon and Yongnuo flashes, whereas some Nikon flashes can be zoomed all the way up to 200 mm, resulting in a much larger *GN* even though the amount of energy produced by the flash is the same.

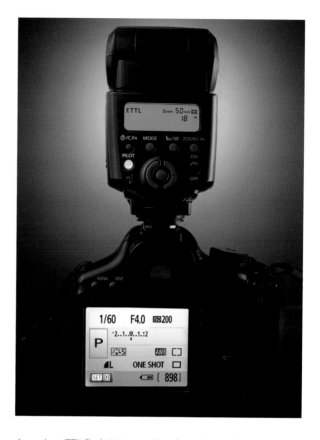

A modern TTL flash is its own "guide number calculator." The Canon Speedlite 430EX II uses the guide number and the current aperture and ISO settings to calculate the maximum flash range (in this case, 18 meters). This model even accounts for the camera's crop factor, indicated by the icon at the top right of the flash's LCD panel.

How to Meter and Set Exposure

In flash photography, the overall exposure is determined by the exposure for the ambient light and the exposure for flash. In many situations, you can set the parameters for the two separately—the following sections explain how.

Metering for Ambient Light

If I need to cut out the ambient light in a flash photo, I set my camera's shutter speed to its flash sync speed. (Also, see "How to Outsmart Your Camera's Sync Speed.") If, however, I want to include the ambient light in my composition, I switch off my flash (or the remote trigger) and set the camera's exposure parameters manually

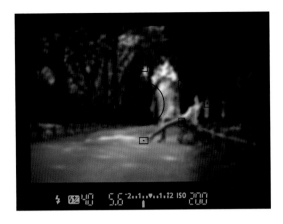

The exposure meter display works in manual mode, too, enabling you to make manual exposure settings for the ambient light with the camera raised to your eye.

using the metering display in the viewfinder. This way, I can set the appropriate aperture, shutter speed, and ISO values without taking the camera away from my eye or having to make test shots. I use center-weighted metering mode and often deliberately underexpose the ambient-light exposure by about one stop to increase the drama in my shots. Once I have made my settings, I take a test shot without flash and evaluate the result using a screen loupe.

Alternatively, you can set the camera to Aperture Priority (Av) mode and adjust the exposure using exposure compensation settings, although I find this more complex and less reliable than the manual approach. If I move the camera to recompose, the exposure parameters may change—a situation that I normally want to avoid.

Flash Exposure Settings

I begin by setting up my flash to provide adequate illumination while keeping it as close to the subject as possible. I make my settings according to experience, the flash-to-subject distance, and the type of light modifier I am using. I usually begin at a medium setting of 1/8 flash power. I evaluate the resulting test shot using a screen loupe—reviewing the overall image, looking for the "blinkies," and examining the histogram—and adjust my flash output setting as necessary.

A screen loupe is a great aid in accurately evaluating the image.

Most inexpensive flashes (I call them "value" speedlights) offer flash power increments of one stop, so each step up or down in power represents either half or twice as much light. High-end speedlights usually offer 1/3-stop increments, while most studio flashes allow adjustments in increments of 1/10 of a stop. The official term for one stop of light is 1 EV (Exposure Value).

This approach makes it easy to quickly set appropriate flash parameters. Practice and experience are the two most essential components, and a screen loupe and the histogram are really useful aids for making quick and reliable settings.

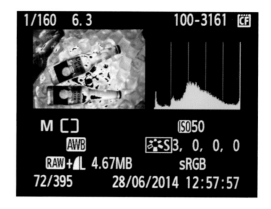

You can increase the reliability of your exposure evaluations if you switch on the camera's highlight clipping indicator (the "blinkies") and check the histogram curve.

How to Use a Handheld Exposure/Flash Meter

In addition to ambient light metering, many high-end handheld light meters also have built-in flash metering functionality. This works either by using a wireless trigger attached to the built-in sync terminal or in cordless mode, where the meter simply waits for a flash to fire before making a reading.

Using a handheld meter requires a little practice but the basics are relatively simple to learn.

Let's take a look at an example. Assuming you are shooting in a studio and want to suppress the ambient light in your shot, you will set a shutter speed close to your camera's sync speed. If you set 1/125 second to ensure that the remote trigger has time to fire the flash within the camera's 1/200 second sync window, your chosen camera settings for this situation might be f/4 and ISO 200 (let's assume that), so you set 1/125 second and ISO 200 in your flash meter.

Now set a medium flash output value (3 bars out of 5, or 5 out of 10, etc., depending on your particular model), attach the supplied dome, and hold the meter directly in front of your subject with the sensor facing the camera. All you have to do now is fire the flash using a remote trigger held in your other hand.

The meter will now display something like "11 6/10," which, in this case, means f/11 plus 0.6 EV (my Sekonic shows these numbers in reduced form like this: 11₆). This readout means that you would achieve a good exposure if you set the aperture to f/11 + two 1/3-stop increments = f/14. However, this is nowhere near your desired aperture of f/4.

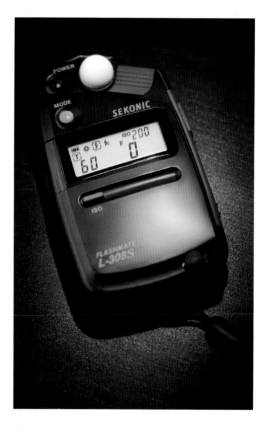

The Sekonic L-308S is a simple and reliable exposure meter with built-in flash metering functionality. In flash metering mode, the meter automatically detects the flash pulse and then starts the metering.

To get things back on track, you need to know the aperture sequence (see the "Light Primer" link in the appendix). You can then calculate the difference between your desired aperture and the metered one. The difference is 3.66 EV. Armed with this data, you can now adjust flash output instead of the aperture to achieve your desired exposure. Just turn down your flash 3 and 3/10 steps if you are using a studio flash, 3 and 2/3 steps if you are using a high-end speedlight, and 4 steps if you are using a value speedlight.

Troubleshooting

In spite of its simplicity, this method is subject to some common errors. If you don't have satisfactory results, use the following list to check that you have everything set up correctly:

› Are the camera and the light meter set to the same ISO value?

› Is the dome affixed properly to the meter with no light leaks? Mine is fixed in place with tape.

› Is the meter positioned as close as possible to the subject with the dome facing the camera and no shadows in between? It is all too easy to cast an unnoticed shadow on the flash meter or unintentionally stand in the light path.

How to Work with the Inverse Square Law

The inverse square law states that the illuminance provided by a point light source is proportional to the inverse of the square of the distance to the source. In other words, if the illuminance at a distance of one meter from the subject is 100%, it will be reduced to 25% at a distance of two meters.

The inverse square law is an important metric in flash photography. The farther the flash is from the subject, the larger the area it has to cover, and illuminance diminishes according to the square of the flash-to-subject distance.

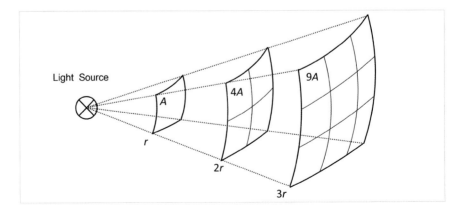

In everyday terms, this means that altering the distance between the flash and your subject has a surprisingly pronounced effect on the overall lighting. With a little practice, you will quickly get used to positioning your lights in circular "orbits" around your subject to avoid having to regularly re-meter your exposure. You will also quickly learn the limits of your speedlight's power and instinctively begin to place your flash as close to the subject as possible to save power. The positive side of the inverse square law is that it helps you estimate the flash-to-subject distance you need in order to produce a white, gray, or black background. The other, even more useful benefit of knowing how the inverse square law works is that you will be able to instinctively adjust your flash-to-subject distances to counteract unwanted light fall-off.

You can alter the color of a background from white through gray to black using the principles of the inverse square law.

The "Angel Dust" workshop on page 112 provides an example of this type of setup, where we made sure that enough light from the front (from a reflector panel) hit the subject by simply increasing the flash-to-subject distance. Unfortunately, nothing in life is free. In this situation, we paid for the reduction in light fall-off from rim light to main light by needing to use much more flash power overall.

Photographers often apply the principle of the inverse square law without actually making precise calculations. The "Light Primer" article listed in the appendix provides a couple of examples if you are interested in finding out more.

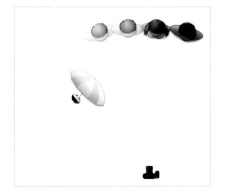 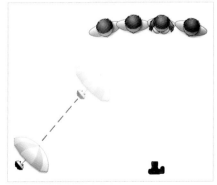

This illustration shows a clever way to use the inverse square law to your advantage. If you increase the flash-to-subject distance for a group portrait, the light fall-off between the left-hand and right-hand subjects will be reduced. The downside of this trick is that it requires additional flash power.

How TTL Metering Works and When to Use It

TTL stands for "Through the Lens" metering and is a standard feature of all mid-range and high-end speedlights.

When you release the camera's shutter for a TTL flash shot, the camera instructs the flash (either directly or remotely) to fire a metering pre-flash that it analyzes to calculate the appropriate exposure parameters. It then transmits this data to the flash, which adjusts flash output accordingly. Once this data swap has taken place, the actual exposure is made using the values that the devices calculated. Modern, high-end TTL systems such as Canon's E-TTL and Nikon's i-TTL combine conventional flash metering values with subject distance data, evaluate disruptive reflections, and apply all sorts of other electronic trickery in an attempt to make flash metering even more precise and reliable.

Modern, high-end speedlights have automatic TTL ("Through the Lens") metering functionality built in. Canon's proprietary system is called E-TTL (Evaluative TTL) while Nikon's system is called i-TTL (intelligent TTL).

TTL metering works much faster than anyone can make manual settings; nevertheless, it has certain disadvantages. It is not completely reliable and, compared with their "dumb" cousins, these smart flash devices can be quite expensive. Additionally, learning to use smart flash technology effectively is much trickier than learning to use conventional technology. There is an increased risk of erroneous operation and incorrectly set parameters.

TTL is ideal for wedding, event, and reportage photographers, or anyone else who needs to shoot flash photos in a hurry. TTL is also great for situations in which the subject is constantly moving, as these involve constant changes to the basic flash settings. A model on a catwalk or actors on a red carpet are subjects that cry out for TTL flash. The alterations to flash parameters caused by the tiny changes in camera position and angle involved in on-camera bounce flash are easier to control using TTL technology, too. Flashes that have built-in TTL technology usually include features like HSS/FP sync, second-curtain sync, modeling flash, and stroboscopic mode, making them useful tools even if you don't actually use their TTL functionality.

TTL is less useful for static subjects in the studio or on location. In situations like these, manual flash settings are generally more reliable, providing consistent, predictable lighting. On team shoots, the probability of a team member accidentally making the wrong camera or flash setting increases and, if TTL is being used, those incorrect settings might even get passed on to the camera when the flash syncs with it.

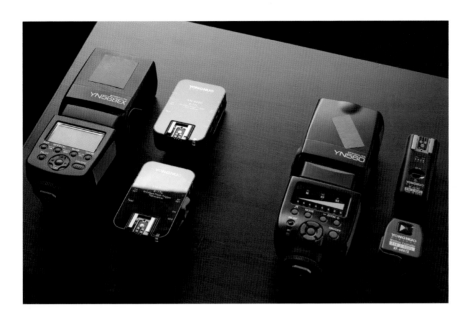

TTL-capable flash and trigger modules (left) compared with non-TTL-capable models (right). Smart TTL technology provides many additional functions but is expensive and tricky to master.

When I go on a single-flash shoot, I take along a TTL-capable flash such as my Canon Speedlite 580EX II. A model like this is ideal for both on-camera TTL-based bounce flash and manual off-camera use. However, if you are just starting out as a strobist, my recommendation is to use an inexepensive non-TTL flash such as the Yongnuo YN-560. It is much easier to learn the ropes and avoid frustration using a non-TTL speedlight.

Once you have learned the basics of manual flash settings, you are sure to want to try out TTL flash techniques, too, but be warned: TTL flashes have a wide range of operational modes and dozens of sophisticated functions. They only really make sense (and are only fun to use) if you study the manual carefully and practice using them. Otherwise, you will have little chance of understanding certain essential concepts such as the relationship between exposure compensation and flash exposure compensation, proper use of flash exposure lock and flash value lock functionality, use of flash groups and communication channels, and much more.

How to Outsmart Your Camera's Sync Speed: HSS, SuperSync, and ND Filters

Most DSLR cameras use focal plane shutters that consist of two major moving parts called "shutter curtains." During a long exposure, the first shutter curtain slides open to expose the sensor, then the second curtain closes to end the exposure. If you use flash during this process, the flash should only fire when the sensor is fully exposed. The term "flash synchronization" is used to describe this limitation.

Canon's high-speed flash mode is called High-Speed Sync (HSS), while the Nikon equivalent is called Focal Plane Sync (FP Sync). Canon flashes display the ⚡H icon in the LCD panel when this mode is activated.

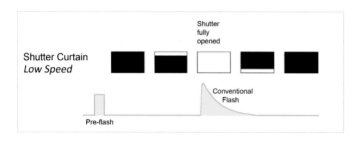

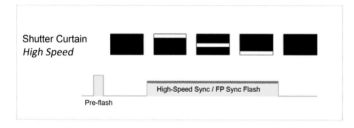

The sync speed is the shortest shutter speed at which a focal plane shutter can be used with conventional flash. HSS/FP Sync make much shorter shutter speeds possible (diagrams not drawn to scale).

The shorter the shutter speed, the faster the shutter curtains open and close. At very fast shutter speeds, they no longer reveal the entire sensor all at once, and instead form a "slit" that moves across its surface. If a conventional flash fired in this scenario, it would only illuminate the portion of the sensor that was exposed, producing a black stripe in the rest of the image. The shortest shutter speed that allows a flash to fire while the shutter is completely open is called the camera's "sync speed," "flash sync speed," or "X-sync speed" (where "X" stands for "xenon flash"). This is usually either 1/200 or 1/250 second.

But we strobists are not happy with this limit to our shutter speeds and are constantly on the lookout for ways to use shorter ones (for example, to "freeze" a subject's movement) or to use wide apertures for flash photography in bright sunlight. Luckily for us, flash manufacturers have recognized the restrictions that limited sync speeds cause and have introduced high-speed sync (HSS) and "focal plane" sync (FP Sync) modes into their high-end speedlights.

These techniques cause the flash to fire stroboscopically throughout the exposure, providing continuous light and making shutter speeds of as little as 1/8,000 second a reality in flash photography.

The downside of high-speed flash sync is a loss of at least two stops of light and further reductions in flash power with every change in shutter speed. For example, switching from 1/250 to 1/500 second halves the available flash output, switching to 1/1000 second leaves you with only one fourth of your original flash power, and so on.

One way to work around this limitation is to use multiple speedlights—a technique often referred to as "gang light." This approach is effective but involves great expense and a lot of effort maintaining all that gear. An eight-flash gang requires 32 fresh batteries and eight separate TTL-capable wireless triggers, making it a complex and extremely expensive way to illuminate a subject.

HSS is often helpful in order to add fill light to portraits taken in bright sunlight but is not a universal solution. If you take another look at the flash timing diagram, you might end up thinking that a flash with sufficient flash duration could also be used as a kind of "continuous" light during an exposure. And you would be right, as long as you are prepared to accept a slight, gradual reduction in brightness across the image. The only thing missing is an effective way to fire the flash the moment the shutter opens, as flash triggered from the camera's hot shoe at shutter speeds faster than the designated sync speed doesn't fire until the shutter is almost closed.

One solution to this quandary is to use a wireless trigger designed to fire the flash early, such as the Yongnuo YN-622N/C-TX, the Phottix Odin, or various PocketWizard models. Depending on the manufacturer, this technology is called either SuperSync, Overdrive Sync, or HyperSync, and the technique is often referred to online as "pseudo HSS" or "long-tail sync." All these names refer to the same technology.

SuperSync/HyperSync uses a slow-burn flash as an alternative to a continuous light source. The most important aspect of the process is the "punctual" firing of the flash (diagrams not drawn to scale).

If you already own an HSS-capable flash, you can use it to trigger a separate off-camera flash. The required procedure is as follows: mount your HSS-capable speedlight on your camera's hot shoe and switch it to HSS and M mode (to suppress any pre-flashes). Then make a "sandwich" from an optical slave trigger (such as a green "Sonia" from colinsfoto.com) and a radio trigger (such as the Yongnuo RF-602 TX) and tape it to your on-camera speedlight. Attach a corresponding radio receiver to the off-camera flash and you are good to go (see the diagram at the top of the following page).

This trick works best with cheap, slow-burning portable flash units with 400 Ws or more of flash energy, but it might even work with a powerful off-camera speedlight.

Check out *wiki.pocketwizard.com* for more details on the HyperSync process.

The ugly duckling of high-speed flash technique is the good old neutral density (ND) filter, also known as a gray filter.

This type of filter enables you to shoot using wide apertures in bright light but is said to reduce image quality and hamper autofocus. I like using moderate-strength ND filters with up to four stops of exposure reduction and don't usually have any autofocus issues. You can alway stop the aperture down a little, too—for example, a 200mm lens set to f/4 will still blur the background nicely.

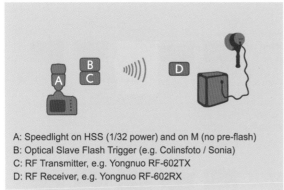

A: Speedlight on HSS (1/32 power) and on M (no pre-flash)
B: Optical Slave Flash Trigger (e.g. Colinsfoto / Sonia)
C: RF Transmitter, e.g. Yongnuo RF-602TX
D: RF Receiver, e.g. Yongnuo RF-602RX

If you already own an HSS-capable flash, you can use it as a SuperSync trigger without having to invest in additional HSS-capable trigger modules.

Neutral density (ND) filters are inexpensive and easy to use. Low exposure reduction values cause negligible image quality loss. ND filters are a usable alternative to HSS/FP Sync and SuperSync/HyperSync techniques.

Combining multiple ND filters really does reduce image quality and is not recommended, while low-profile "slim" ND filters are often impossible to stack with polarizers and other filters. Variable ND filters—which allow you to vary the strength of the filter—are available, too, although cheaper models are not as good as single-strength models, and high-end "vario filters" (such as Singh-Ray's Vari-ND) are very expensive. In my opinion, the best solution is to use a set of standard-strength filters from a reputable manufacturer such as Hoya or B+W.

I own 77mm versions of all my ND filters and simply hold them in front of lenses with smaller front elements. Step-down rings work, too, but I find them too fiddly.

The parameters of some commonly used ND filters. The types often used by strobists are shown in blue.

Optical Density	ND Notation	Exposure Reduction (in EV)
0.3	ND2	1
0.6	ND4	2
0.9	ND8	3
1.2	ND16	4
1.5	ND32	5
1.8	ND64	6
2.1	ND128	7
2.4	ND256	8
2.7	ND512	9
3.0	ND1024	10

Using Color Filters

Depending on its manufacturer, age, and power rating, a xenon flash has a color temperature of 5000–6000 K (Kelvin), which is well suited to use in neutral daylight, which has a color temperature of around 6500 K. If, however, you are shooting indoors, you will often have to deal with artificial light sources that have very different color temperatures. Incandescent light lies in a range between 2600–3000 K, halogen light is a little cooler at 2900–3200 K, and the temperatures of fluorescent and LED lamps vary according to type.

Light Source	Color Temperature
Candle	1500 K
30 W Incandescent Lamp	2600 K
60 W Incandescent Lamp	2700 K
100 W Incandescent Lamp	2800 K
200 W Incandescent Lamp	3000 K
100 W Halogen Lamp	3200 K
Neutral White Fluorescent Lamp	4000 K
Morning and Evening Sun	5000 K
Xenon Flash	5000 to 6000 K
Midday Sun	5500 K
The "Blue Hour"	10,000 K

Color temperatures

If you cannot (or don't want to) eliminate any artificial light sources in your scene, you have to adjust the color of your flash accordingly using conversion filters. The table on the next page lists the most important LEE conversion filters and the color temperatures they cover. The LEE Filters Swatch Book contains samples of all major LEE filters cut to a size that can be easily adapted for use with a speedlight. For more details on LEE conversion filters, see *www.leefilters.com/lighting/packs.html*.

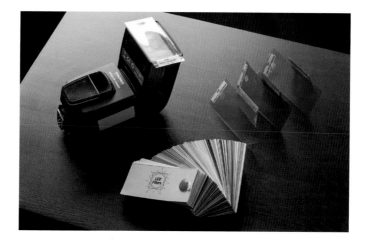

Here are a LEE Filters Swatch Book and a flash equipped with a filter made from two of the gels (one serves as a "tongue" for affixing the other to the flash). Although building them can be a bit tricky, a homemade set of filters with the numbers glued to the sides is a really useful tool.

LEE Filter Number	Color	Color Temperature Conversion	Notes
204	Full CT Orange	6500 K to 3200 K	Adjusts flash to match incandescent light (lightbulb)
205	1/2 CTO	6500 K to 3800 K	
206	1/4 CTO	6500 K to 4600 K	
223	1/8 CTO	6500 K to 5550 K	
285	3/4 CTO	6500 K to 3600 K	
441	Full CT Straw	6500 K to 3200 K	Adjusts flash to match lightbulbs; slightly yellower than CTO
442	1/2 CTS	6500 K to 4300 K	
443	1/4 CTS	6500 K to 5100 K	
444	1/8 CTS	6500 K to 5700 K	
219	Fluorescent Green		Adjusts incandescent light to match fluorescent light; use for unknown color temperatures
201	Full CT Blue		Adjusts incandescent light to match flash
244	Plus Green		Adjusts daylight and incandescent light to match fluorescent light

A selection of LEE conversion filters. The ones with color factors 3/4, 1/2, 1/4, and 1/8 produce a gradual adjustment that can be used to produce more natural-looking effects.

Gel filters can also be used to add interest and drama to an otherwise dull image. If the surroundings on a shoot are too dull, try adding some color filter effects (the workshop chapters contain examples). Furthermore, combining color filters with custom white balance settings produces a whole new world of color moods to explore (see the "Cool American Night" workshop for an example).

If you are interested in color filter effects, try out the LEE Swatch app for iPhone and iPad, which costs $0.99 and provides you with an overview of the spectral curves of all LEE filters.

The LEE Swatch app (available from the Apple App Store) is a great aid in choosing the right filter.

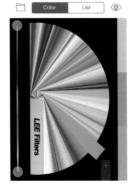
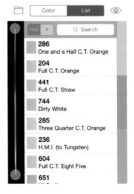
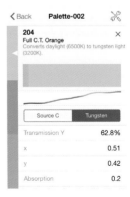

The Aesthetics of Lighting

You can certainly recognize great light in photos you like, but is it possible to take that knowledge and create a system that ensures optimum lighting for any type of subject? This may sound impossible, but it is actually easier than you might think.

What we are talking about is the ability to produce a quality of light that complements and enhances the most important and attractive aspects of a subject. **The source of the light** illuminating the subject contributes its own unique spectrum, adds its own hardness or softness, and comes from a specific angle. **The scene itself** has attributes such as shape, color, and surface texture, while its **surfaces** have attributes such as texture, reflectivity, and transmittance. The interplay between a scene and the light illuminating it produces shade around the subject, shading on the subject's surface, and shadows cast by the subject on its surroundings. **The observer**, on the other hand, is equipped with knowledge of the world at large that includes assertions like "a chair has four legs" or "small yellow things in a game of tennis are balls, which are spherical" or "objects with six sides that cast a certain type of shadow are cubes."

A **cube** on a plane is a highly recognizable three-dimensional shape and is most easily identifiable if the three visible surfaces display maximum contrast to one another, which is the case when a cube is lit from the side. This leads us to the conclusion that light emanating from the observer's point of view is not suited to making an object easily identifiable, as it produces very little shadow. We also see that light hitting an object from a different direction produces shadows that lend it recognizable form. Shadows pointing toward the viewer can also increase an object's recognizability, as these reiterate its shape.

The left-hand image shows a cube illuminated by light shining along the camera's optical axis, while the right-hand image shows the same cube illuminated from the side. The shadows in the second image give the subject a recognizable three-dimensional form.

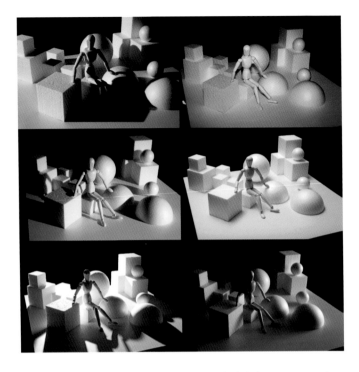

Prototypical scenes of cubes and spheres. Which lighting setup makes the shapes easiest to recognize?

The more complex scene on the left has no color or surface texture but is lit by multiple light sources of varying diffuseness and helps to emphasize the point I am making. If I asked you which of the six photos shows the scene in its most recognizable form, you would probably choose the center image in the right-hand column. In this image, the lighting provides clear shading and shadows and a broad distribution of brightness levels with no obvious discontinuity. The spheres and cubes are obviously three-dimensional, but there are no shadows that compete for the viewer's attention. By comparison, the shadows in the images in the left-hand column make it more difficult to identify the individual shapes.

Alongside its basic shape, an object also possesses attributes such as **color**, **texture**, **absorption**, and **reflectivity**. "What a cute kitten!" is the most likely reaction from a viewer shown a photo like the one below, in which the photographer has lit and captured the soft fur, bright blue eyes, and whiskers in a way that makes each feature perfectly identifiable.

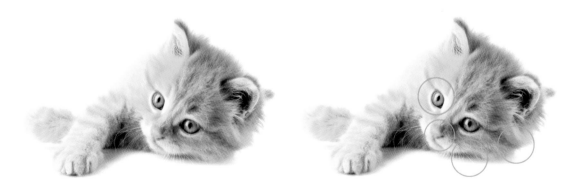

The proper lighting makes this a really cute picture. The kitten's fur appears fluffy, its bright blue eyes are accented by a nice catchlight, its whiskers are slightly transparent, and its nose is obviously moist. (© Africa Studio@Fotolia)

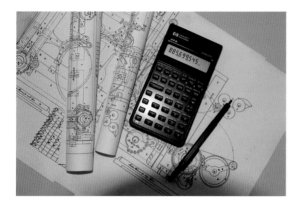
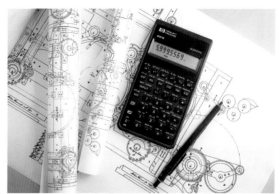

The scene from an engineer's office shown on this page is another good example (which you will also find in the workshop section). This scene only becomes properly identifiable once the shape of the rolled-up plans and the color, material, and legibility of the calculator are clearly defined. It is also important to make the three-dimensional form of the calculator's buttons and the hexagonal shape of the pen clear to the viewer.

But this scene also contains attributes that are better hidden—or at least suppressed. The paint on the calculator could easily look cheap if the lighting produces reflections in its surface. Disadvantageous lighting would also make the scratches and dents on the surface of the pen more obvious than its shape. Additionally, unwanted shadows like the one at the bottom of the left-hand image make the subject less clearly identifiable.

The workshop chapters provide many more examples, including caviar and beer lit from behind to make it look as tasty as possible. In the transistor radio workshop (page 124), the grain in the plastic housing and the Plexiglas cover on the tuning dial only show their true form when lit from the side.

The left-hand image is lit with "hard" light emanating from the same direction as the camera's standpoint. The right-hand image is lit from the side by diffuse light, which gives the subject the required shading, produces a three-dimensional look, and makes the important details easily identifiable.

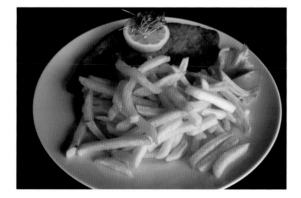
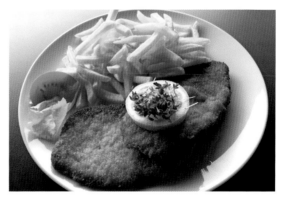

Which schnitzel looks more appetizing? In the left-hand image, the light emanates from the observer's point of view, while the backlight in the right-hand image makes the color and texture of the subject much easier to perceive—and the dish more attractive.

The most widely used portrait lighting patterns are based on similar observations. These four patterns are Rembrandt, loop, butterfly (or "Marlene Dietrich"), and split lighting, and it helps if you are familiar with the principles of how they work. However, you can still create great lighting without knowing these standard lighting setups because, boiled down to its essential components, great portrait lighting depends on sticking to four simple rules:

› Make sure that the subject's eye sockets are well lit and that the eyes reflect the main light to provide a "catchlight."

› Make sure that your subject's nose casts an attractive shadow. Nose shadows should always be formed to point downward, and they should not be too short or too hard. Also, they should not cross the subject's lips. Those that are cast to the side or upward are less than ideal. "Rembrandt" lighting is traditionally set up at around 45 degrees to the axis of the subject's nose and casts the right type of nose shadow, but it can also produce too much contrast and shade. However, adjusting the angle to around 30 degrees often produces better-looking results. This type of lighting setup is also known as "loop" or "open loop" lighting, as the shadow it produces is not a "closed" block between the nose and the cheek like the one produced by the Rembrandt setup (which is why Rembrandt lighting is often referred to as "closed loop" lighting). Instead, loop lighting produces a subtle and open "loop" of light around the nose.

› Make sure that more light hits the subject from above than from below. Having the main light come from below (sometimes called "horror lighting") occurs very rarely in nature and thus appears abnormal to the viewer. While fill light from below is often a useful addition to a lighting setup, the majority of the light should always come from above the subject's eyeline.

› If the subject's nose isn't facing directly toward the camera, the resulting portrait will reveal two distinct sides of the face—one that faces slightly toward the camera and one that faces slightly away from it. The side facing the camera is broader than the other. If this side is illuminated, the lighting is called "broad lighting." If the short side is illuminated, the lighting is called "short lighting." Short lighting usually produces more interesting shading effects and thus better defined faces and more compelling portraits.

From top to bottom, the shadows produced by Rembrandt, loop, butterfly, and split lighting patterns. These well-known lighting setups all adhere to the basic lighting requirement—that it hits the subject above the eyeline while brightening the eyes and producing a favorable shadow of the nose.
(Original illustration © ColorValley@Fotolia)

Generally speaking, light that comes from above and is between 30 and 45 degrees to the side of the subject's face produces the best portraits, but always check your results on the camera monitor to see if you have properly applied the rules listed on the previous page. Sometimes deep-set eyes, hair, or a hat block too much of the light.

And then, if the main light is set, the next step might be to use a reflector or a ring light for fill. You can also include a second flash from behind as an edge light, from above as a hair light, from the side as a kicker light, or as a simple background spot light. For all these lights, the basic rule mentioned at the beginning of the section applies: A well-placed light is one that emphasizes the positive aspects of the subject.

Comparing broad (left) and short (right) lighting shows that the shadows produced by the short lighting setup can make for a more interesting image. (Original illustration © Essl@123RF)

03

EQUIPMENT

Do you remember the days of film—the enormous costs of buying and processing it!—and having prints made? Back in the day, photography was an expensive hobby. Shooting digitally today is a completely different situation; once you have made the initial investment in your gear, you can carry on photographing for years at no additional expense. Unfortunately, photographers love new gadgets, and it is never long before they end up buying a new lens, a better bag, a sniper strap, the latest color filter, or a light modifier of questionable usefulness. My best tip is to buy less and shoot more. Experience will improve your results much more than new equipment ever can. Only purchase what you really need—everything else is just excess baggage.

You don't need to spend much money when you are starting out. A simple hose clamp is all you need to affix an umbrella to an old tripod and produce pleasant, soft light. The YN-560 shown here is triggered by the camera's built-in flash using its built-in optical control sensor.

Lightweight Speedlight Flash Kit

The components described on the following pages have all proven their worth as they have been put through the rigors of my everyday flash photo workflow. Whether a piece of equipment is cheap and cheerful or high-end and robust, each one is worth every penny. There is no point in spending too much on components like umbrellas that have a limited lifespan anyway, but it is definitely worth spending a little more on quality where it is needed, as this saves a lot of frustration in the long run. I am not sponsored by any of the manufacturers listed here, so you can be sure that my recommendations are based solely on experience. I use everything listed here regularly and find each item great for the job at hand.

Back when I started taking flash photos, I used an old camera tripod, a shoot-through umbrella, a hose clamp, and a slave trigger. This simple setup worked perfectly and taught me a lot about the basics of flash photography. Make sure that flash is something you really want to pursue before you go out and spend a lot of money on gear you might not need.

Once you are sure you want to take your experiments further, it is time to build your first proper flash setup. To keep things affordable and to avoid making the learning process more complicated than necessary, I recommend that you start with a non-TTL flash. However, the following section includes tips on building a TTL-capable setup for more advanced use.

The components listed in the box below have proved useful and reliable over years of use.

> A basic strobist kit for manual flash photography:
> Yongnuo YN-560 flash plus Yongnuo RF-602RX and RF-602TX wireless triggers

This setup works with virtually any contemporary camera (although some Sony models require the use of an adapter). The newer YN-560 III and IV speedlights aren't any more robust or powerful than the older I and II models, but they have receivers for the RF-602 and RF-603 wireless triggers built in, which saves space and batteries.

If you don't want to attach the RF-602RX directly to your light stand, you can use a universal flash shoe instead. I attach mine to my stand using a Manfrotto MA-026 umbrella adapter, which is robust enough to outlive us all. My starter kit is rounded out with a mini shoot-through umbrella, which I attach to the MA-026.

Umbrellas are available in a wide range of shapes and sizes, with prices starting at less than $10. I use a slightly more expensive Walimex Pro Mini, which folds down like a conventional travel umbrella and is easy to stow away in my backpack.

I recommend Walimex and Manfrotto light stands. My Manfrotto MA1051BAC is more expensive than some comparable models but can be packed down really small and, if you have more than one, you can clip them together for easy transport. The Manfrotto 5001B Nano is a bit more expensive, but even smaller and also a very good choice. Both can be used as a monopod or a "boom stick" if you extend them but leave the legs folded up.

The TTL version of my flash starter kit is more expensive than its manual counterpart but gives you the functionality you need to shoot fast-moving subjects or in situations where you simply don't have time to make manual settings. TTL flash is ideal for wedding and event photography.

Canon, Nikon, Sony, Panasonic, Pentax, and Olympus all sell dedicated TTL speedlights and some off-camera flash accessories. The downside of most of these units is that they are based on optical triggers that require visual contact with the master flash and don't work over long distances or in bright sunlight.

Sample TTL Flash Kits

Canon
1. Speedlite 580EX II or 600EX plus two Yongnuo YN-622C wireless flash controllers
2. Yongnuo YN-568C flash plus two YN-622C wireless flash controllers

Nikon
1. Speedlight SB-900 or SB-910 plus two Yongnuo YN-622N wireless flash controllers
2. Yongnuo YN-568N plus two YN-622N wireless flash controllers

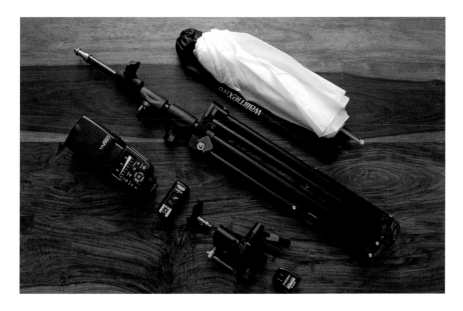

A portable, affordable, and flexible beginner's flash kit made up of a Walimex mini shoot-through umbrella, universal flash shoe, Manfrotto light stand, umbrella adapter, Yongnuo YN-560 flash, and RF-602 trigger.

The TTL version of the flash starter kit is more expensive and more complicated to operate, but can be used at weddings and other fast-moving events. The kit consists of a Canon Speedlite 580EX II and a Yongnuo YN-622C TTL wireless flash transceiver. The other components are the same as those listed for the manual kit on the previous page.

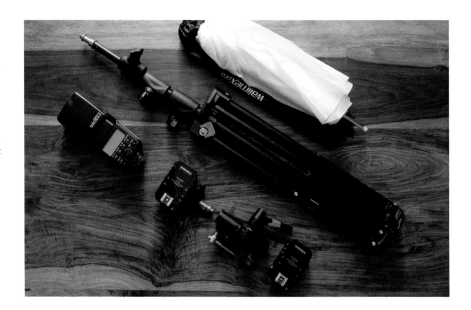

Canon has identified this issue and now sells the radio-controlled wireless Speedlite 600EX-RT/ST-E3-RT system. The greatest drawback of this system is its high price. A more affordable approach is to use Yongnuo components designed for use with Canon or Nikon flashes.

Other manufacturers such as Phottix, Pixel King, and PocketWizard also offer TTL-capable wireless triggers and receivers for Canon and Nikon, but as far as I know, Yongnuo is the cheapest option.

Even though cheaper third-party gear made in Asia offers virtually the same specifications as more expensive equipment from camera manufacturers, you need to be patient and persistent when using it. The manuals provided are minimal and often poorly written, the flashes themselves sometimes simply crash and have to be reset, and the initial batches of new models often have more than their fair share of teething troubles. I don't mind experimenting to solve issues that crop up, but if reliability is more important to you than price, you are definitely better off purchasing high-end devices from one of the major manufacturers.

Our kit is now ready for use; all that is missing are the camera and a set of batteries. Nonrechargeable batteries will work, but the cost of using them quickly adds up, and they are bad for the environment. In the long run, rechargeable Eneloop batteries are a better option. This technology, developed by Sanyo, makes it possible to manufacture precharged batteries with a very long shelf life. Nowadays, there are various copycat products available (such as eneReady). Eneloop batteries can be charged using an original Sanyo charger or a more powerful third-party device such as the one shown on the following page.

Speedlights and wireless flash controllers require power, and using standard (nonrechargeable) batteries is expensive in the long run. Rechargeable batteries and a smart charger make a much better investment.

Like most technology-based products, speedlights and flash controllers (wireless transmitters and receivers) are constantly being improved and updated. In some cases, it makes sense to purchase newer products (such as the Yongnuo YN-560 III/IV flashes with their built-in RF functionality), while some older versions are actually better than their successors. For example, the RF-603 trigger lacks the 1/4-inch thread built into the earlier RF-602 model and is not backwards compatible, which can cause problems if you are planning a workshop or a group shoot. Other products simply have better or different features. For instance, one version of the RF-602TX transmitter has a built-in PC (Prontor-Compur) flash socket, which I find really useful in a lot of situations. I also still use my old, first-generation YN-560 flashes rather than my YN-560 III, because the LED display of the original YN-560 is much easier to read than the LCD displays built into later models. Details on a range of speedlights, RF modules and their specifications, as well as user experience reports can be found at these online resources:

www.lightingrumours.com
www.fredmiranda.com/forum
www.neilvn.com/tangents
www.dpreview.com/forums

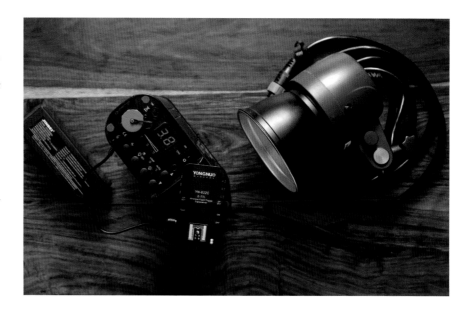

The 400 Ws Jinbei Freelander FLII 500 is a really powerful unit with a Bowens bayonet and a long flash duration that makes it great for performing the SuperSync trick. This photo shows the flash head, the supplied mini PAR reflector, the transceiver unit, an extra LiPo battery, and a Yongnuo YN-622C wireless flash transceiver (the additional battery and the YN-622C are not included in the purchase price).

Portable Flash Generators: Heavier but More Powerful

If you're on a shoot that requires more flash power than a speedlight can provide, why not use a portable flash unit instead? "Porty" was originally the name of a range of portable flash generators made by Hensel but has since become a widely used term for all types of powerful portable flash generators. A portable flash unit is heavier and more powerful than a speedlight. Most speedlights deliver 60–70 Ws of flash energy, whereas a portable flash unit delivers approximately 400 Ws (and some even deliver up to 1,200 Ws). Another important feature of portable flash units is that they come with a standard bayonet for mounting studio light modifiers.

If you are prepared to put up with the inconsistencies in quality that Chinese and Taiwanese gear sometimes has, you can purchase a powerful portable flash unit like the Jinbei Freelander FLII 500 for less than the price of a high-end speedlight. Of course, such a flash is not as robust or reliable as an original Hensel Porty Lithium, but in addition to being less expensive, this portable flash unit also offers a much longer flash duration. Long flash durations used to be seen as a drawback but now, thanks to increased interest in SuperSync techniques, they are enjoying a newfound popularity (see page 31 for more details).

Jinbei and Walimex are two manufacturers of value lighting gear who both utilize the Bowens accessory bayonet, for which a wide range of light modifiers is available. Other manufacturers and bayonet types may offer better quality, but I hate spending more than I have to on light modifiers and, to my eyes, the difference between the results produced by inexpensive versus expensive light modifiers is most often undetectable anyway.

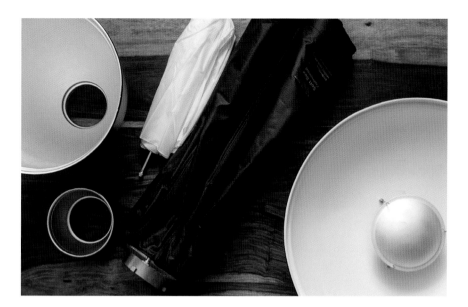

A range of light modifiers for the Jinbei portable flash unit: a tele PAR reflector, a mini PAR reflector, an umbrella, an octabox (shown here folded down), and a beauty dish.

A beauty dish makes a great standard light modifier for a portable flash unit, providing soft, engaging light at a decent price. A beauty dish is also less susceptible to the effects of wind and is more robust than either an umbrella or a softbox.

At some point, you should definitely purchase a large, air-cushioned light stand. Air-cushioning doesn't add much to the price and ensures that your flash head doesn't get damaged if your stand should unexpectedly collapse.

If you still don't want to take the plunge and buy a portable flash unit, check out the "Additional Techniques" chapter for a hands-on guide to building your own powerful Bowens-bayonet flash unit from two modified speedlights.

Cameras, Lenses, and Accessories

When it comes to selecting cameras and lenses, everyone has their own personal preferences, but I thought you might like to take a look in my camera bag anyway.

I can cover most situations with my Canon full-frame body and my 24–70mm f/2.8 and 70–200mm f/2.8 zooms. I vary only my third lens: I take along either a macro lens, an 85mm f/1.8, a set of Kenko extension tubes, or a Lensbaby. On the rare occasions when I shoot cityscapes alongside my flash photos, I use a 17–35mm wide-angle zoom. Whichever lenses I use, I always carry a set of ND filters, one or two TTL speedlights, and color filter gels. Other bits and pieces that I usually have with me include gaffer tape, safety pins, model release forms, a pen, business

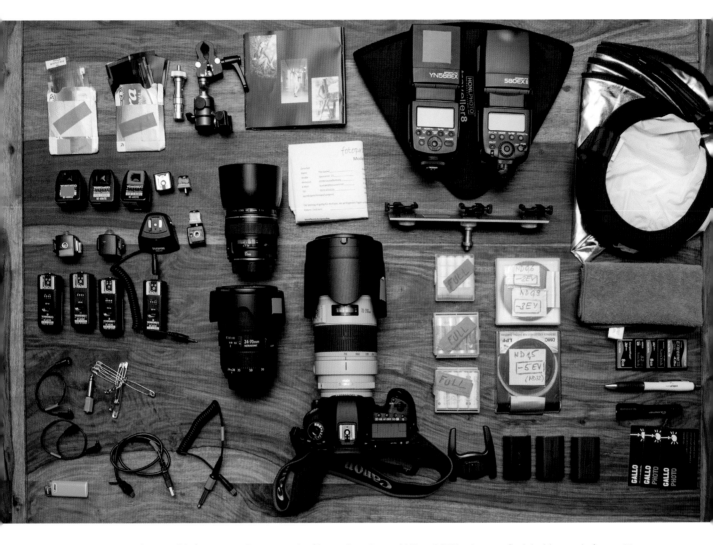

My current kit, roughly from top to bottom: color filter gels; spigots, 1/4" and 3/8" adapters; flash holder made from a Man-frotto Nano Clamp and a Novoflex 19P ballhead; homemade pose book; Yongnuo YN-568C and Canon Speedlite 580EX II TTL flashes; Honl Traveller8 mini softbox; mini foldable reflector; Yongnuo RF-602 flash controllers; Sonia slave trigger from colinsfoto.com; adapters and cables; EF 85mm f/1.8, EF 24–70mm f/2.8 II, and EF 70–200mm f/2.8 II lenses; EOS 5D Mark III camera body; model release forms; homemade three-flash bracket; rechargeable batteries; ND filters; microfiber cleaning cloth; CompactFlash memory cards; pen; flashlight; business cards; flash shoes; safety pins; lighter.

cards, spare batteries, a pocket flashlight, wireless flash controllers, a couple of slave triggers, and various spigots. The photo above shows my current kit laid out for you to see.

I carry my gear in either a Lowepro SlingShot 302 backpack or in a Think Tank Airport Navigator wheeled camera bag. I carry my larger stands with my other gear and transport my Manfrotto 5001B Nano stands in two Sirui TB-52 tripod bags, which also contain my speedlights, my umbrellas, and my umbrella adapters.

Most of the gear I use is standard, but there are a couple of additional details I would like to mention. I mark all my gear with blue fabric tape to avoid mix-ups at workshops or on group shoots. I often use a Kinotehnik screen loupe to check focus and exposure. I always carry a "black foamie thing" (BFT) to flag my flash; the BFT was invented by Niel van Niekerk and crops up a lot in the workshop chapters. Check out Neil's website at *www.tiny.cc/nj5ekx* for more details.

I always carry a roll of LEE 204 filter gel because the small gels from the LEE Filters Swatch Book are too small for use with my portable flash unit. And last but not least, I take along a Yongnuo YN-622C (or the newer TX version) wireless transceiver for situations in which I have to focus in the dark. This particular piece of gear is worth carrying for its powerful focus assist lamp alone, even in the rare situations when I am not using flash.

The deeper you delve into the world of flash photography, the more stands, reflectors, diffusers, Magic Arms, and Super Clamps you will collect. I can unreservedly recommend products by Manfrotto, Lastolite, and Novoflex, but as I mentioned previously, I am also happy using more affordable gear from Walimex, Jinbei, and Yongnuo. It's not the end of the world if a Yongnuo YN-560 happens to drown or break, but it is a much more painful experience if a high-end Nikon flash fitted with a PocketWizard bites the dust.

Incidentally, you might be thinking that the photo of my gear took a lot of effort to shoot, but in fact I empty my bag completely before every shoot to clean and check my gear, replacing any broken or missing parts before packing it all up again. This check-up procedure has become instinctive and ensures that my kit always works properly when I am out and about.

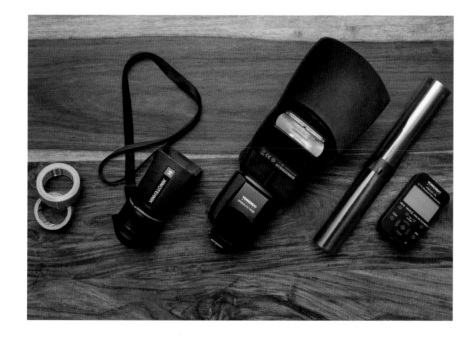

Some of my other essential bits and pieces: blue fabric tape, a screen loupe, a "black foamie thing," a roll of CTO filter gel, and a YN-622C-TX wireless flash transceiver.

WORKSHOPS

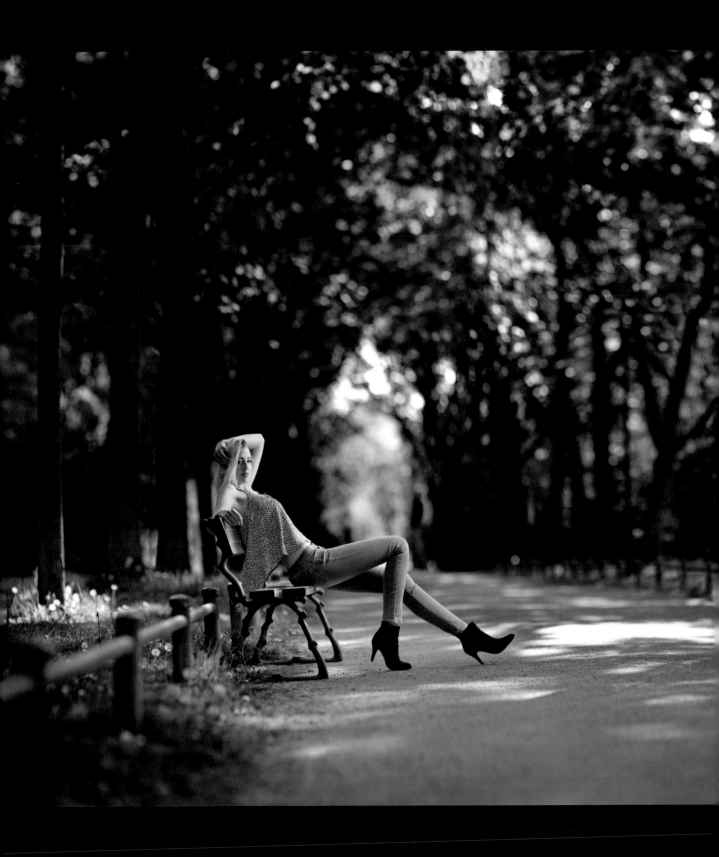

01

PEOPLE

If you take a look at a few online forums on flash photography, you will find that speedlights are most often used for people photography. While food and product photos are frequently captured using conventional studio flash gear, the light weight and versatility of speedlights makes them ideal for use on location. The workshops in this chapter include examples of simple indoor portraits using just a single umbrella or softbox, more complex shots using shadow projections, tricks with white balance settings, SuperSync techniques, and much more.

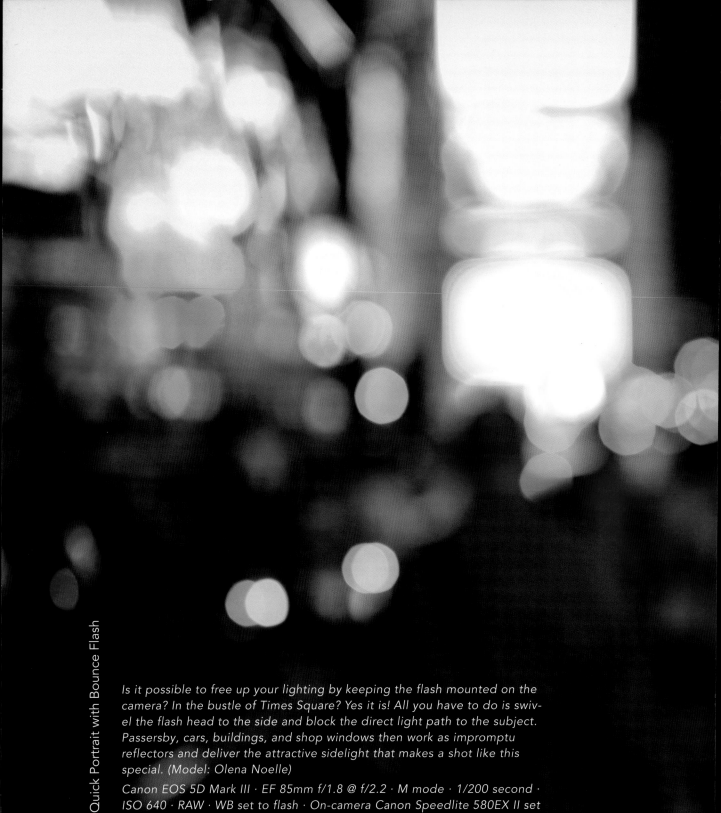

Is it possible to free up your lighting by keeping the flash mounted on the camera? In the bustle of Times Square? Yes it is! All you have to do is swivel the flash head to the side and block the direct light path to the subject. Passersby, cars, buildings, and shop windows then work as impromptu reflectors and deliver the attractive sidelight that makes a shot like this special. (Model: Olena Noelle)

Canon EOS 5D Mark III · EF 85mm f/1.8 @ f/2.2 · M mode · 1/200 second · ISO 640 · RAW · WB set to flash · On-camera Canon Speedlite 580EX II set to TTL, rotated sideways and fitted with a flag · –0.33 EV flash exposure compensation (FEC)

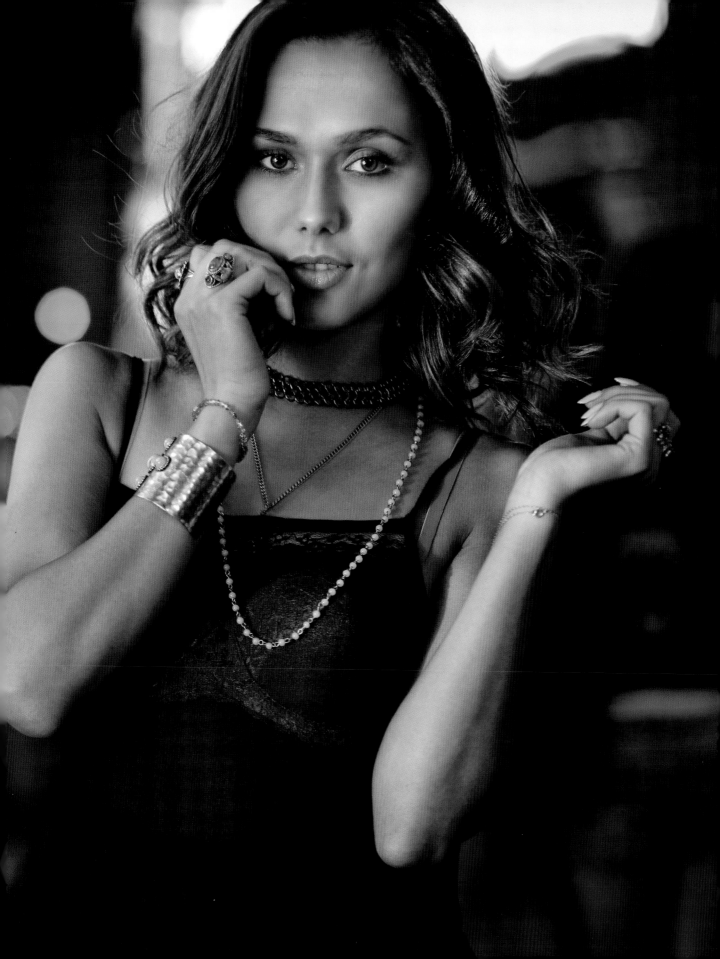

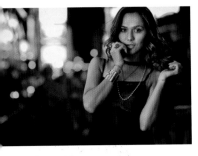

#1 Quick Portrait with Bounce Flash

> › Freeing up the light from your on-camera flash
> › Using a flag
> › Selecting the optimum flash angle

Sometimes you simply don't have the necessary time or space to set up an off-camera flash, but there are still effective ways to free up the light that your flash produces. The simplest way to do this is to rotate the flash head and "bounce" the light off a wall, much as you would bounce a pool ball off a cushion. This is a standard technique in indoor situations but, as you will see, it can be really effective on location, too.

We completed the shoot shown here in about 15 minutes in a heavily trafficked Times Square. Neil van Niekerk was with me, and I wanted to tease him a little by testing his legendary "black foamie thing" (BFT) under fairly extreme conditions. Ideal bounce flash conditions include a nearby white wall but a crowd, a shop window, or a red bus also works, if that's what the situation demands.

Location, Equipment, and Lighting

We began our shoot with a few shots on a side street off Broadway before moving into the Times Square crowd. We had to work quickly, and this is where TTL flash performs so well. If you find yourself close to a suitable bounce surface such as a bus, a wall, or a shop window, TTL should help you to take well-exposed photos without first having to make time-consuming test shots.

For this shoot, I used a full-frame Canon EOS 5D Mark III with an 85mm lens and a Speedlite 580EX II TTL flash. I rotated the flash head to the side as shown in the illustration below and used Neil's "black foamie thing" to block the direct light path between the flash and our model's face.

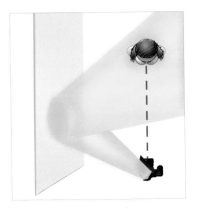
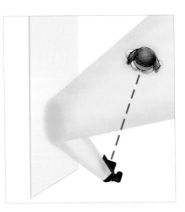

The setup for lateral bounce flash. Using the angle shown in the right-hand illustration ensures that some of the light hits the side of the subject's face that is farthest from the wall. In situations like this, you should also tilt the flash head slightly upward so that the bulk of the light comes from above the subject's eyes.

In its simplest form, the BFT consists of an 8" x 6" piece of foam rubber, felt, or card attached to the flash using an elastic hair band. I love using this type of flag and I am constantly fine-tuning mine. You can see my current "Mark IV" version in the photos on the right.

A close-up of my version of Neil van Niekerk's "black foamie thing" (BFT). This great little tool is made from a piece of foam rubber, a rubber band, and a patch of sewn-on felt that makes it easier to rotate and vary its position. Sooner or later, a BFT becomes an essential part of every strobist's kit (for more details, visit www.tiny.cc/xgkfmx).

Settings and Shooting

Although we were using TTL flash, I made all my other settings manually. In a situation like this, I begin without flash. In order to get the background to look just right, I set the aperture to f/2.2 to keep depth of field shallow and subject details sharp, then set a shutter speed of 1/200 second to eliminate camera shake, and adjust the ISO value. I keep an eye on the metering display in the viewfinder to check exposure and then make a couple of test shots. Once everything is set up, I switch on my flash, rotate it to the side, tilt it upward, and attach my BFT to block any residual direct light.

These are the settings you have to use to get good results, but you can still fine-tune the look of your photos using flash exposure compensation (FEC) and the flash spot metering feature (FEL/FV Lock). With a little practice, you will quickly learn to find the best possible settings for the subject's skin, although TTL flash should even be able to deliver acceptable results without any additional tweaks. In the photos shown here, I used an FEC setting of −0.33 EV and didn't use the FV Lock feature.

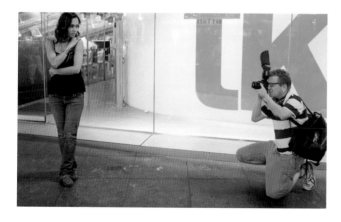

Man at work. This photo shows the work in progress at the TKTS booth in Times Square (photo by Neil van Niekerk). In this shot, the shop window serves as our bounce surface. In this case, I am bouncing from the right, but I continually switched between right- and left-hand bounce during the session.

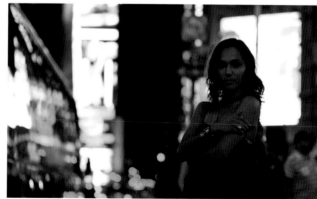

This is the first test shot I made for the ambient light in the photo on page 60. I ended up increasing the ISO value to let in more ambient light.
Canon EOS 5D Mark III · EF 85mm f/1.8 @ f/2.2 · M mode · 1/200 second · ISO 320 · JPEG · WB set to flash · Flash switched off

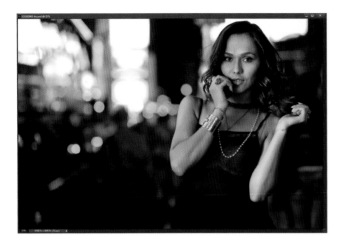

The effectiveness of shots like this depends on shallow depth of field, which helps to produce the nice bubbles of big city light in the background. Here's the quick way to shoot in a situation like this: select a long focal length, a wide aperture, and a short camera-to-subject distance, and keep the background as distant as possible.

It can be tricky to focus when using such wide apertures. To ensure perfect focus, I set one of the edge focus points to focus on my subject's eyes and then, if I decide to move the subject even further toward the edge of the frame, I focus, recompose, and stop the aperture down a little (in this case, from f/1.8 to f/2.2). If I then need to move the model even further toward the edge of the frame, I shoot a panorama made up of two or three separate images. Panorama techniques are covered in more detail in workshop #7 on page 100.

Post-Processing in Photoshop

Because shots like this contain a mix of ambient and flash light, you will often find that a subject's skin tones tend toward green or violet, depending on the amount of ambient light involved. The color of the bounce surface plays a role, too, so it is always a good idea to shoot photos with mixed light sources in RAW mode to give yourself as many options as possible when it comes to adjusting white balance.

The screenshots on the left show the original and processed versions of our image and the corresponding Photoshop layer stack. The four lower layers correspond to the background, the entire subject, the upper body, and the face, which I processed individually using Photoshop CC's Camera Raw Filter tool and masks. The other steps I applied were skin retouching, dodge and burn, and the Photoshop Liquify filter.

The unprocessed photo, the Photoshopped version, and the corresponding layer stack.

Tips and Tricks

› For test shots in situations like these, it is best to use back-button focus. This technique enables the camera to capture an image even if it cannot "see" any well-defined edges to focus on, thus speeding up the process of taking test shots for the ambient light, with little or no demands regarding sharpness.

› A "black foamie thing" isn't just great for portrait work. Later in the book I'll describe food and product shots that benefit just as much from this universal light modifier.

This shot was captured on a side street off Broadway and illustrates the importance of keeping an eye on background patterns and textures. The bokeh bubbles are a major feature of this shot.

Canon EOS 5D Mark III · EF 85mm f/1.8 @ f/2.2 · M mode · 1/160 second · ISO 640 · RAW · WB set to flash · On-camera Speedlite 580EX II set to TTL, rotated to the side and fitted with a BFT flag · –0.33 EV FEC

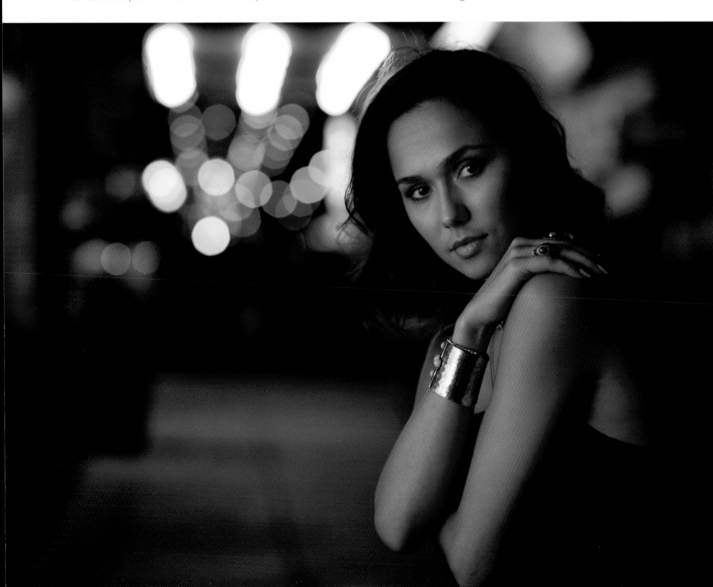

› It is probably better to use a TTL-capable flash for this type of bounce shot, as it will automatically compensate for small changes in subject distance and angle. However, you can shoot using an inexpensive non-TTL flash if you want. It will just take a bit longer to get everything set up.

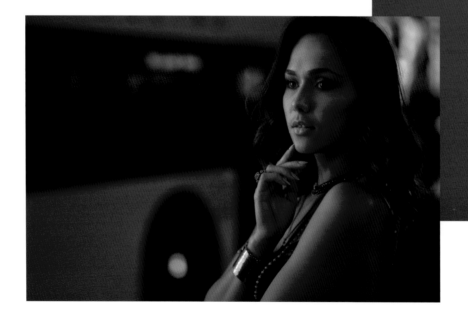

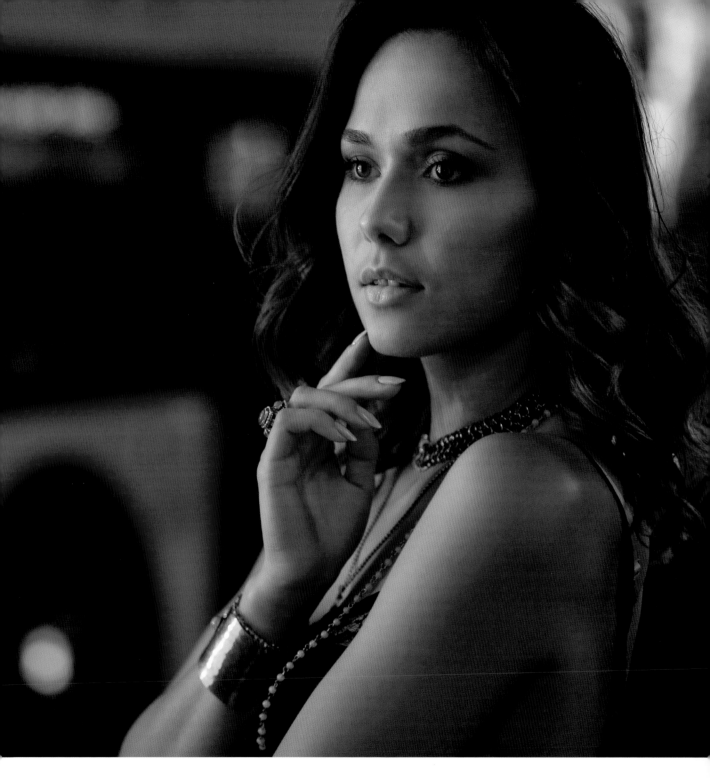

This photo from our Times Square shoot was lit using flash bounced off the red bus in the background. As you can see at left, it showed a distinct red cast. We balanced out this effect with the White Balance tool in Adobe Camera Raw, using the whites of our model's eyes as a reference.

Canon EOS 5D Mark III · EF 85mm f/1.8 @ f/2.2 · M mode · 1/200 second · ISO 320 · RAW · WB set to flash · On-camera Speedlite 580EX II set to TTL, rotated to the side and fitted with a flag · −0.33 EV FEC

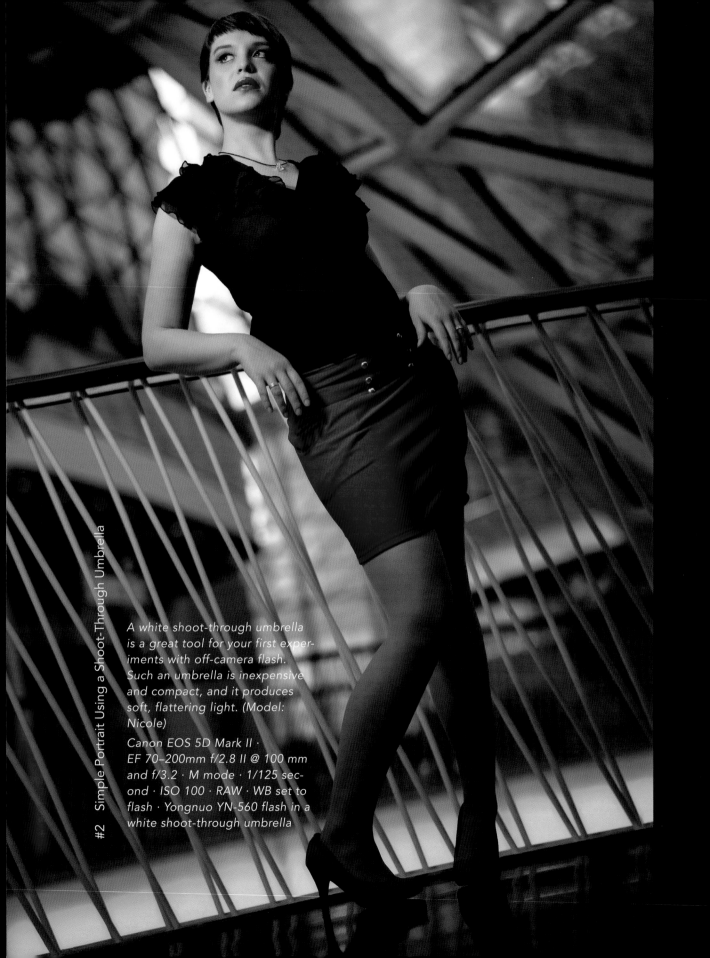

A white shoot-through umbrella is a great tool for your first experiments with off-camera flash. Such an umbrella is inexpensive and compact, and it produces soft, flattering light. (Model: Nicole)

Canon EOS 5D Mark II · EF 70–200mm f/2.8 II @ 100 mm and f/3.2 · M mode · 1/125 second · ISO 100 · RAW · WB set to flash · Yongnuo YN-560 flash in a white shoot-through umbrella

#2 Simple Portrait Using a Shoot-Through Umbrella

> › Getting to know and love umbrellas
>
> › Using a shoot-through umbrella for a portrait on location

Umbrellas are not as popular on the strobist scene as they deserve to be, probably because accessory manufacturers can make more money adding clever features to their more expensive softboxes. Umbrellas, however, are cheap and compact, and they provide beautiful soft light. Admittedly, there are a couple disadvantages: the light that escapes from the back of a shoot-through umbrella can be a drawback in small spaces, and in some situations the shaft of a parabolic umbrella simply gets in the way. However, these are minor issues that you can learn to circumvent with a little practice. I prefer to use shoot-through umbrellas because the light they produce is easier to apply. I often get a usable shot on my first attempt using a shoot-through umbrella, whereas it takes longer to get things right when I use a parabolic umbrella, a softbox, or a beauty dish.

Shoot-through and silver parabolic umbrellas each have their own advantages and disadvantages. A shoot-through umbrella allows light to escape at the back, which can be a problem in small spaces, while the shaft of a parabolic umbrella often simply gets in the way. Practice is the best way to get used to using both.

Location, Equipment, and Lighting

For our shoot with Nicole, we chose the MyZeil shopping mall in Frankfurt with its unique lattice-style architecture as our location. It always helps to get advance permission to shoot in locations like this, but if you are not sure whether you need permission, be sure to use light, compact gear that you can set up in advance. This way, you can shoot quickly and get the shot, even if you have to high-tail it later on.

The location for this shot was the MyZeil shopping mall in Frankfurt, with its stunning modernist architecture.
iPhone 4S · 4.28 mm · f/2.4

This simple setup uses a single speedlight mounted in a shoot-through umbrella. The main light is set up at an angle of approximately 30 degrees to the model's face and comes mostly from above her eyeline.

For this shoot, I used a light stand, a white shoot-through umbrella, manual Yongnuo RF-602 flash controllers, and a Yongnuo YN-560 manual flash, along with my trusty EOS 5D Mark II and my EF 70–200mm f/2.8 II lens.

Settings and Shooting

At our location, we could have suppressed the background using a high-powered flash the way I described in the first part of Chapter 1, "Quick Start Guide." However, this would have spoiled the point of shooting at such a great location. A better approach was to follow the second part of the "Quick Start Guide" and begin by making test shots without flash to check how the background looked. I switched to M mode and set my aperture, shutter speed, and ISO values using the exposure meter readout in the viewfinder. This allowed me to find the right exposure parameters without taking the camera from my eye and without having to make any test shots. On location, I use center-weighted metering and usually set a deliberate underexposure of about –1 EV. Once I have made these settings, I take a test shot of the background and check the result using a screen loupe.

Then we add the speedlight for the subject. I placed my umbrella as close to the subject as possible but as far away as necessary. The closer the main light is to the subject, the softer the light and the more battery power I can save. On the other hand, moving the light further away makes it easier to illuminate the subject's entire upper body. The most important aspects of this particular shot are that the subject's face is the brightest part of the frame and that the light comes from above her eyeline.

The photos below show the setup with and without flash. You can also see the edge of the umbrella protruding into the frame.

Left: Always take an initial test shot without flash to check the exposure for the background.

Right: Once the background looks right, set up the lighting for your main subject.

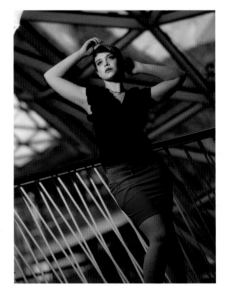

Post-Processing in Adobe Camera Raw and Photoshop

For these RAW shots, I fine-tuned the exposure a little in Adobe Camera Raw and performed some slight beauty retouching in Photoshop. My standard tweaks include some dodging and burning, as well as application of the Liquify filter. I often add a subtle vignette, too. The illustrations here show the original image, the processed version, and the corresponding Photoshop layer stack.

The post-processing steps for this image included standard beauty retouching as well as a subtle vignette and a slight adjustment to the contrast.

Tips and Tricks

› As well as changing its angle and height, you can also swivel a shoot-through umbrella to alter the effect it produces. If you find that too much light hits your model's legs, try swiveling your umbrella slightly upward or backward to attenuate the effect.

› If you want to play it safe with your lighting setup, make sure that your model's nose points in the direction of the umbrella shaft. This way, you can be sure of producing a nice, light nose shadow. With a little practice, you can use more extreme angles to produce more interesting shadows (loop lighting, Rembrandt lighting, etc.). Try standing where your model stands in order to see the effect and direction of the lighting for yourself.

› As well as shoot-through and parabolic umbrellas, you can also use an umbrella softbox (or "brolly box"), which combines a reflective umbrella with a diffuser cover. The result is a kind of softbox. With this construction, there is no unwanted stray light from the back of the umbrella. The downsides of a brolly box are its higher price and its increased bulk compared with a standard umbrella. I have yet to find a collapsible "mini" brolly box that is suitable for my kind of location work, but I do use larger standard-sized models for studio-based work.

This is another shot from the "MyZeil" shoot. (Model: Jenny)
Canon EOS 5D Mark II · EF 70–200mm f/2.8 II @ 200 mm and f/3.2 · M mode · 1/200 second · ISO 100 · RAW · WB set to flash · Manual Yongnuo YN-560 mounted in a white shoot-through umbrella

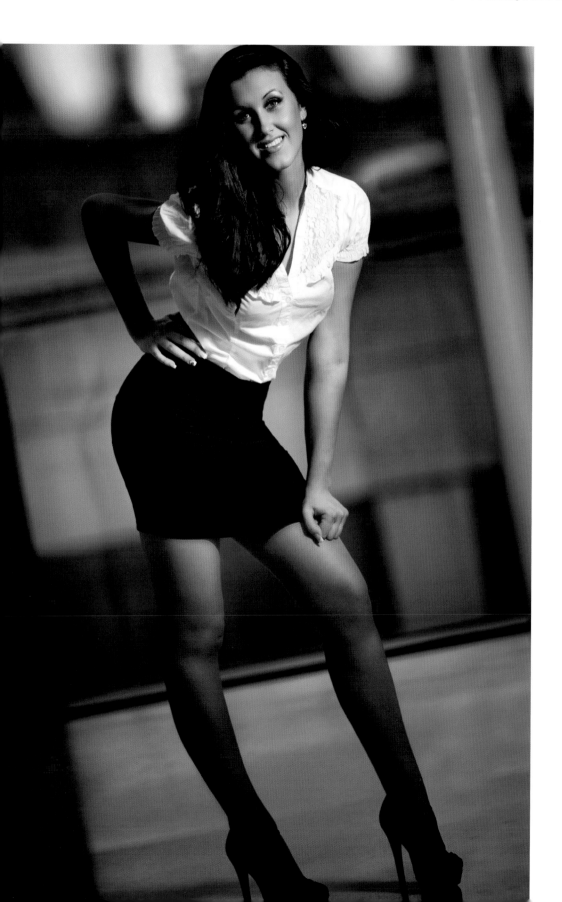

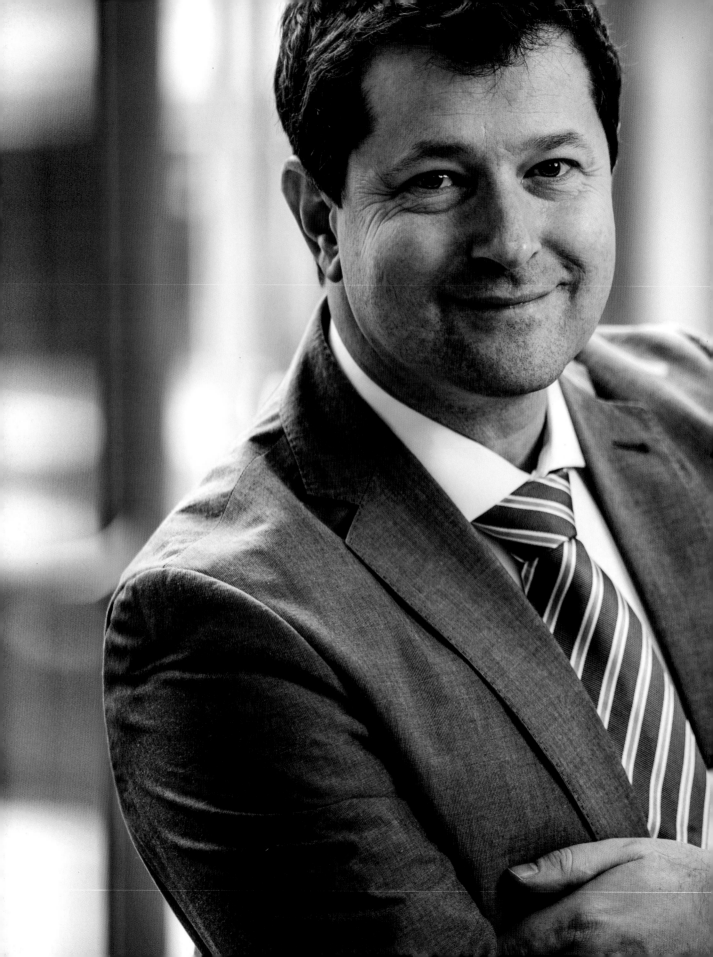

Using only one flash doesn't mean you are limited to using a single source of light. This shot shows how you can use the ambient light as an integral part of your composition. (Co-photographer and model: Mike Silberreis)

Canon EOS 5D Mark III · EF 70–200mm f/2.8 II @ 123 mm and f/2.8 · M mode · 1/100 second · ISO 640 · RAW · WB set to flash · Canon Speedlite 580EX II in TTL mode (with FEL and –0.33 EV FEC), mounted in a Firefly II softbox and triggered using a Yongnuo YN-622C TTL wireless flash transceiver

#3 Business Portrait Using a Softbox and Natural Light

> › Using a softbox
> › Using ambient light as a hair light, rim light, or kicker

The previous shoot shows how to use the location itself as the background. This shoot takes a different approach and shows you how you can use the attributes of a location to provide lighting accents that complement the main light from your flash. A portrait can really benefit from a natural hair or rim light. Furthermore, a location like this enables you to follow the current trends in business portraiture, which favor "cool" out-of-focus backgrounds with plenty of steel and glass.

Location, Equipment, and Lighting

The location is particularly important in shots like these, and we were on the lookout for a building made almost entirely of glass to provide an interesting background. We also needed to be able to work unhindered without special permission. We decided to shoot at the "Die Welle" ("The Wave") office building in Frankfurt. For the setup, we used a Firefly II collapsible softbox with a Canon Speedlite 580EX II set to TTL mode and a Yongnuo YN-622C wireless flash transceiver.

We wanted to use the ambient light as backlight, so it was important to get the subject to stand with his back to the glass façade. Once again, I began by taking test shots without flash to check the effect of the ambient light.

This is the Firefly II softbox we used, shown here with a manual flash. This particular model folds down like an umbrella and is really quick to set up.

I used my Canon EOS 5D Mark III and my 70–200mm f/2.8 II lens, which enabled me to open the aperture really wide and create a nice soft background effect. If you use a crop-format camera with an 85mm f/1.8 or 100mm f/2 prime lens for a shot like this, it might be a good idea to use a tripod or monopod to prevent having to use too high an ISO value. I used ISO 640 for the shots shown here.

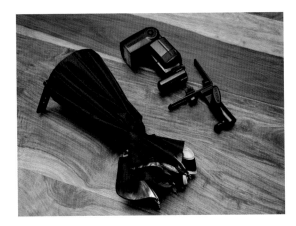

Settings and Shooting

I began by setting the camera manually to provide a satisfactory background effect. I then set my flash to TTL mode and used the flash exposure lock (FEL) feature. Finally, I fine-tuned the flash power using –0.33 EV flash exposure compensation (FEC).

Because neither the subject nor the flash moved during the shoot, it might have been easier to use manual flash settings. But I was too lazy to alter the flash settings and stuck to using TTL mode with FEC instead.

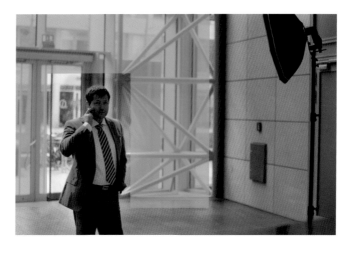

The test shot without flash shows the additional hair, rim, and kicker light effects provided by the ambient light. The rim and kicker effects are highlighted in pink, while the green highlight shows the structure that we hoped would provide interesting background texture.

This is the unprocessed setup shot with flash.

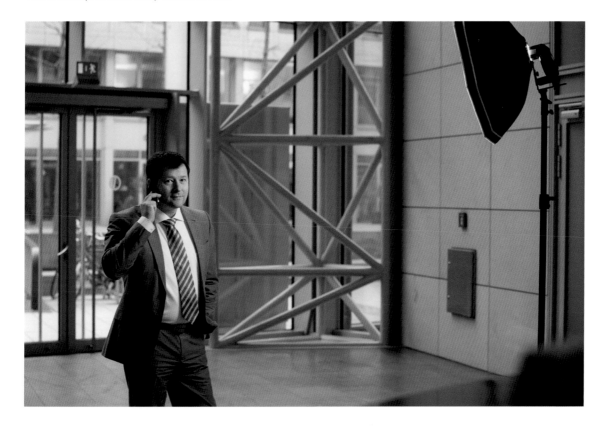

The "before" and "after" images, as well as the Photoshop layer stack showing the processing steps I applied.

Post-Processing in Photoshop

You can use higher contrast, more distinctive Clarity settings, and cooler tones in portraits of men than you can in photos of women, but it still pays to remove any unwanted skin blemishes. The illustrations here show the original and processed images with the corresponding Photoshop layer stack.

Tips and Tricks

> Shooting the glass façade of a building like this from outside wouldn't work because there is no backlight. If we had tried this, it would have made the background too dark, and the additional natural lighting effects described on the previous page would be missing.

> We used a large light stand and a Manfrotto 026 umbrella adapter. This setup worked fine, but using a boom stand for shots like this makes it easier to adjust the softbox. If a dedicated boom stand is too expensive, you can always build your own from normal stands and parts from a reflector holder (see page 15 for more details).

› Always take some extra shots of interesting backgrounds when you are on location. A collection of interesting backgrounds is perfect for pepping up studio shots. You can download the backgrounds I captured during our shoot at "Die Welle" from *www.tiny.cc/4vgqmx*.

Stock backgrounds are ideal for pepping up dull studio shots, and you can never have too many.

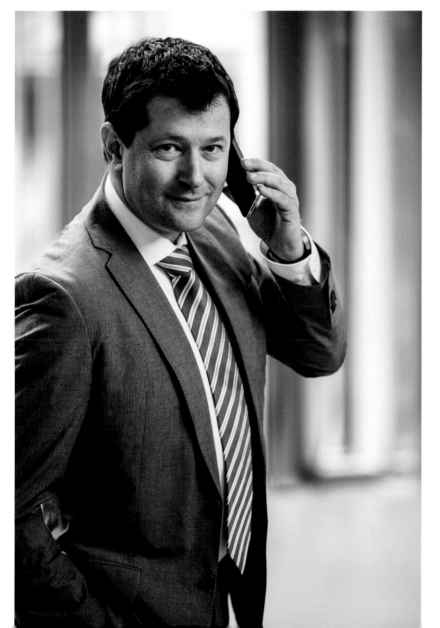

Another business portrait shot at "Die Welle" in Frankfurt.

Canon EOS 5D Mark III · EF 70–200mm f/2.8 II @ 130 mm and f/2.8 · M mode · 1/100 second · ISO 640 · RAW · WB set to flash · Canon Speedlite 580EX II in TTL mode (with FEL and –0.33 EV FEC) mounted in a Firefly II softbox and triggered using a Yongnuo YN-622C TTL wireless flash transceiver

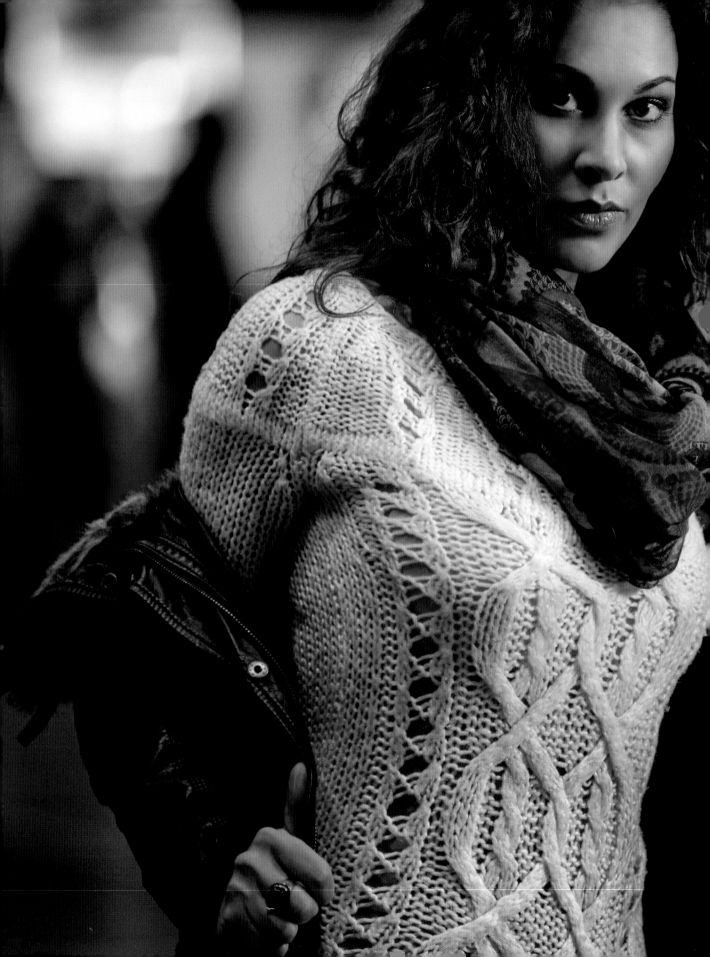

If you shoot using a wide aperture in evening light, the big city lights turn into beautiful bokeh bubbles—an effect that quickly becomes quite addictive! (Model: Mia Carma, Co-photographer: Alexander Kasper)

Canon EOS 5D Mark III · EF 70–200mm f/2.8 @ 200 mm and f/2.8 · M mode · 1/100 second · ISO 2000 · RAW · WB set to flash · Canon Speedlite 580EX II, TTL, FEL, Firefly II softbox, triggered remotely using a Yongnuo YN-622C

#4 High-ISO Fashion Shoot

> › Shooting at high ISO values using a wide aperture
> › Using city lights to create bokeh effects
> › Dealing with mixed light sources

The latest cameras, with much better sensors than earlier DSLRs, make the issues previously involved in shooting at high ISO values a thing of the past. Nowadays, you can get great results using high ISO values to create interesting background bokeh effects while using flash to illuminate the main subject in the foreground.

Location, Equipment, and Lighting

Bokeh effects quickly become addictive, and great big bubbles of bokeh are the most distinct form of this nice effect. To create bokeh bubbles, you need background lights that are as colorful as possible, like the ones we found at a food stall at the main train station in Frankfurt. You normally need permission to shoot if you use a tripod or flash in a location like this, but on this particular occasion we decided to shoot without asking. This time around, security left us alone, but you can never count on that.

An overview of our railway station shoot, showing our model lit using a handheld softbox and the food stall in the background that provided the bokeh effect. (Model: Mia Carma, Co-photographer: Alexander Kasper)

A bokeh addiction isn't cheap! Ideally, you should have access to a full-frame camera and fast telephoto lenses. For this shoot, I used my Canon EOS 5D Mark III and my 70–200mm f/2.8L IS II lens. The great stabilizer built into the lens means I can shoot at 1/100 second handheld, and the camera's sensor allows me to shoot at ISO 2000 or 3200 without having to worry about the quality of my images. If you can't shoot with a full-frame camera, a DX or APS-C body with a less expensive Sigma or Tamron 70–200mm f/2.8 lens will do the trick, although in the case of non-stabilized lenses you might need to use a monopod to help keep things sharp.

For this shoot we set up a 20" Firefly II softbox mounted on a Manfrotto 1051BAC stand, which we used extended but with the legs folded up to make a boom stick. We used a Canon Speedlite 580EX II in TTL mode and a Yongnuo YN-622C wireless flash transceiver.

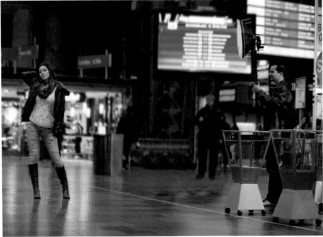

Settings and Shooting

As usual, I began by setting the exposure for the ambient light. I selected the widest possible aperture and the longest telephoto setting for my lens to give me extremely shallow depth of field, and I moved my shooting position back to make sure that the subject filled the frame. In situations like this, it is tempting to zoom back out a little instead of moving 50 feet away, but you have to be disciplined if you want to achieve maximum background blur. I then selected an ISO value that slightly underexposed the background without spoiling its overall look.

I then added flash in TTL mode and used a combination of auto exposure lock (AE lock) and flash exposure lock (FEL). (Nikon calls this feature Flash Value Lock [FV Lock].) My first attempt was spot on, so I didn't need to use additional flash exposure compensation.

I could have used a cheap manual flash for this shoot but, due to the distance between me and my flash, I found it a lot more convenient to use TTL and my "voice-operated light stand" (the co-photographer).

Post-Processing in Adobe Camera Raw

For this shoot, post-processing was a little trickier than normal due to the yellow-green cast produced by the fluorescent lights at our location. I counteracted this effect in the color images by slightly desaturating the colors and using the Split Toning tool in Adobe Camera Raw to give my images a warmer look. The screenshots on the next page show the settings I used.

For the monochrome images, I used a Photoshop Black & White adjustment layer to increase contrast and added a little noise. I also applied some standard beauty retouching steps to both sets of images.

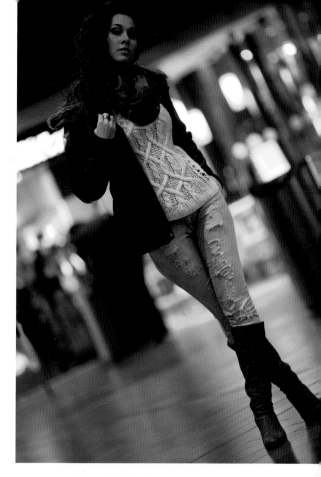
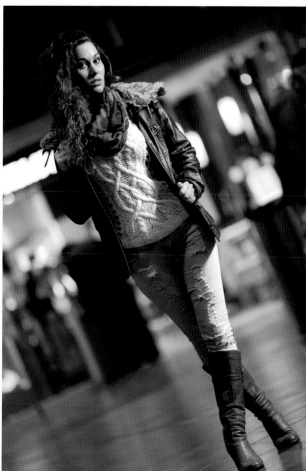

As usual, I began by taking a test shot without flash to check the exposure for the ambient light (above right) before adding flash (below right). Thanks to the high ISO value and the wide aperture, I was able to shoot using low flash power.

Canon EOS 5D Mark III · EF 70–200mm f/2.8 @ 200 mm and f/2.8 · M mode · 1/100 second · ISO 2000 · RAW · WB set to flash · Canon Speedlite 580EX II in a Firefly II softbox, TTL, FEL, triggered using a Yongnuo YN-622C transceiver

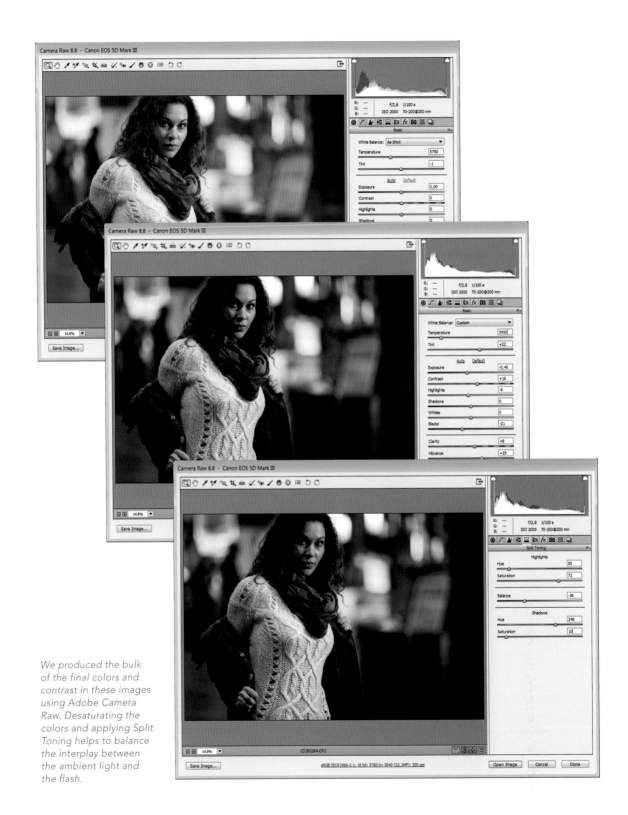

We produced the bulk of the final colors and contrast in these images using Adobe Camera Raw. Desaturating the colors and applying Split Toning helps to balance the interplay between the ambient light and the flash.

If balancing the colors of flash and artificial ambient light is too complicated, you can simply convert your images to black and white. Increasing the contrast and adding a little noise completes the analog look.

Canon EOS 5D Mark III · EF 70–200mm f/2.8 @ 200 mm and f/2.8 · M mode · 1/100 second · ISO 2000 · RAW · WB set to flash · Canon Speedlite 580EX II in a Firefly II softbox, TTL, FEL, triggered using a Yongnuo YN-622C transceiver

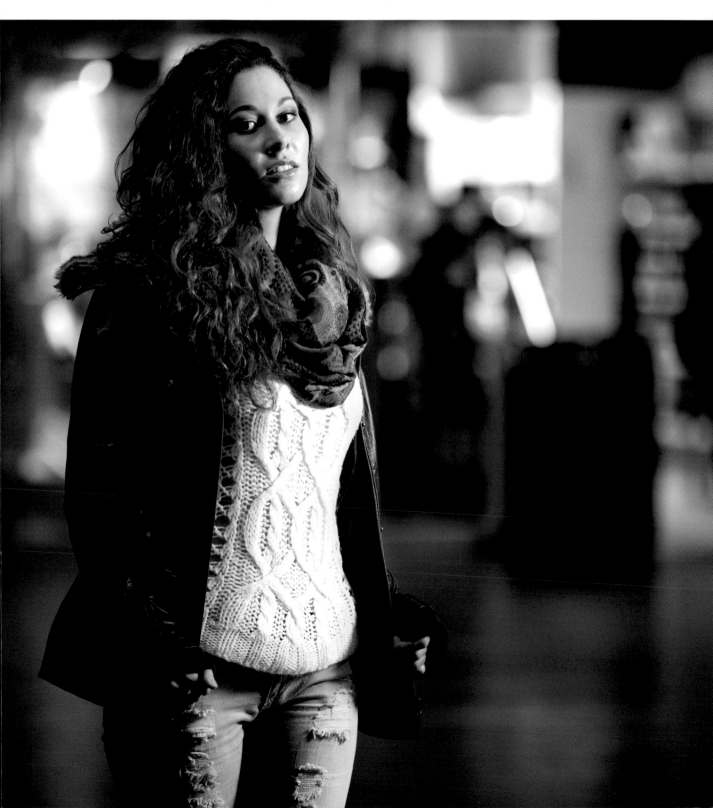

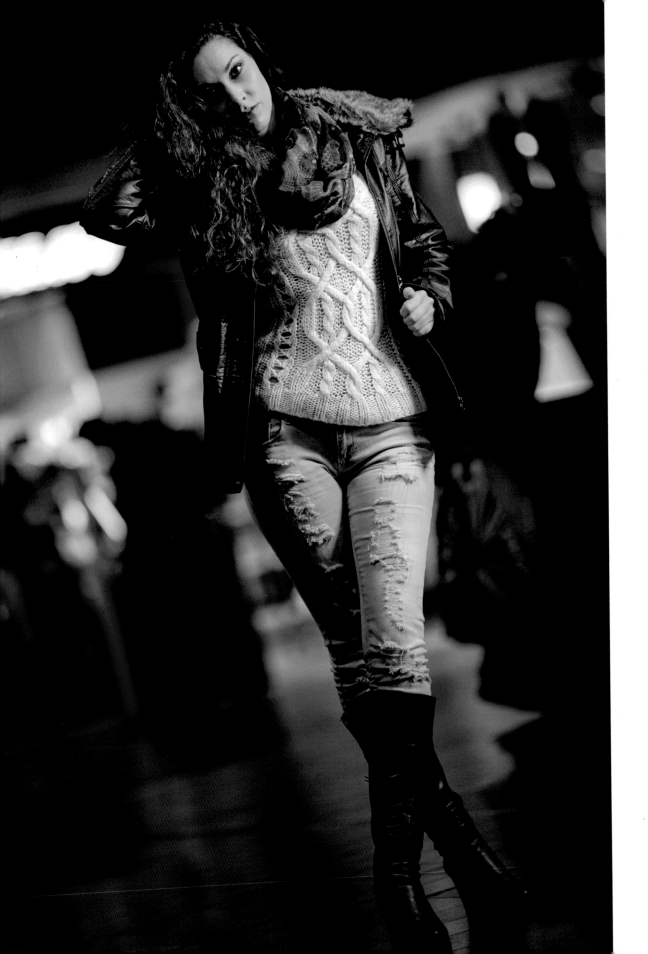

Tips and Tricks

Mixed halogen light and flash often looks great without any additional adjustments, whereas fluorescent lamps often produce a "dirty" yellow-green cast. There are various ways to work around this issue:

> › You can try to suppress the unwanted neon light by setting the shutter speed to your camera's sync speed. This maximizes the effect of your flash. For more details on how this works, see the "Quick Start Guide" chapter. Unfortunately, this technique rarely works well on location.

> › You may be able to adjust your flash to match the spectrum of the ambient light. For incandescent or halogen light, use a LEE 204 Full Color Temperature Orange (Full CTO) or 205 (1/2 CTO) filter gel. In fluorescent light, use a LEE 244 (Plus Green) filter gel. For more details, see the "Techniques in Detail" chapter.

> › The greater the amount of ambient light, the more annoying its effects will be. You can counteract this effect by using multiple flash·units positioned strategically around the scene. This way you can provide a kind of balanced ambient light of your own and relegate the artificial light to providing fill effects. But be warned: this technique involves a lot of effort. For more details, check out wedding photographer Moshe Zusman's work and his videos at *www.tiny.cc/5tkqmx*.

This is another shot from our evening bokeh shoot to whet your appetite and get you started with your own bokeh experiments.
Canon EOS 5D Mark III · EF 70–200mm f/2.8 @ 200 mm and f/2.8 · M mode · 1/100 second · ISO 2000 · RAW · WB set to flash · Canon Speedlite 580EX II in a Firefly II softbox, TTL, FEL, triggered using a Yongnuo YN-622C transceiver

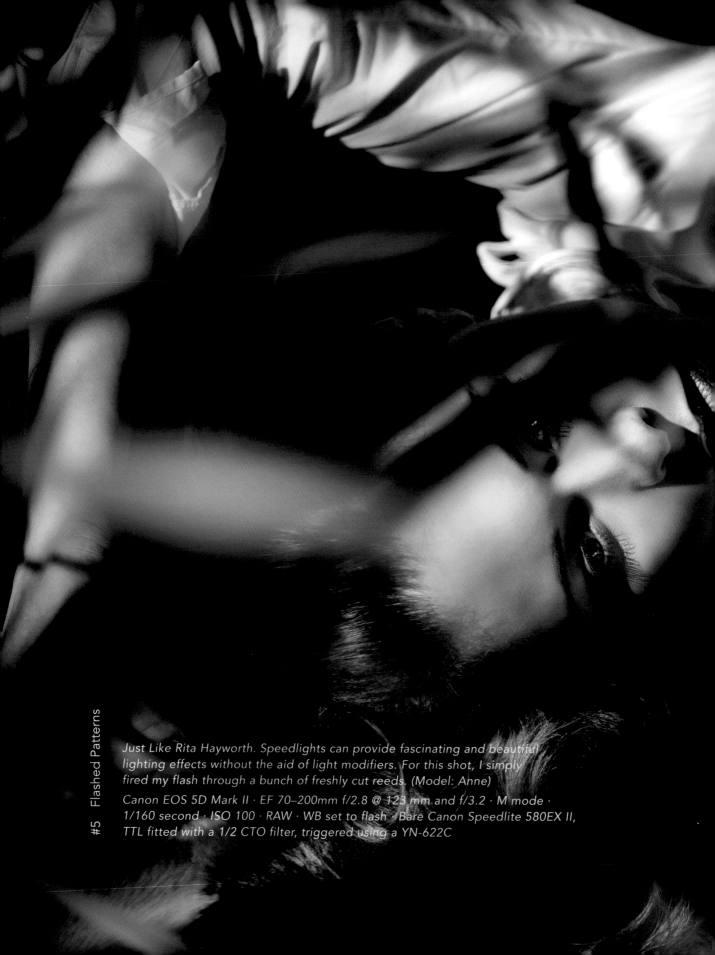

Just Like Rita Hayworth. Speedlights can provide fascinating and beautiful lighting effects without the aid of light modifiers. For this shot, I simply fired my flash through a bunch of freshly cut reeds. (Model: Anne)

Canon EOS 5D Mark II · EF 70–200mm f/2.8 @ 123 mm and f/3.2 · M mode · 1/160 second · ISO 100 · RAW · WB set to flash · Bare Canon Speedlite 580EX II, TTL fitted with a 1/2 CTO filter, triggered using a YN-622C

#5 Flashed Patterns

#5 Flashed Patterns

> › Using a speedlight without additional light modifiers
> › Using reeds and lace to create interesting shadow patterns

There is always a danger that studio photos end up looking too similar to each other, with a model posing in front of a wall and the only variety being in the color of the background. But there are a thousand ways to break this mold and make your shots interesting, and some involve no extra expense at all. All you need is a speedlight and accessories such as lace, grass, twigs, or a Venetian blind to create fascinating shadow patterns in your image. In this shoot, we used a bundle of freshly cut reeds and a piece of synthetic lace found on eBay.

Location, Equipment, and Lighting

Our photo gear consisted of a remotely triggered off-camera flash, and we shot in a modestly sized studio space. I cut the reeds at a nearby lake and put them in a vase to keep them fresh. Anne lay on a beanbag covered with a cowhide and I took the shots from above standing on a small ladder. For the lace shots, I hung the material up like a curtain and fired my flash through it. To increase the sharpness and contrast in the resulting pattern, all you have to do is increase the distance between your flash and your prop, or move the prop closer to your model.

Settings, Shooting, and Processing for the "Reeds" Shot

For a shot like this, it is best to almost completely eliminate the ambient light and set a shutter speed close to your camera's sync speed. I used 1/160 second. I chose a low ISO value of 100 to keep the noise level down and prevent the ambient light from playing too great a role in the image. My aperture setting of f/3.2 was close

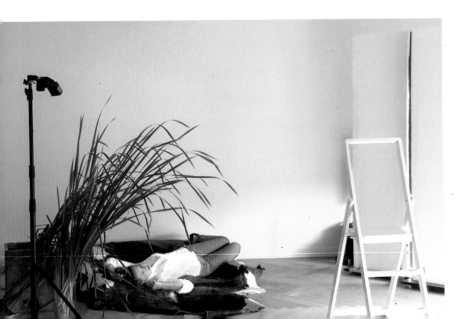

Our simple setup consisted of a bunch of reeds, a cowhide for the background, and a short ladder to capture the scene from above.

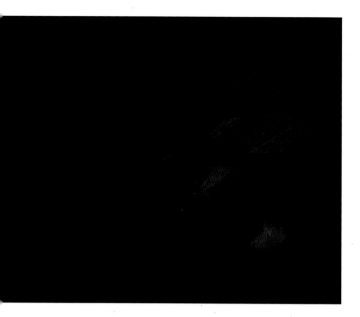

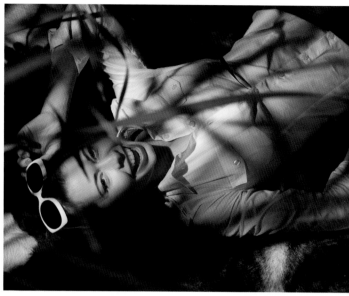

A test shot without flash at the beginning of the shoot helps you judge whether the ambient light is sufficiently suppressed. In this case, everything was fine.
Canon EOS 5D Mark·II · EF 70–200mm f/2.8 @ 70 mm and f/3.2 · M mode · 1/160 second · ISO 100 · RAW · WB set to flash · Flash switched off

Then we added flash, much to Anne's relief!
Canon EOS 5D Mark II · EF 70–200mm f/2.8 @ 70 mm and f/3.2 · M mode · 1/160 second · ISO 100 · RAW · WB set to flash · Bare Canon Speedlite 580EX II, TTL, with a 1/2 CTO filter gel, triggered using a YN-622C

to maximum and prevented the reeds in the foreground from appearing too sharp; instead, they created a soft, streaky effect.

Any flash with more than 20 Ws that can easily be fired remotely will do. An inexpensive manual flash is fine but will probably require several test shots before you get the shadows looking just right. It is quicker and easier to use the modeling light in a high-end flash from the same manufacturer as your camera, as this enables you to evaluate the effect of the shadows by eye without having to take a test shot.

For the photos shown here, I used a Canon Speedlite 580EX II and two Yong-nuo YN-622C wireless transceivers. This combo allows me to fire an approximately two-second stroboscopic modeling flash by pressing the depth-of-field preview button on the camera. I can then evaluate the shadows it produces by eye. We also attached a 1/2 Color Temperature Orange (1/2 CTO) color filter gel to the flash to make its light appear a little sunnier.

The image on pages 84–85 was desaturated using a Photoshop Black & White adjustment layer. The color images look nice and sunny thanks to the 1/2 CTO filter gel. I also created a slightly more sophisticated look in some of the color images by making the green tones a bit more autumnal using the Adobe Camera Raw Split Toning and HSL/Grayscale tools.

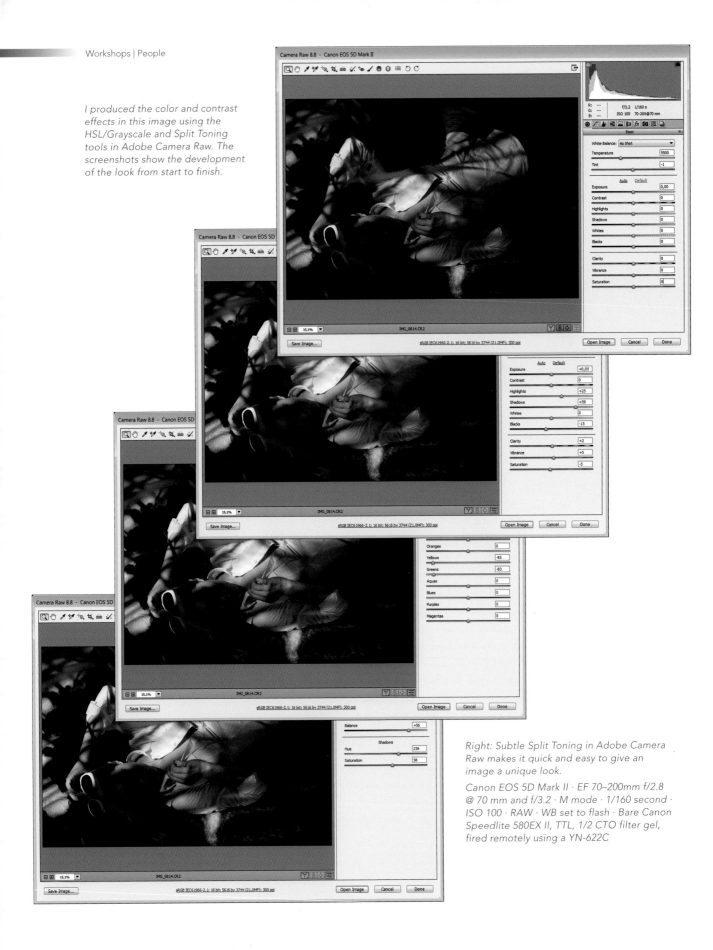

I produced the color and contrast effects in this image using the HSL/Grayscale and Split Toning tools in Adobe Camera Raw. The screenshots show the development of the look from start to finish.

Right: Subtle Split Toning in Adobe Camera Raw makes it quick and easy to give an image a unique look.

Canon EOS 5D Mark II · EF 70–200mm f/2.8 @ 70 mm and f/3.2 · M mode · 1/160 second · ISO 100 · RAW · WB set to flash · Bare Canon Speedlite 580EX II, TTL, 1/2 CTO filter gel, fired remotely using a YN-622C

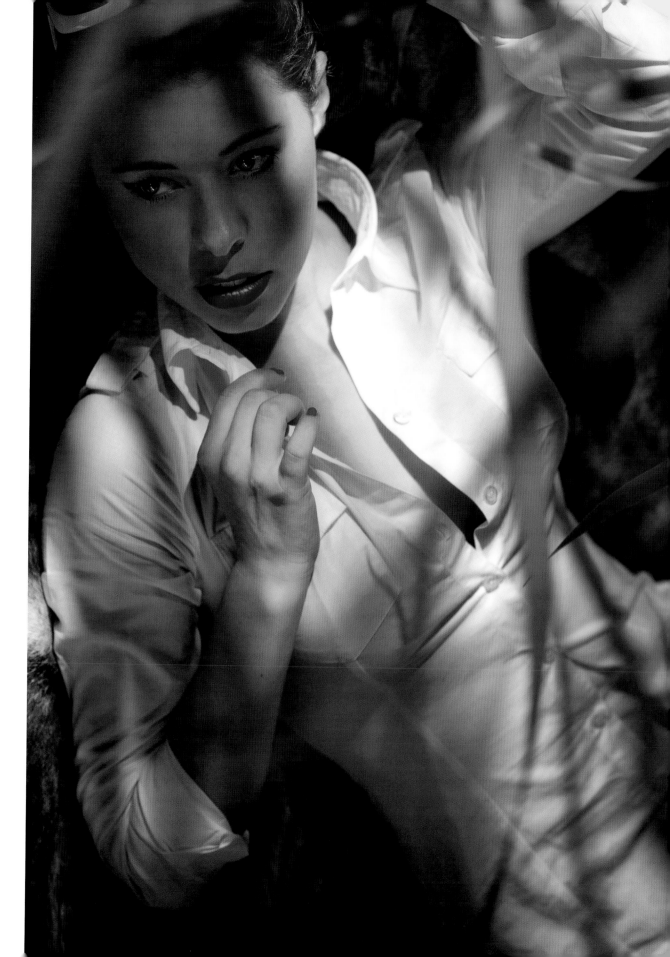

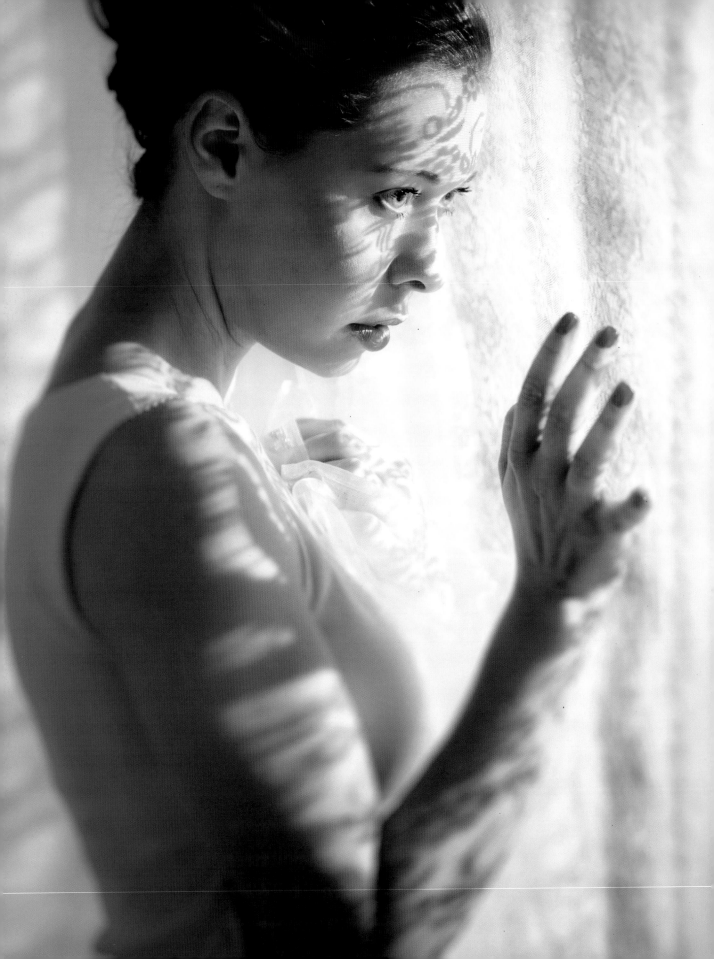

Settings, Shooting, and Processing for the "Lace" Shot

The setup for the "lace" shot (opposite page) was very similar to the previous one, although we increased the flash-to-subject distance to about four meters (13 feet) to increase the sharpness of the shadow pattern. I hung the lace fabric from a stand using a horizontal spar and placed Anne behind it. All the other settings are listed in the caption.

I produced almost the entire cool/pink look of the final images using Adobe Camera Raw. You can see the parameters I set in the screenshots.

Once I was finished with my RAW development, I opened the image in Photoshop and replaced the ICC-sRGB color profile with the profile from my monitor (*Edit > Assign Profile*). This doesn't make much sense technically but sometimes produces really crisp-looking results. This step is comparable to using a color lookup table *(Layer > New Adjustment Layer > Color Lookup)*, and the format of the ICC lookup tables and those in the filter are—at least theoretically—interchangeable.

To finish, I performed some subtle beauty retouching and blurred the edges of the frame:

This second setup was simple, too. It consisted of a piece of synthetic lace bought on eBay and a flash positioned about four meters away and fired through the fabric.

Canon EOS 5D Mark II · EF 70–200mm f/2.8 @ 90 mm and f/2.8 · M mode · 1/160 second · ISO 125 · RAW · WB set to flash · Bare Canon Speedlite 580EX II, TTL, fired remotely using a YN-622C

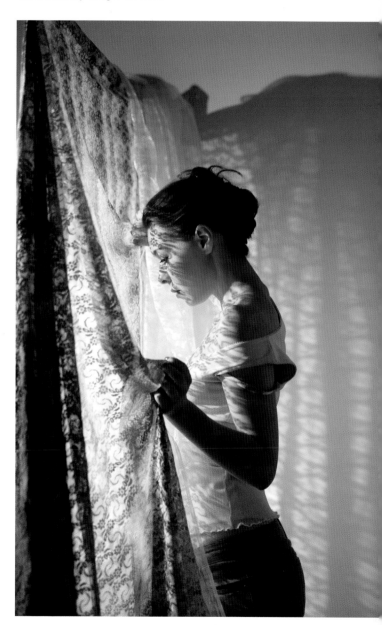

The final image was flipped horizontally and I added some slight blur to the edges.

Canon EOS 5D Mark II · EF 70–200mm f/2.8 @ 200 mm and f/2.8 · M mode · 1/160 second · ISO 125 · RAW · WB set to flash · Bare Canon Speedlite 580EX II, TTL, fired remotely using a YN-622C

The cool, pink look with its slight glow effect is created mainly by altering the white balance and reducing the Clarity setting.

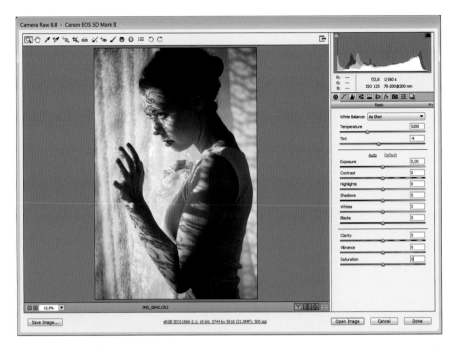

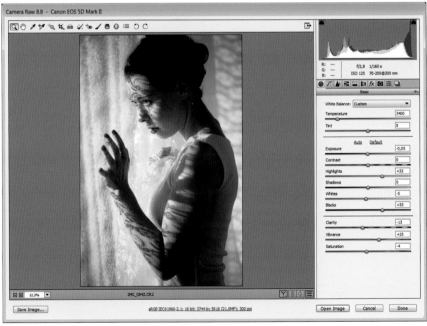

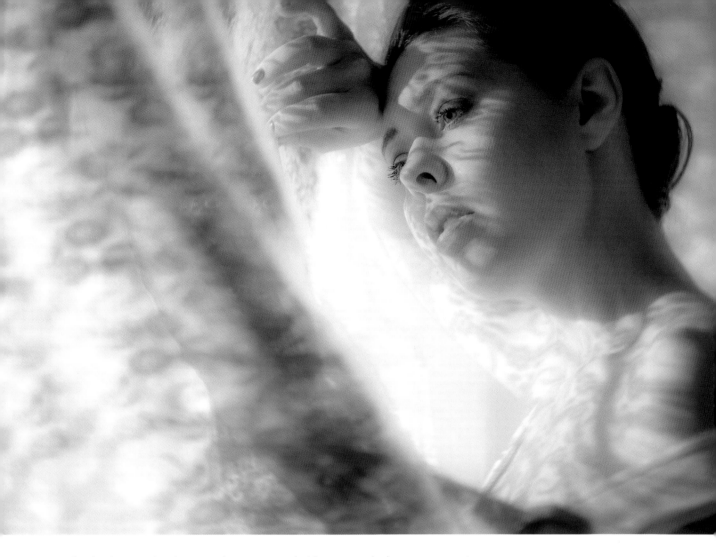

Another image to inspire you and get you started with your own shadow pattern experiments.
Canon EOS 5D Mark II · EF 70–200mm f/2.8 @ 145 mm and f/2.8 · M mode · 1/160 second · ISO 125 ·
RAW · WB set to flash · Bare Canon Speedlite 580EX II, TTL, triggered remotely using a YN-622C

Tips and Tricks

› If you want to produce a clear, high-contrast shadow pattern, try covering parts of the flash reflector to leave just a small gap. The smaller the light source, the sharper the shadows it produces.

› If you are using a flash without a built-in modeling light, you can improvise by placing a desk lamp without a shade beside your flash. If it is close enough to the flash, it will enable you to evaluate the shadows your flash will produce before you take any photos.

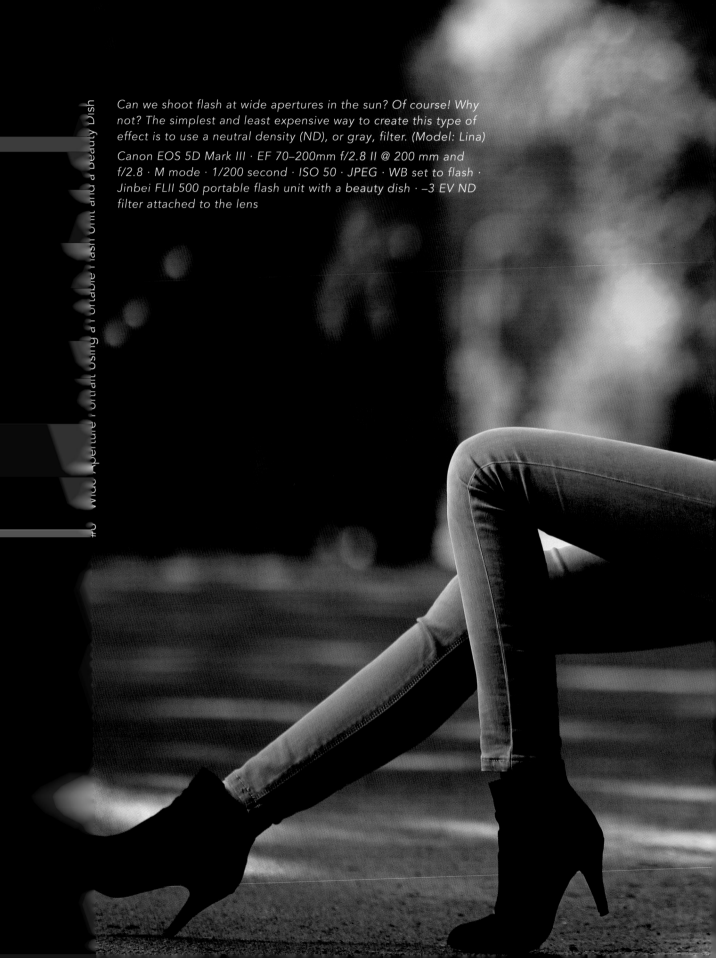

Can we shoot flash at wide apertures in the sun? Of course! Why not? The simplest and least expensive way to create this type of effect is to use a neutral density (ND), or gray, filter. (Model: Lina)

Canon EOS 5D Mark III · EF 70–200mm f/2.8 II @ 200 mm and f/2.8 · M mode · 1/200 second · ISO 50 · JPEG · WB set to flash · Jinbei FLII 500 portable flash unit with a beauty dish · –3 EV ND filter attached to the lens

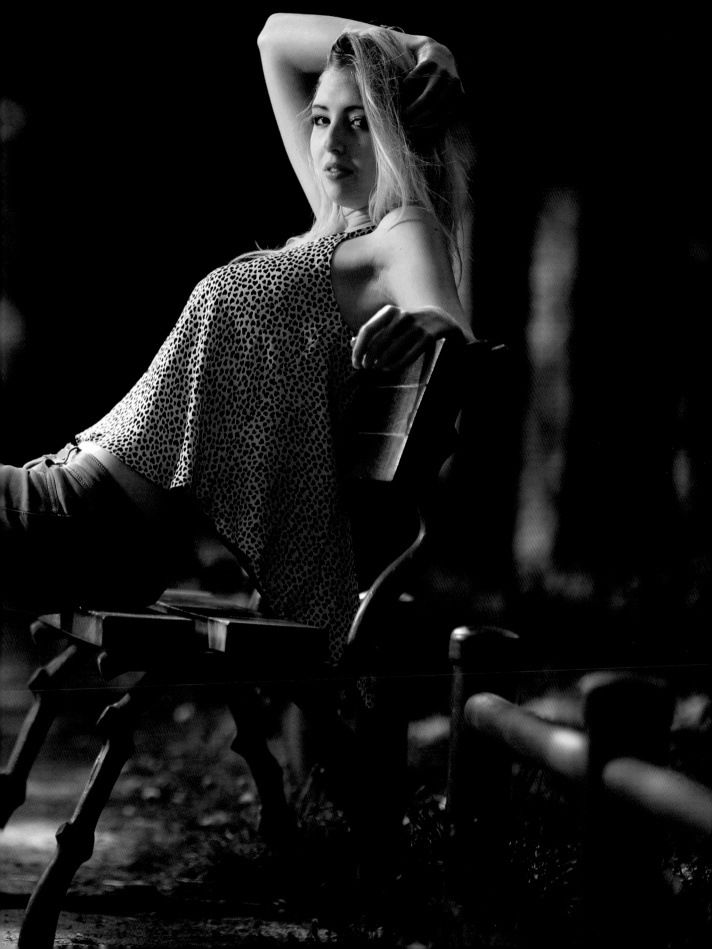

#6 Wide-Aperture Portrait Using a Portable Flash Unit and a Beauty Dish

> › Using a portable flash unit with a beauty dish
> › Using a low ISO and an ND filter to shoot at wide apertures in the sun
> › Minimizing depth of field

If you want to keep your lighting options open when you are on location, you need a powerful portable flash—and this is where models with standard light modifier bayonets come in. For this setup with model Lina, I used a portable flash unit to give myself enough power to shoot in the midday sun and as much flexibility as possible when choosing the proportions of ambient and flash light.

 If you are thinking this sounds like an expensive setup, I can assure you that there are plenty of affordable lights available. For example, the 400 Ws Jinbei FLII 500 and the beauty dish used here cost less together than a high-end Canon 600EX-RT flash.

The sun falling through the foliage produces specks of light and reflections that turn into attractive "circles of confusion" when captured using a wide aperture. You can use this effect to create elegant backgrounds.

Location, Equipment, and Lighting
The Rosenhöhe Park is located on a hill in the east of the city of Darmstadt and is definitely worth a visit if you happen to be nearby. Among its attractions, the park has a "Rose Dome" built on top of the hill and a statue of an angel at the monument to Princess Elizabeth of Hesse. The entrance to the park takes you through a tree-lined boulevard that we chose as our location for this shoot.

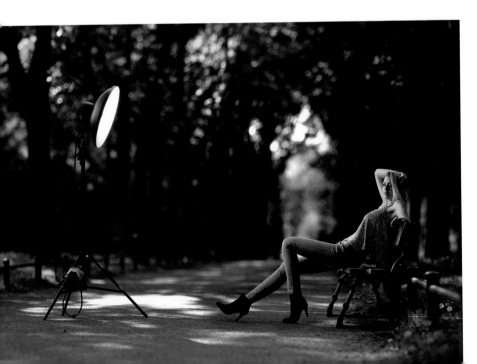

Our lighting consisted of a Jinbei FLII 500 portable flash unit and a 20"Jinbei Beauty Dish. The flash control unit was fixed to the light stand with tape and served as a counterweight.

I chose this location deliberately because I knew that the colorful backlit leaves would make an attractive background if I captured them using a wide aperture that transformed them into circles of confusion.

The gear I used consisted of the Jinbei portable flash unit/beauty dish combo as well as a Canon EOS 5D Mark III, an EF 70–200mm f/2.8 IS II lens, and an ND filter.

Settings and Shooting

Once again, the first step was to set up the camera to expose for the ambient light. If I am shooting in relatively bright ambient light, I begin by setting the shutter speed to a value close to my camera's sync speed. This enables me to maximize the proportion of flash light to ambient light in the shot. I then set the aperture to suit the artistic requirements of the shoot—in this case, wide open. I selected the lowest possible ISO value. Most cameras have a minimum ISO value of 100, although some have a low-ISO mode, too. The Canon I used here can be set to ISO 50, and the equivalent Nikon D810 can even be set to ISO 32.

It is not essential for your camera to have a low-ISO setting, as shots like this depend on the use of an ND filter with up to two stops of exposure reduction anyway. An alternative is to stop the aperture down slightly to f/4—at a focal length of 200 mm, the background will still look really soft.

I used a B+W ND filter with –3 EV exposure reduction (see "Techniques in Detail"). Using a –3 EV filter is perfectly justifiable and doesn't have a serious effect on the colors or sharpness of the resulting images. I sometimes use a filter with –5 EV exposure reduction, although this does cause a loss in image sharpness as well as obvious color shifts.

As usual, we started by taking a test shot without flash to check exposure for the ambient light.

Once the exposure for the ambient light was set up, we added flash.

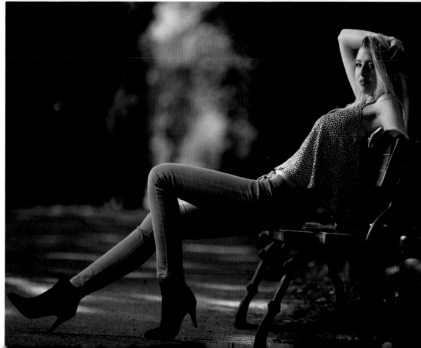

Post-Processing in Adobe Camera Raw and Photoshop

I developed the final image shown here from the JPEG version of the shot; this is unusual for me, but I simply liked the way the JPEG looked. The screenshots show the individual processing steps I applied.

I created the warm colors using Photoshop CC's Camera Raw Filter tool. The tool can be found under the Filter menu (*Filter > Camera Raw Filter*), where you can use the HSL/Grayscale tab to shift the green tones toward a warmer value.

I also used a different ICC profile to get the colors looking a little crisper. The effect can be adjusted using the following steps:

1. Create a new copy of your image: press Ctrl-A, Ctrl-C, then Ctrl-N. Confirm by clicking OK and press Ctrl-V. (On a Mac, use the Command key instead of the Ctrl key.)

2. Select *Edit > Assign Profile*, [Profile] (in this case, I selected my monitor's profile).

3. Insert the enhanced image on a new layer in the original image: press Ctrl-A, then Ctrl-C, select the original image, and then press Ctrl-V. If you check the *Convert* (*preserve color appearance)* option, the new image is converted to the color space of the original.

4. Adjust opacity and mask details as necessary.

 The following workshop uses another example from this shoot that we processed a bit more comprehensively.

The "before" and "after" images and their corresponding Photoshop layer stack.

Tips and Tricks

Selecting a shutter speed of 1/200 second may appear to be a bold choice, as this is the same as the camera's sync speed. If you are shooting using wireless triggers rather than wired flash, you increase the risk of wireless signal delay, which can result in the flash firing while the shutter is not fully open. If you are shooting in landscape format, the result of that is a black stripe at the bottom of the frame, whereas if you shoot in portrait format, the stripe appears at the right-hand edge of the frame. Fortunately, there are ways to fool the system!

The simplest approach is to remove the black stripe by cropping the image. In some cases (as in our example) there is no black stripe because the bottom or right-hand edge of the frame contains no flash-lit detail. In our shoot, the lower edge of the frame was lit by ambient light only.

The photos of Olena below show a more extreme form of this trick. In this case, the shutter speed was set to 1/250 second which, when used with the EOS 5D Mark III and a Yongnuo RF-602, guarantees that the shutter is not fully open during the flash. If you take another look at the photo armed with this knowledge, you will see that Olena's left shoe is actually too dark because it protrudes into the area covered by the black stripe. The cobblestones are lit by the sun rather than the flash and, consequently, look fine.

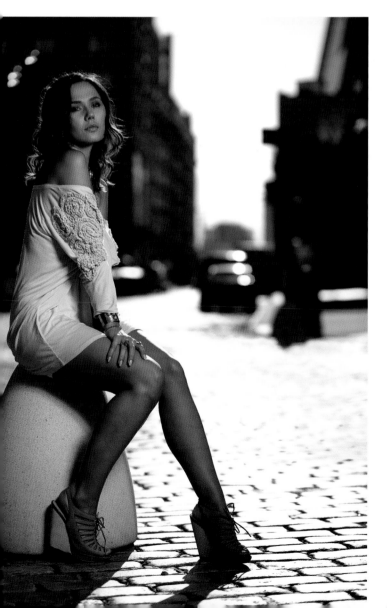

Tricking the system: You can shoot flash at 1/250 second with an EOS 5D Mark II/III if you know how the shutter behaves. In this shot, the shutter curtain entered the frame from the right and just touched Olena's left shoe. (Model: Olena Noelle)

Canon EOS 5D Mark III · EF 85mm f/1.8 @ f/2.5 · M mode · 1/250 second · ISO 50 · JPEG · WB set to flash · −3 EV ND filter · white shoot-through umbrella

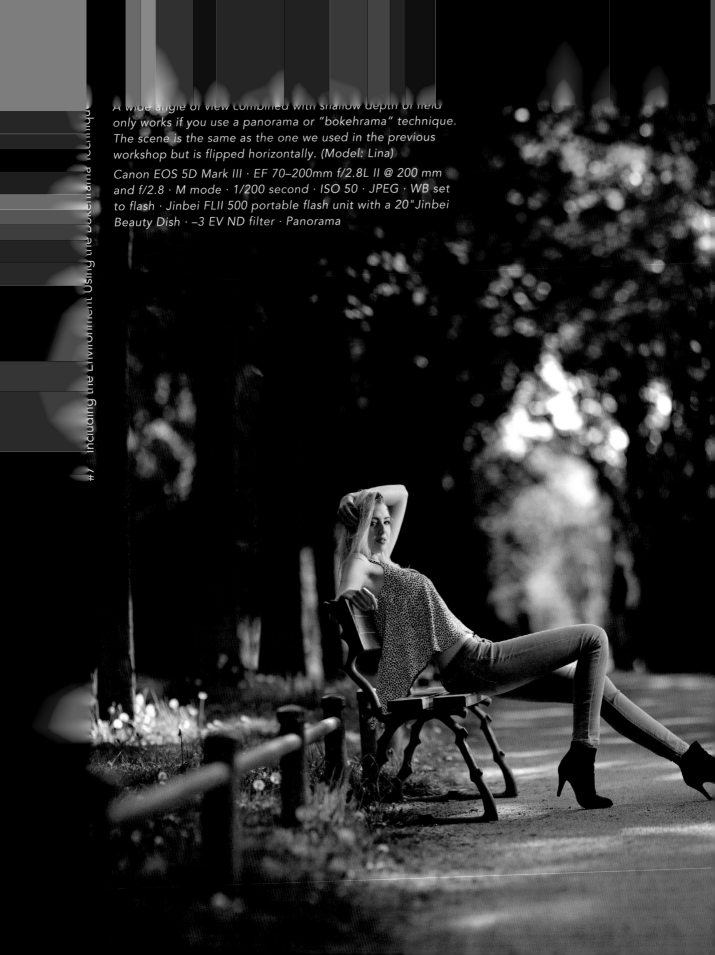

A wide angle of view combined with shallow depth of field only works if you use a panorama or "bokehrama" technique. The scene is the same as the one we used in the previous workshop but is flipped horizontally. (Model: Lina)

Canon EOS 5D Mark III · EF 70–200mm f/2.8L II @ 200 mm and f/2.8 · M mode · 1/200 second · ISO 50 · JPEG · WB set to flash · Jinbei FLII 500 portable flash unit with a 20"Jinbei Beauty Dish · –3 EV ND filter · Panorama

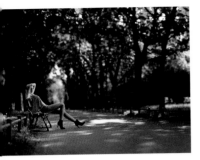

#7 Including the Environment Using the Bokehrama Technique

› Learning to use Ryan Brenizer's bokehrama technique

› Avoiding parallax errors

› Merging multiple source images on a computer

The wide aperture and the long lens we used in the previous workshop enabled us to produce an attractive degree of background blur but prevented us from showing much of the boulevard in the background. Using a wide-angle lens would have given us a broader angle of view but wouldn't have provided a depth of field shallow enough to produce the bokeh bubbles in the leaves. We are, however, able to outwit physics by using the same setup as we did for the previous shot and creating a panorama instead of a single image.

Back home, it takes just a few minutes using specialized software to "stitch" the source images together to make a bokeh-filled panorama, or "bokehrama."

If you rotate the camera around your own axis when shooting a panorama, you will end up capturing images with parallax errors (above right). Rotating the camera around its no-parallax point (below right) solves the issue. The no-parallax point lies on the optical axis of the lens, either within the lens or just in front of it.

Location, Equipment, and Lighting

The location, gear, and flash setup were the same as in the previous workshop. The only additional piece of gear was a SteadePod steadying device. Such a device helps to keep the source images level when shooting panoramas.

Panoramas only work out perfectly if you rotate and tilt the camera around its no-parallax point. If you rotate your camera around any other point, your images will contain parallax errors and the resulting panorama will contain merging errors. If parallax errors are too pronounced, the software might not be able to stitch together the panorama at all.

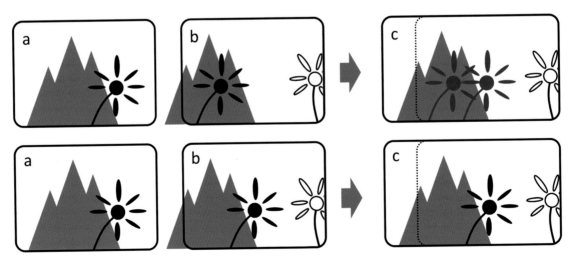

This approach is not as critical if you use the bokehrama technique, as it mostly involves shooting with a telephoto lens from a fair distance. It is nevertheless important to know that the no-parallax point lies either within the lens or slightly in front of it. This means that you have to rotate the camera around its own axis rather than around the axis of your own standing position. A steadying device will help you stick to this rule. With a little practice, you should be able to shoot panoramas without using a steadying device, but I like to use mine anyway because it helps to reduce the amount of postprocessing involved in the stitching later on.

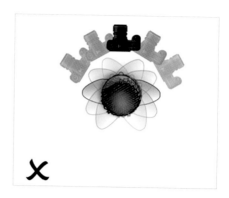

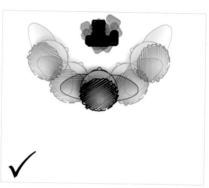

Settings and Shooting

When shooting a bokehrama portrait, you have a choice: you can allow your model to leave the frame during the shoot, or you can choose the less elegant approach, where she has to stay put until you are done capturing your images. Here is a quick rundown of these two options:

I. Panorama Shoot without the Model

1. The starting point is the photo of the model. It is always better to take several shots to ensure that focus is okay and that her eyes are open. The model image itself can also be composed of multiple source images that you stitch together later on. Once you have captured your model shot, switch to manual focus to ensure that focus remains the same for the remaining photos in the sequence. If you use back-button focus, all you have to do is take your thumb off the AF-ON button.

2. Your model can now leave the frame. If you have already captured all the areas that are lit by flash, she can take the flash and stand with her.

3. Now shoot a handheld zigzag sequence of images that covers the entire landscape surrounding the model, making sure that each image overlaps the previous image by at least 25 %. If the model didn't take the flash with her, the flash only has to fire when you are capturing the parts of the scene that it lights, but it won't do any harm if it fires for the other images in the sequence, too.

4. Stitch together the landscape on your computer using a program like Microsoft ICE (Image Composite Editor), and then insert the image of your model into the result.

If you are shooting a panorama handheld, be sure to rotate your camera around the camera's axis rather than your own. This helps to avoid parallax errors in the resulting images. Using a camera-steadying device like the Steade-Pod helps to keep your source images level (see www.tiny.cc/yjeknx for more details).

II. Panorama Shoot with the Model

1. As before, the first step is to capture the model shot. Then switch to manual focus or take your thumb off the AF-ON button to ensure that focus remains the same for the remaining photos in the sequence.

2. The model and the flash remain in place while you shoot the rest of your sequence. Once again, the flash only has to fire when you are covering parts of the frame that were lit by the flash in the first image. If you are using a Jinbei portable flash unit, you will learn to either listen for the sound it makes when it charges following a flash or see the flash itself out of the corner of your eye. If necessary, you can slow the speed at which you take the sequence of shots or reshoot any shots where the flash didn't fire.

3. Stitch together the panorama on your computer, retouch the flash and light stand out of the image, and then insert the photo of your model.

This is the result we achieved using Microsoft ICE. We can now crop the image, export it, and perform further processing in Photoshop. Don't forget to reduce the resolution (width and height) of your image to a reasonable level during export.

The first method involves more effort during the shoot but less in post-processing. The second method reverses these priorities, as it can take some time to clone out the flash and the light stand. Stitching is more reliable using the first method, too, as the model will probably move slightly between shots in the second method, which in turn makes the stitching process more prone to errors.

Unfortunately, it is not always possible to get the model to leave the frame, so we had to use the second approach to create the image of Lina that you can see here.

Post-Processing in Adobe Camera Raw and Photoshop

Post-processing for this image was relatively complex. I stitched the panorama using ICE before using the Stamp tool to remove the flash, the stand, and some passersby. I then inserted the shot of our model and performed some slight beauty retouching. I didn't care much for the original bright green tones, so I finished up by sampling the warmer red and orange tones using the Eyedropper tool and then painting over the grass and leaves with a brush set to the Color layer mode.

These screenshots show the original image that I stitched using ICE, the processed image including our model, and the final processed image. The layer stack shows the individual image and effect layers we used.

Tips and Tricks

You can use any contemporary panorama stitching software or Photoshop's built-in tools to perform the steps described here. Nowadays, I only use the free Microsoft ICE software because it is not too fussy about the quality of the image series you feed it, and it is extremely fast. It took less than four minutes to stitch our 86 high-res JPEG source images on my 3.2 GHz Intel-based Windows 7 computer with 16 GB of RAM, which I am sure is something of a re-

cord! You can also extend ICE's functionality to import RAW files, although I only use JPEGs or, rarely, TIFFs generated in Adobe Camera Raw. Check out *www.tiny.cc/007jnx* for more details on the software's RAW support. Unfortunately, ICE is only available for Windows, so Linux and Mac users who want to try it out will have to use a dual-boot system or just use Photoshop (or some other compatible package). You can find a list of alternative programs at *www.tiny.cc/fb6jnx*.

The Photoshop Photo-merge tool is quite good at stitching panoramas too, although I had to wait 38 minutes for Photoshop CC 2014 to perform this particular merge. Even if the result shows fewer stitching errors than the result we produced using ICE, in my view Photoshop simply takes too long.

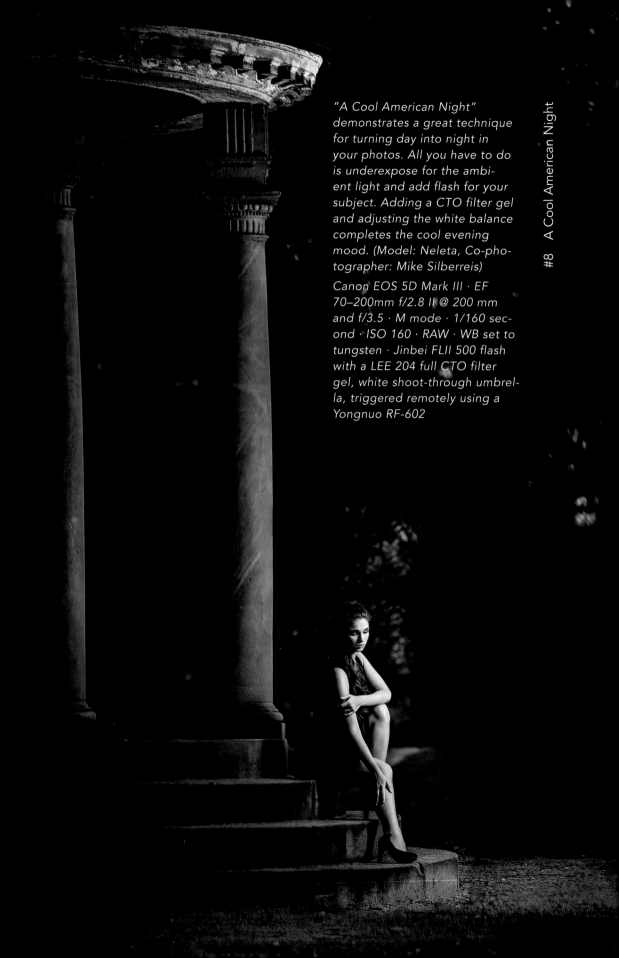

"A Cool American Night" demonstrates a great technique for turning day into night in your photos. All you have to do is underexpose for the ambient light and add flash for your subject. Adding a CTO filter gel and adjusting the white balance completes the cool evening mood. (Model: Neleta, Co-photographer: Mike Silberreis)

Canon EOS 5D Mark III · EF 70–200mm f/2.8 II @ 200 mm and f/3.5 · M mode · 1/160 second · ISO 160 · RAW · WB set to tungsten · Jinbei FLII 500 flash with a LEE 204 full CTO filter gel, white shoot-through umbrella, triggered remotely using a Yongnuo RF-602

#8 A Cool American Night

> › Introducing color filter gels and white balance tricks
> › Using flash to transform an overcast afternoon into the "blue hour"

If you're like me and prefer to shoot on location, you have to rely on the weather playing ball. If you have prepared for a shoot in an attractive park but the sky remains stubbornly gray (with drizzle to boot), it is once again time to fall back on your flash.

The first thing to do is pack your flash in a freezer bag so that it doesn't get damaged by the rain, and then attach a LEE 204 Full Color Temperature Orange (Full CTO) filter gel. If you dial exposure for the gray surroundings all the way down and set the camera's white balance to tungsten, the flash will illuminate your model in neutral-colored light and the background will become a beautiful dark blue!

Location, Equipment, and Lighting

I chose the Nilkheimer Park near Aschaffenburg for this shoot because the pavilion located there is photogenic and also provides shelter for the model and my gear if it rains. I used a 400 Ws Jinbei FLII 500 portable flash unit with a white shoot-through umbrella as my light modifier. The Jinbei unit has a built-in umbrella bracket, so I didn't need to use a separate adapter.

LEE Swatch Book sample filter gels are fine for use with my smaller speedlights (see Chapter 2, "Techniques in Detail"), but the Jinbei requires larger sheet filters, which are available in rolls from most well-stocked stagecraft dealers.

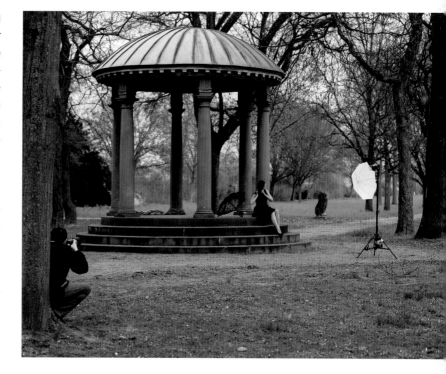

The Nilkheimer Park near Aschaffenburg is an attractive location but, on a dull day, requires the creative use of flash to capture atmospheric photos. (Model: Neleta, Co-photographer: Mike Silberreis)

Settings and Shooting

I began by setting the camera's white balance to tungsten before setting the exposure parameters (without flash) for the ambient light. I selected a shutter speed that was close to the camera's sync speed but that included a margin of safety to ensure that the remote trigger had time to transmit its signal. I ended up using 1/160 second. I set the aperture to f/3.5 to keep my subject sharp, although the large distance to the subject in this shot would normally prevent too much unsharpness anyway. I then selected an appropriate ISO value (in this case, ISO 160) that kept the exposure for the ambient light looking good before adding flash.

Post-processing was restricted to adding the marble texture in the columns, color and contrast adjustments, and a little beauty retouching. The screenshots show the original image, the processed version, and the corresponding layer stack.

Post-Processing in Adobe Camera Raw and Photoshop

I didn't have to perform much post-processing, but I did allow myself the liberty of adding a marble texture to the sandstone columns in the pavilion. The other steps were my standard color and contrast adjustments using Photoshop's Camera Raw Filter tool, followed by a little beauty retouching and subtle application of the Liquify filter.

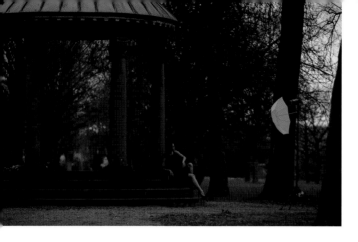
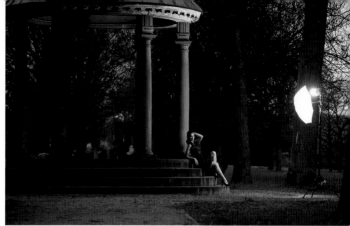

Tips and Tricks

Could I have captured this shot using a speedlight instead of the portable flash unit? It is certainly possible, although you should never underestimate how bright even the cloudiest sky can be—and thus how much flash power you need to produce an appropriate amount of light considering the underexposed surroundings.

Actually, from time to time I use multiple flashes attached to the three-flash bracket introduced in the "Equipment" chapter. My bracket is homemade, but there are commercial alternatives available that are said to be just as good (see *www.tiny.cc/7ajknx* for some examples).

I like to build my own accessories because I can select the individual components myself and the result is often more robust than the commercial competition. If you want to build a bracket like mine, the components I used are listed in the table below.

The three steps to the mystical atmosphere in the finished image. Left: the shot without flash, captured in Auto mode. Center: M mode, underexposed with white balance set to tungsten. Right: Same as in the center but with flash.

Quantity	Item Description	Source
3	Universal flash shoe	Walimex
3	Thread adapter with 1/4" male and female threads	Hama
1	Anodized aluminum, 40 mm × 220 mm, 4 mm thick	Hardware store
1	Universal 1/4" spigot, model 108	Manfrotto
1	Bottle of Loctite screwlock	Loctite

It is not necessarily cheaper to build your own accessories. I build my own because the results are often more robust than the commercial competition.

Admittedly, from time to time I use not just one flash, but several flashes in parallel. But at least it is still only one light source! Sometimes, shooting with just one flash is possible, but using multiple flashes in parallel is less hassle: recycle times are faster, the batteries last longer, and the overheating safety cutout is less likely to interrupt your shoot.

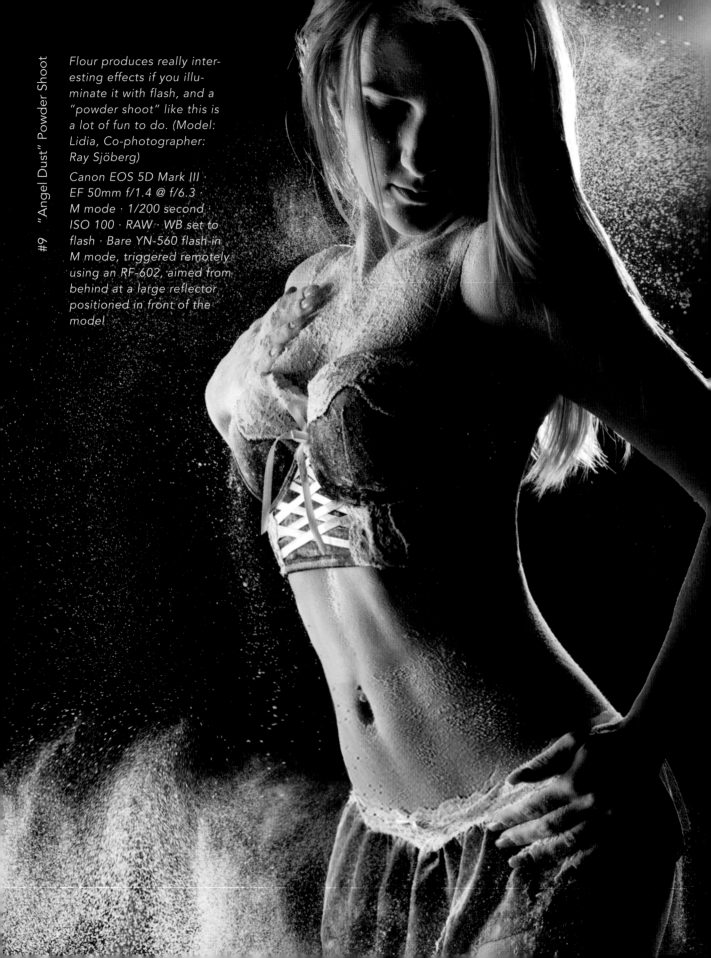

Flour produces really interesting effects if you illuminate it with flash, and a "powder shoot" like this is a lot of fun to do. (Model: Lidia, Co-photographer: Ray Sjöberg)

Canon EOS 5D Mark III · EF 50mm f/1.4 @ f/6.3 · M mode · 1/200 second · ISO 100 · RAW · WB set to flash · Bare YN-560 flash in M mode, triggered remotely using an RF-602, aimed from behind at a large reflector positioned in front of the model

#9 "Angel Dust" Powder Shoot

> › Learning to shoot using powder effects

> › Performing a single-flash flour shoot

You may already have seen shoots involving flying flour on Heidi Klum's *Project Runway*, although the technique and gear we used here are slightly different. In the shoot shown on TV, they used a snow shovel to throw colored flour at the models, whereas our version involves carefully applying flour to our model's legs, arms, and hair and giving her some more flour to hold in her hands. All she has to do is turn quickly, or jump, and open her hands to get the flour flying.

Location, Equipment, and Lighting

For a shoot like this, you need plenty of space to get the background looking as dark as possible. In smaller spaces, reflections from the floor and ceiling can spoil the overall effect. The room we used is part of an old industrial complex and, with almost 5,500 square feet of space and 60-foot ceilings, it provided perfect conditions for our shoot. If you don't have access to a space like this, you can always wait until evening and shoot in a field or a clearing in the woods.

A typical setup for a shoot like this would consist of two flashes in gridded softboxes, positioned in a cross-lighting pattern. But this approach is, of course, taboo in a book called *One Flash!* With a little thought and some testing, we managed to achieve great results using a single bare flash.

We would have preferred to use two flashes—to light the flour from behind and our model from the front. Without a front light, the model would appear as a dark silhouette with a bright outline. The setup we ended up with used a bare flash located behind our model and a large silver reflector that softly cast part of the light provided by the flash back onto the model.

Apart from the camera, the only other gear we needed was several pounds of flour, towels for the model, and a broom.

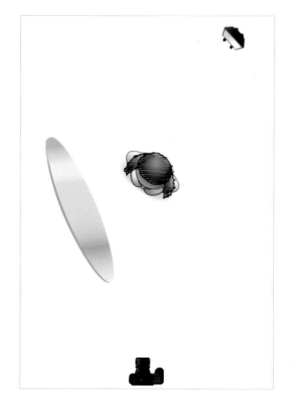

The simple setup consists of a bare YN-560 flash and a large collapsible reflector.

An overview of our setup, showing the YN-560 flash fired remotely from behind our model using RF-602 wireless modules, and our 60" x 75" 5-in-1 collapsible reflector propped up against a second light stand.

Settings and Shooting

Setting up the lighting took a while. The exact location of the flash is important, as its distance from the subject and its angle determine the proportions of main light and backlight (see the section on the inverse square law in the "Techniques in Detail" chapter). We positioned the reflector by eye so that it redirected the light from the flash back onto our model. Remember: angle of incidence = angle of reflection.

I used a Canon EOS 5D Mark III, which is to some extent dust- and moisture-proof and therefore (hopefully) flour-proof, too. Instead of an L-series lens, I used a not-so-expensive EF 50mm f/1.4. Furthermore, on shoots like this, it is essential to prefocus on the subject before the flour flies, and the best way to do this is by using back-button focus.

Once again, back-button focus makes it simple to prefocus before the action starts. In Canon and Nikon cameras, you can assign this function to the AF-ON and AE lock buttons. Check your camera's manual for more details on which functions can be assigned to which buttons.

Photos like this aren't too tricky to capture and, once you have set up your lighting, it is a good idea to mark the model's position on the floor. Prefocus and, once the flour starts flying, resist the temptation to release the shutter too soon, as the flour needs time to spread out and form interesting patterns in the air.

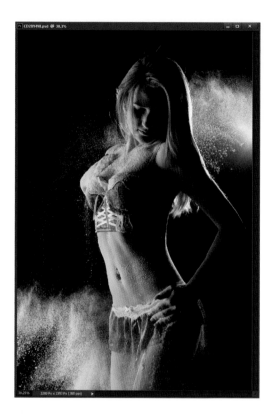

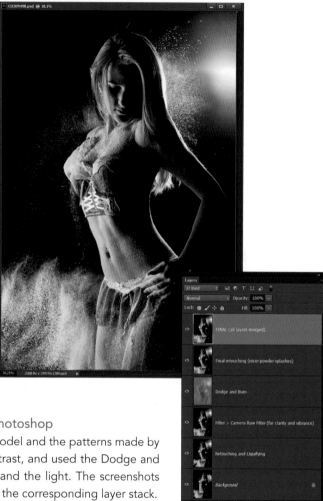

Post-Processing in Adobe Camera Raw and Photoshop

I used the Liquify filter to add a little verve to the model and the patterns made by the flour. I then adjusted the colors, increased contrast, and used the Dodge and Burn tool to emphasize the shapes, the shadows, and the light. The screenshots show the original and processed images, as well as the corresponding layer stack.

Tips, Tricks, and Notes

By the time we were done, everything was covered in a light dusting of flour, but we managed to tap and blow most of it off our gear. By the way, never swap lenses on a powder shoot, as some of it is almost certain to find its way into the camera. And don't let the flour get even slightly wet, as this makes it even more difficult to clean up afterward.

> **WARNING!** Danger of dust explosion!
> Open flames, sparks, and embers are completely taboo on a powder shoot.

During post-processing, I used the Liquify filter on the model and the flour before adjusting the colors and contrast. The screenshots show the original photo, the processed version, and the corresponding layer stack.

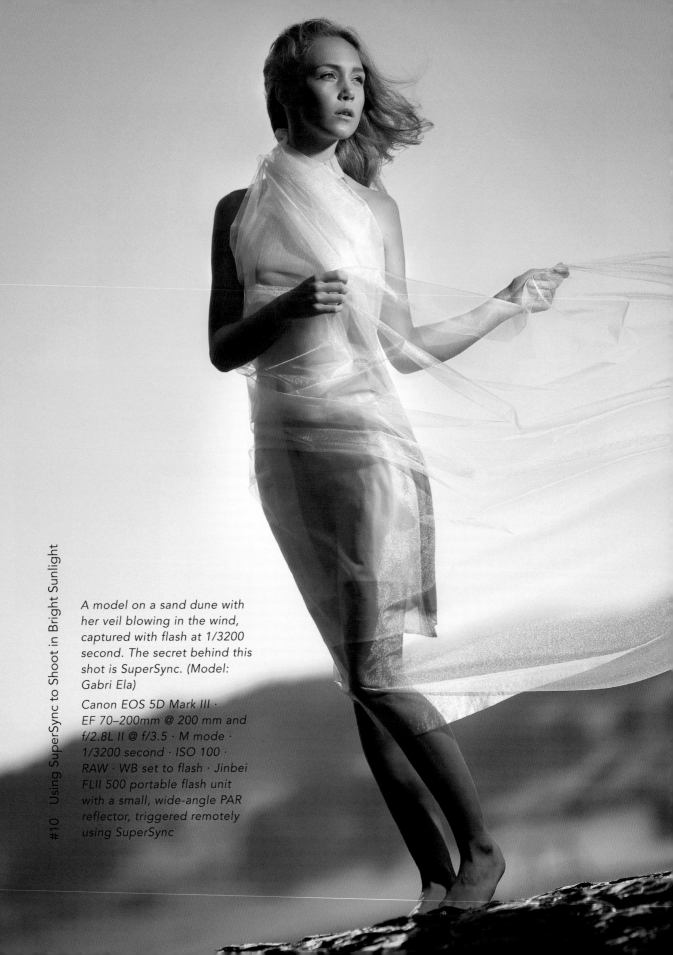

A model on a sand dune with her veil blowing in the wind, captured with flash at 1/3200 second. The secret behind this shot is SuperSync. (Model: Gabri Ela)

Canon EOS 5D Mark III · EF 70–200mm @ 200 mm and f/2.8L II @ f/3.5 · M mode · 1/3200 second · ISO 100 · RAW · WB set to flash · Jinbei FLII 500 portable flash unit with a small, wide-angle PAR reflector, triggered remotely using SuperSync

#10 Using SuperSync to Shoot in Bright Sunlight

> › Using flash with shutter speeds faster than your camera's sync speed

> › Learning all about SuperSync

> › Using a simple wide-angle parabolic reflector

Shooting with flash in bright sunlight is technically quite complex and is the subject of endless online discussions. You need a lot of flash power to compete with the sun, and you need to apply advanced techniques to be able to keep the aperture wide open while you shoot. This workshop shows you how to use an unusual light modifier to extract maximum flash power from a Jinbei portable flash unit, and it provides details on how to use the SuperSync technique (see the "Techniques in Detail" chapter). At the end of this section, you'll see a "bokehrama" image captured using SuperSync in combination with a portable flash unit fitted with a wide-angle reflector.

Location, Equipment, and Lighting

The images in this section come from a flash workshop that I held with Mario Dirks on the North Sea island of Norderney. The island landscape is fantastic, but you need to have a trick or two up your sleeve if you want to shoot there in the midday sun. Mario had it easy with his powerful 1200-joule Jinbei DC1200, which delivers enough energy to the flash tube to shoot in bright sun using a less efficient light modifier such as a beauty dish. Things get trickier if you use a 400 Ws unit like the Jinbei FLII 500. To make this setup work, I used a Walimex VC/D/DS-series parabolic wide-angle reflector. Jinbei and Walimex use a standard Bowens bayonet (called "VC" by Walimex) in many of their products, so this accessory fits on my Jinbei flash, too.

Parabolic reflectors are extremely efficient and provide as much as two stops more light than a beauty dish. One drawback is that the light is less soft and flattering than the light from a beauty dish, but at least there is no risk of creating boring light, as there is when using a large softbox. The light it creates has a bit more "snap" to it; results are normally contrasty with interesting and distinctive shadows.

Because our workshop was about using SuperSync and wide apertures, the fact that the participants were using cameras from different manufacturers presented an additional hurdle.

A simple wide-angle parabolic reflector is one of the most efficient light modifiers around. This is a standard tool for stage use but is still quite rare on the strobist scene.

If you already own an HSS-capable speedlight, you can use SuperSync without having to acquire any new gear. Simply build a "sandwich" from a slave trigger (Kaiser, colinsfoto. com "Sonia" green or similar) and a wireless transmitter, and attach it to your speedlight. Then set your speedlight to M mode, low power, and HSS.

Normally, the simplest solution in a situation like this is to use Yongnuo YN-622C/N or Phottix Odin wireless triggers, but we couldn't use these here because they are camera-specific. However, an on-camera, HSS-capable speedlight pointed upward—and set to low power, HSS, and manual (to suppress any pre-flashes)—could also do the trick. Then, all we had to do was attach a slave trigger/RF-602 transmitter "sandwich" to the flash and an RF-602 receiver to the portable flash unit. Set up this way, any owner of an HSS flash can use SuperSync without having to buy new gear.

I used a Canon EOS 5D Mark III with an EF 70–200mm f/2.8 IS II lens and an on-camera Speedlite 580EX II set to 1/32 output, HSS, and M mode.

This is the setup for our Norderney beach photos. We used a Jinbei FLII 500 portable flash unit and a small Walimex wide-angle reflector.

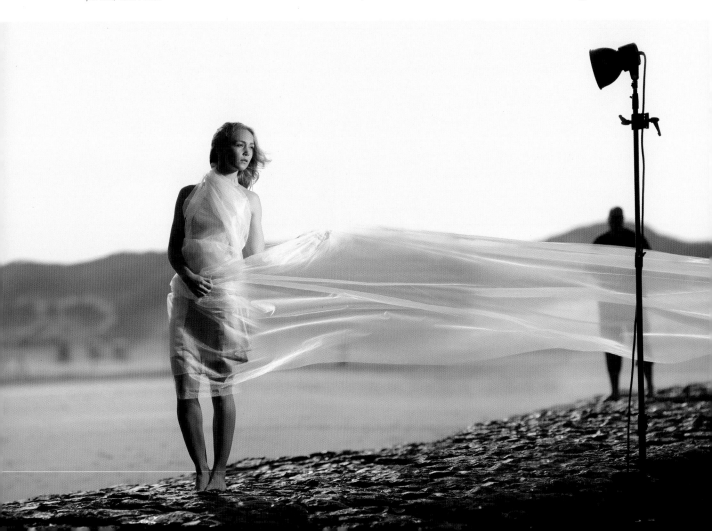

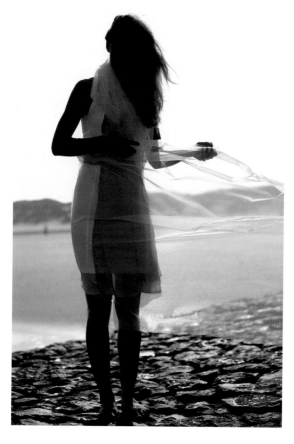

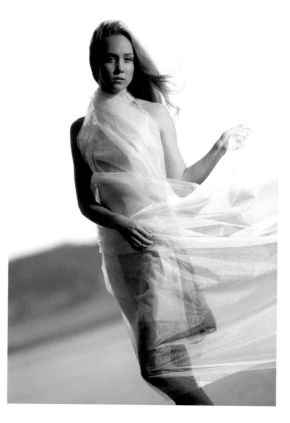

The initial shot without flash that I used to set exposure for the ambient light. This shot is straight out of camera (SOOC).

Canon EOS 5D Mark III · EF 70–200mm f/2.8L II @ 70 mm and f/3.5 · M mode · 1/3200 second · ISO 100 · RAW · WB set to flash · No flash

This is our SOOC flash shot.

Canon EOS 5D Mark III · EF 70–200 f/2.8L II @ 200 mm and f/3.5 · M mode · 1/3200 second · ISO 100 · RAW · WB set to flash · Jinbei FLII 500 portable flash with a small, wide-angle parabolic reflector, fired remotely using SuperSync

Settings and Shooting

As usual, I began by setting the exposure for the ambient light. I selected ISO 100 and set the aperture almost wide open to ensure that the results had shallow depth of field but remained sufficiently sharp. For example, at f/3.5 I don't have to focus as precisely as I might otherwise have to. I then set the shutter speed to 1/3200 to ensure that the sky wasn't overexposed.

Once the ambient-light exposure was established, I added the Jinbei flash, set to about 1/2 power and triggered using SuperSync. I selected the flash-to-subject distance such that Gabri Ela was evenly lit and her face was the brightest point in the frame.

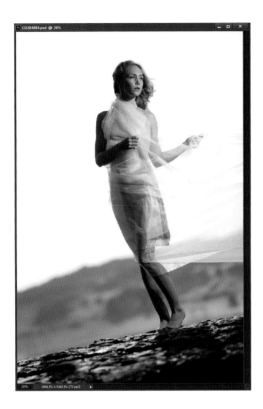

The screenshots show the original image, the processed version, and the corresponding layer stack.

Post-Processing in Adobe Camera Raw and Photoshop

During processing I slightly darkened the sky, selected warmer colors, and applied some slight beauty retouching. The screenshots show the original image, the processed version, and the corresponding layer stack.

Tips and Tricks

I was only able to use the wide-angle reflector on my Jinbei flash because both have standard Bowens/Walimex VC bayonets. If you are wondering if it is possible to adapt a speedlight to use the Bowens bayonet, the answer is yes; for example, you could use the Jinbei ET-1 flash adapter.

You should nevertheless be aware that, because a speedlight has a built-in reflector that concentrates the light from the flash tube, it won't work well with all standard light modifiers. Softboxes and beauty dishes work fairly well but, because of its narrow beam characteristic, a speedlight simply cannot "fill" a parabolic reflector like the one we used here. A small "yogurt container"–style diffuser attached to the speedlight is one solution; modifying your flash to work in bare-bulb mode is another. See the "Additional Techniques" chapter following the workshop sections for more details on flash modding.

The final image in this "People" workshops section combines a number of the techniques demonstrated in the preceding pages. For this image of Gabri Ela, we used the same Jinbei portable flash/wide-angle reflector as before, triggered using SuperSync and captured as a bokehrama sequence, which we later stitched together digitally in post-processing.

This image combines bokehrama with portable flash and SuperSync. (Model: Gabri Ela)
Canon EOS 5D Mark III · EF 70–200mm f/2.8L II @ 200 mm and f/3.5 · M mode · 1/3200 second ·
ISO 100 · RAW · WB set to flash · Jinbei FLII 500 flash with a wide-angle reflector, triggered
remotely using SuperSync · Bokehrama merged from 14 source images

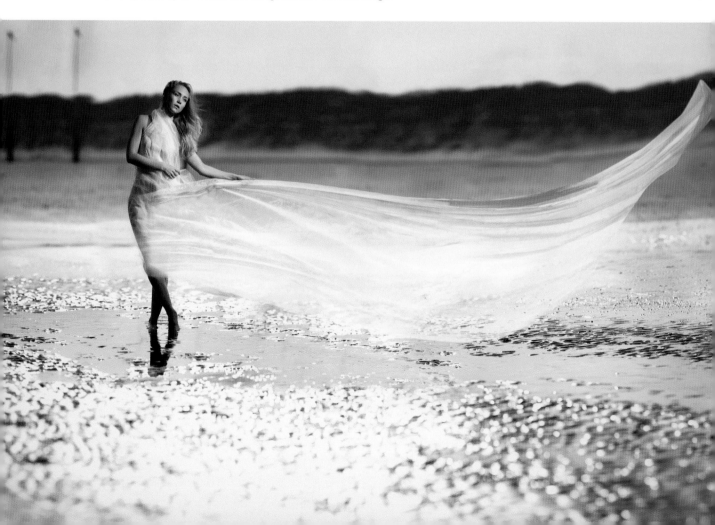

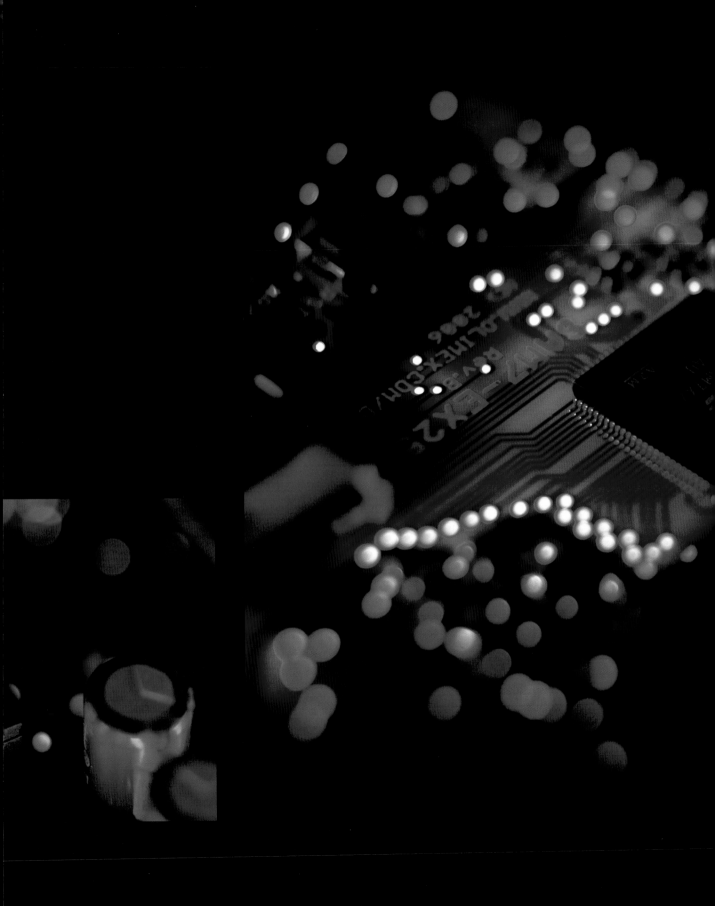

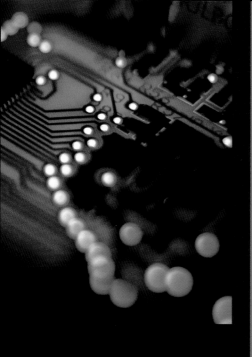

02

OBJECTS

Small, relatively inexpensive, battery-powered speedlights are also ideal for product photography. You can use them in the studio or on the go to produce attractive object, product, and tabletop shots. Although they are relatively low-powered units compared to studio flash, you will see that they don't present any barriers to creativity.

A product shot captured using on-camera flash. A shot like this is ideal for eBay auctions.

Canon EOS 5D Mark II · EF 24–70mm f/2.8 II @ 59 mm and f/8 · M mode · 1/160 second · ISO 320 · JPEG · WB set to flash · On-camera Canon Speedlite 580EX II, TTL mode, swiveled to the side and fitted with a flag · Image stacked from a series of five photos with varied focus

#11 Quick Product Shot Using Bounce Flash

› Using bounce flash for object and product photos

› Increasing depth of field using focus stacking

The demand for attractive product shots has increased dramatically in recent years. Whether you want to sell something on eBay or simply share it with the world on Facebook or your blog, there are many occasions when you need a good product photo. On eBay, if you use a photo created under neon light using your smartphone camera, you are sure to waste a lot of potential and get a lower price for your auction. And actually, successful product shots don't have to be complicated to shoot, and you can even achieve good results with on-camera flash. The icing on the cake is the enhanced depth of field produced using the focus-stacking technique explained at the end of this section.

Equipment and Lighting

For a shot like this, all you need is a camera with a TTL flash, a flag for the flash (see the portrait workshop on page 58 for more details on the "black foamie thing"), a sheet of paper to serve as a seamless background, and a white wall or corner. This particular shot requires no tripod, remote flash trigger, or additional light modifiers.

The diagram below and the overview photo opposite show how the setup works.

My EOS 5D Mark II with its 24–70mm f/2.8 II lens, TTL Canon Speedlite 580EX II, and the legendary "black foamie thing," which works as a flag and blocks the direct light path from the flash to the subject (see the glossary and the portrait workshop on page 58 for more details).

The setup for our bounce flash product shot.

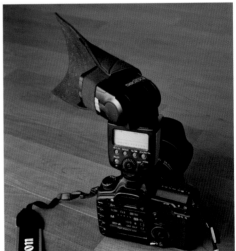

Settings and Shooting

The steps listed here—and especially the focus-stacking procedure—may appear complex, but are in fact relatively simple. This shot took me just 13 minutes from the start to the stacked, retouched, and color-corrected result. I know because I timed it! Shooting with a smartphone in ambient light may be faster, but not much faster.

In a shot like this, I try to suppress as much of the unattractive ambient light as possible. Therefore, I selected a shutter speed close to my camera's sync speed—in this case, 1/160 second. Instead of setting a small aperture, I used focus stacking to provide me with sufficient depth of field. I selected an aperture of f/8, which is close to the critical aperture of my lens and makes it possible, with only five or six shots, to cover the entire depth of the scene. I selected an ISO value that was just high enough to cut out virtually all of the ambient light, and my test shot without flash showed that ISO 320 was just the ticket.

I selected a focal length that reproduced the subject looking neither too flat nor too distorted. For a full-frame camera, 50–100 mm is a good choice.

I pointed the flash backward and to the left and shot five exposures with varying focus settings, which I merged later on my computer into a single image that is sharp from the close foreground all the way to the furthest point in the subject.

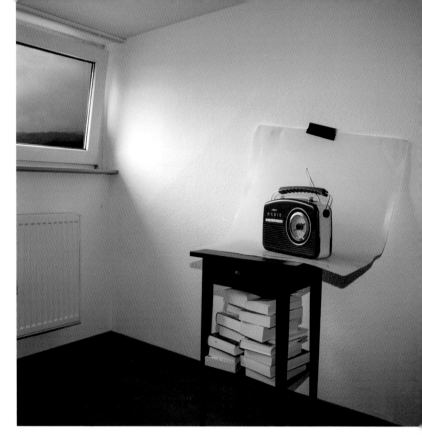

The setup showing the radio, the seamless background, and the white walls. For a shot like this, the flash can be swiveled to the left and tilted slightly upward to fill the dormer with light and transform it into a large, bright light source. A white wall to the left of the subject would also work.

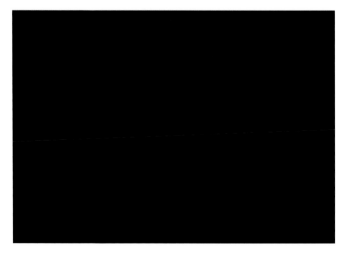

The initial test shot without flash to confirm that the ambient light was sufficiently suppressed. In this case, everything was fine.

From left to right, these screenshots show one of the five original images, the result of focus stacking and digitally extending the seamless background, the final image, and the corresponding layer stack.

Post-Processing in Photoshop

To keep things fast and simple, I shot my sequence in JPEG format and loaded the results using the *File > Scripts > Load Files into Stack* command, making sure the *Attempt to Automatically Align Source Images* option was checked.

Once the images were loaded, I selected all the layers in the resulting Photoshop file using Ctrl-click (Command-click on a Mac), then selected the *Edit > Auto-Align Layers* command and checked the *Stack Images* option. Photoshop usually does a good job with simple subjects, and it didn't produce any obvious errors in our example. I then combined the layers into one single new layer and retouched the final image using the Patch and Stamp tools. In the course of my retouching, I added some extra foreground to the seamless background and adjusted the colors and contrast to taste.

Tips and Tricks

When using bounce flash, it is essential to test the available bounce surfaces before you go ahead with your shoot. I always try tilting my flash to the left, backward and to the left, or to the right. My "black foamie thing" (BFT) is ideal for these experiments, and the sewn-in felt patches make it really easy to adjust its position on the flash.

Although it worked perfectly, my handheld approach to shooting for a focus stack is, technically speaking, somewhat lackadaisical. If you want to shoot perfect stacks, you need to use a macro focusing rail rather than the camera's own focusing mechanism to alter the focus setting, as this is the only way to ensure that the magnification doesn't change between shots. Check out *www.tiny.cc/tz5nnx* for a comparison of the two methods.

Same, but different! The camera, flash, subject, and surroundings were identical in both photos, but the results are worlds apart. Bounced flash, focus stacking, and final retouching make all the difference!

This piece of photographic magic is possible thanks to the "flash composite" technique.
Canon EOS 5D Mark III · EF 24–70mm f/2.8 II @ 50 mm and f/16 · M mode · 1/200 second ·
ISO 500 · JPEG · WB set to flash · Tripod-mounted camera · Yongnuo YN-568C flash set to TTL in a
Firefly II softbox, handheld · Image is a flash composite made from seven separate source images

> › Producing multiple lights using just one flash

> › Triggering the shutter remotely

> › Introducing some alternatives to Photoshop

Although the previous workshop demonstrated how to use a single flash to produce attractive lighting, you will still sometimes wish that you had more options for illumination. Some scenes only look really good if you add a soft highlight from above, a rim light from behind, or a kicker from diagonally and behind. If you think this is impossible to achieve using just one flash, think again! The solution to this particular dilemma is to use the "flash composite" technique to capture multiple images with different flash positions and then merge the results using Photoshop.

Equipment and Lighting

For this example, I mounted the camera on a tripod and used one hand to fire the shutter using a cable release and the other hand to direct my Firefly II softbox/Yongnuo YN-568C TTL flash combo. The flash was set to TTL mode and was triggered using YN-622C TTL wireless transceivers.

If you want to use this technique to photograph a large object (such as a car) but your cable release is too short, you can always release the shutter using the camera's self-timer or manually using a Yongnuo RF-602 radio trigger.

The setup consisted of a tripod-mounted camera and a handheld softbox that I moved around the subject during the remotely fired shooting sequence.

This is the usual test shot without flash that helped me confirm that I cut out enough of the ambient light from the exposure.

Camera Settings and Shooting

As usual, I started by setting the camera to almost completely suppress the ambient light, which meant selecting a shutter speed of 1/200 second (i.e., the camera's sync speed). To preserve sharpness throughout the entire depth of the subject without having to use the focus-stacking technique, I selected a slightly larger camera-to-subject distance than the one I used in the previous shot of the radio, as well as a shorter focal length (i.e., a wider angle) and a much smaller aperture of f/16. To conserve flash power, I also selected a higher ISO setting, but then checked again to ensure that no ambient light would be visible in the shots. I checked my settings by way of a test shot without flash.

TTL flash was ideal for this shoot because it automatically compensated for the slight changes in flash-to-subject distance caused by the changing position of the handheld flash. If you don't use TTL for a shot like this, make sure that the distance between the subject and the flash remains constant once you have made your camera and flash settings. To keep the distance constant, it helps to imagine that the flash is attached to the subject with a piece of string.

Post-Processing in Photoshop

Processing began by loading the source images into a layer stack using the *File > Scripts > Load Files into Stack* command. In this case, it was better not to activate the *Attempt to Automatically Align Source Images* option, as the source images for this project were only partially lit and would probably have caused software errors. If you used a tripod, additional alignment wouldn't be necessary anyway, but you could check whether you accidentally jogged your tripod between shots by alternately showing and hiding each layer and checking the alignment by eye.

I then set the blend mode of all the layers to *Lighter Color*, showed suitable layers (or hid unsuitable ones), and adjusted the opacity of each as necessary. The other processing steps I applied here involved isolating the subject and adding a new graduated orange background. If you take more care than I did capturing your original images, you can save yourself the trouble of swapping out the background. To finish up, I painted in a nicer and softer reflection in the upper part of the machine's housing.

Always take a few more shots than absolutely necessary, as you can hide any superfluous layers with a mouse click—the effect is the same as switching that shot's light source off. If you develop this idea further, you are sure to come up with new ways of enhancing the final merged image—for example, by applying Photo Filters to the individual layers. This is the equivalent of adding color filter gels to your flash after the photos have been captured. The required Photoshop commands are:

Layer > New Adjustment Layer > Photo Filter
Layer > Create Clipping Mask

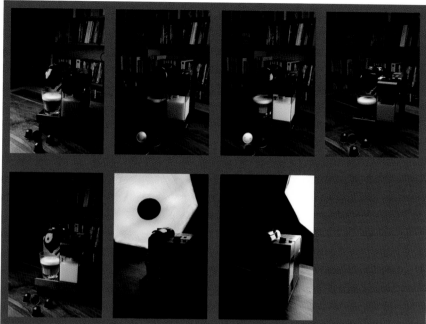

These are the seven source shots I used to create the final image.

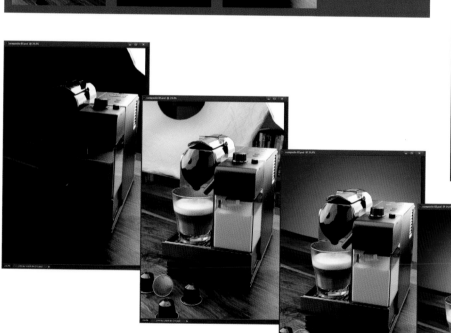

The Photoshop steps involved are: blending the layers, swapping out the background, and final retouching. The screenshots show (left to right) one of the source images, the result of merging all seven source images, the result of swapping the background, the final result, and the layer stack.

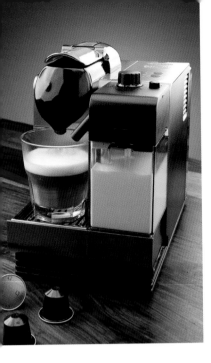
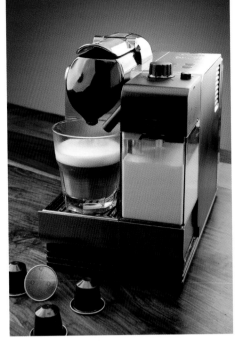

The magic of the flash composite technique even makes it possible to add color filters to your flash after you have finished shooting!

Alternatives to Photoshop

Photoshop is the undisputed market leader in image-processing software. It includes unbeatable tools for a wide range of image retouching and merging applications and, as you have seen, I often recommend it for the processes described in my workshops. But not everyone wants to spend a lot of money on software, and the high price of legacy versions and the new CC subscription model scares many potential users away. One cheaper way to use Adobe's products is to purchase a Student & Teacher License (see *www.adobe.com/creativecloud/buy/students.html* for details on whether you qualify).

Another alternative is to use Photoshop Elements, which nowadays incorporates many of the features previously only offered by its big brother, making it a powerful and useful image-processing package. If you combine Elements with the powerful RAW import functionality built into Lightroom, you will be able to perform virtually all of the processes demonstrated in this book. The table opposite lists the most important differences between Photoshop, Photoshop Elements, and Lightroom.

Same, but different! The camera, subject, and surroundings were identical in both photos, but once again, the results are worlds apart. The photo at left was captured in ambient light, while the photo at right was created using the technique described in this workshop.

Tool	Adobe Photoshop CC 2014	Adobe Photoshop Elements 13	Lightroom CC/6
Levels adjustment	✓	✓	✓
Quick Selection tool	✓	✓	✗
Photo Filter	✓	✓	✗
Layer functionality, including layer masks and blend modes (for merging multiple source images, etc.)	✓	✓	✗
Multiple RAW development steps on separate layers	✓	(✓) with manual creation of image copies	✗
Panorama stitching	✓	✓ Microsoft ICE is faster	✓ but not as powerful
Curves adjustment	✓	✗ can be added via Elements Plus	✓ but not as powerful
Camera Raw dialog as a filter	✓	✗ requires reloading	✗
Liquify filter	✓	✓ "Lite" version	✗
Color Lookup adjustment layer	✓	✗	✗
Split Toning	✓ also available in Adobe Camera Raw	✗ with workarounds	✓
Comprehensive RAW processing: Adding noise, advanced color options, etc.	✓	✗	✓
Focus stacking	✓	(✓) using the Photomerge *Group Photo* option. CombineZP (and others) are better	✗

Even if you like to use the best tools available, this doesn't mean you always have to use Photoshop. Some of its more useful tools are also available in Photoshop Elements, Lightroom, and even in free software packages (like Microsoft ICE).

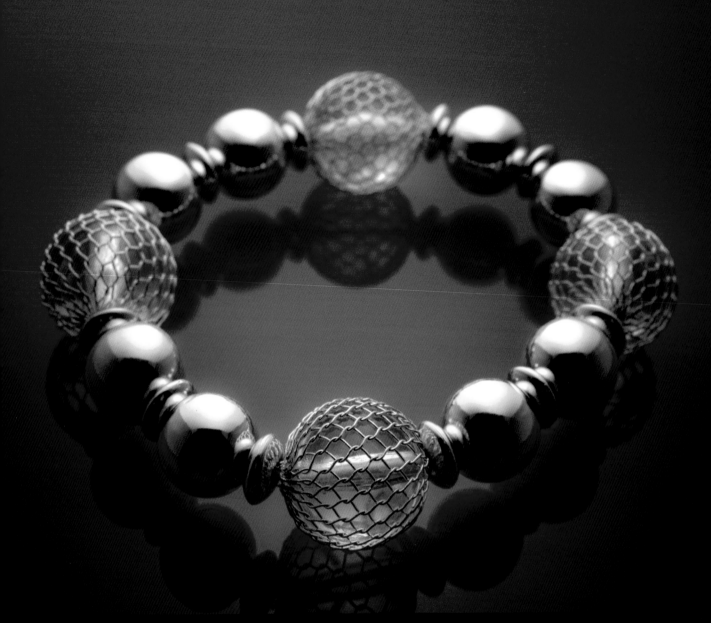

High-gloss jewelry reflected subtly in the back-ground—an effect that is simple to achieve using just a speedlight and a few sheets of Plexiglas.

Canon EOS 5D Mark II · EF 50mm f/2.5 Compact Macro lens @ f/16 · M mode · 1/160 second · ISO 320 · RAW · WB set to flash · Yongnuo YN-560 manual flash mounted on a Manfrotto Magic Arm, fired through translucent Plexiglas

#13 Classic Jewelry Shoot

› Capturing reflective jewelry using simple tools

› Selecting the right background and avoiding double reflections

› Plus: focus stacking for extra depth of field

Jewelry shots aren't easy. Individual pieces of jewelry are quite small, making it necessary to use extension tubes or a macro lens. At such short distances, it is difficult to achieve sufficient depth of focus, so you often have to use focus stacking or other tricks. Furthermore, jewelry is usually extremely shiny, reflecting its surroundings to a fault. Things get even trickier if you want to create a reflection in the background of the piece you are shooting.

Equipment and Lighting

One flash was enough to light this shot, but the real difficulty was in creating a setup that prevented unwanted reflections in the subject's surface and only captured reflections of selected light or dark shapes instead of the entire room. Rather than simply lighting the jewelry, the trick for a shot like this is to create bright and dark reflected accents in the jewelry that are completely under your control.

Our setup consisted of three sheets of translucent Plexiglas placed beside and above the subject. The bracelet was placed on another sheet of Plexiglas with its underside covered in red acrylic varnish to prevent the unwanted double reflection. The Yongnuo YN-560 was mounted above the subject on a Manfrotto Magic Arm with its wide-angle diffuser extended and a BFT flag attached to prevent any stray light spoiling the shot. I began by capturing a shot in which only the foremost edge of the bracelet was in focus, then I created a second image with depth of field that stretched from the foreground all the way to the farthest point on the subject.

For this shot, I used a Canon EOS 5D Mark II with the little known but highly commendable EF 50mm f/2.5 Compact Macro lens.

The setup for our jewelry shot, showing the translucent Plexiglas sheets beside and above the subject. The bracelet was placed on a sheet of clear Plexiglas with its underside coated in red acrylic varnish.

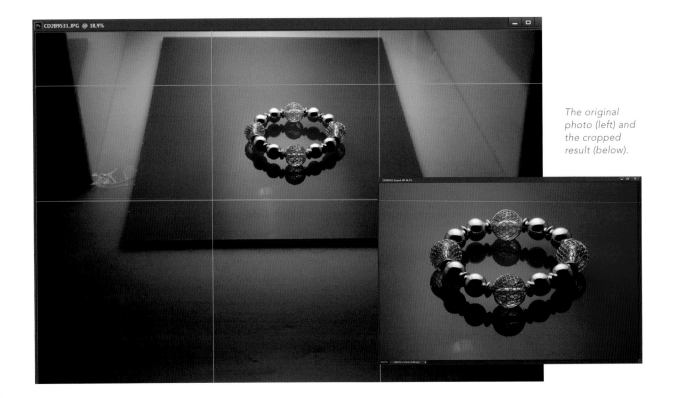

The original photo (left) and the cropped result (below).

One way to keep the entire subject in focus without resorting to focus stacking is to increase the camera-to-subject distance, shoot using a small aperture, and crop the resulting image. The downsides of this approach are a slight decrease in overall sharpness and lower resolution due to the crop.

Canon EOS 5D Mark II · EF 50 f/2.5 Compact Macro @ f/20 · M mode · 1/160 second · ISO 250 · RAW · WB set to flash · Manual Yongnuo YN-560 flash mounted on a Manfrotto Magic Arm, fired through Plexiglas

Settings and Shooting

In shots like this, the camera-to-subject distance is so small that even an aperture of f/16 doesn't provide sufficient depth of field to keep the entire subject sharp from front to back. In the photo on page 136, I simply accepted this shortcoming and used it as a deliberate stylistic device.

If the job at hand requires a completely sharp subject, the focus-stacking technique explained in the following workshop is one way to achieve satisfactory results. Another way to work around the depth-of-field issue is to shoot from directly above the subject, thus reducing the physical depth that you need to capture. Alternatively, you can use a (compact) camera with a small sensor and a short focal-length lens to provide greater depth of field. I, however, decided to take a different approach.

Depth of field increases with a smaller aperture and an increase in camera-to-subject distance, so I decided to retain the same focal length while stopping the aperture all the way down and moving further away from the subject. The bracelet was then in sharp focus from front to back but appeared smaller within the frame, making it necessary to crop the image later. In other words, the trade-off for greater depth of field is lower overall resolution. The images above show the original photo and the cropped, lightly processed version.

The f/20 aperture setting I used is far away from the critical aperture, which is somewhere between f/5.6 and f/8 for this particular lens. The image I captured shows obvious diffraction blur, but I was able to counteract this to some extent by applying heavy sharpening.

Post-Processing in Photoshop

Jewelry has to look perfect—there can be no dust, fluff, or scratches—so you need to take particular care when retouching shots like this. The screenshots below show the processing steps I applied to my second image. I used the same red-varnished sheet of Plexiglas for both shots and changed its color slightly during post-processing.

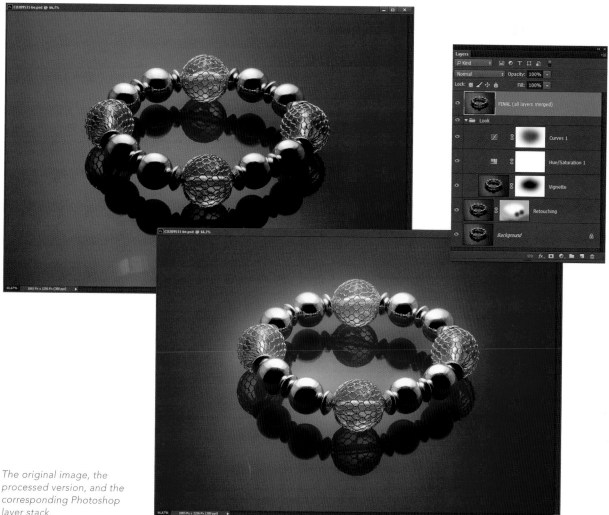

The original image, the processed version, and the corresponding Photoshop layer stack.

Tips and Tricks for Tack-Sharp Images

The image I took for the second part of this workshop was captured using an aperture of f/20. This increased the depth of field but reduced overall sharpness due to the diffraction blur caused by the narrow opening. If you want to get the best possible sharpness from your lens, you have to set it to its critical aperture. You can find resolution charts for a range of popular lenses at *www.slrgear.com*; in these charts you can find the critical (the sharpest) aperture for each lens.

Regarding focusing, I recommend using a zoomed-in live view image on your camera's LCD monitor. Because the reflex mirror is usually raised in live view mode, this approach also typically means you'll get the same effect as using your camera's mirror lock-up feature. If your camera functions differently, it is definitely worth setting mirror lock-up manually. This step is, of course, not necessary if you use an SLT (single lens translucent) or mirrorless system camera.

Same, but different! These two photos show the difference that careful photography and presentation can make. The camera, lens, flash, and subject were the same in both photos, but the off-camera flash, the increased depth of field, and the extra post-processing in the lower image make quite a difference.

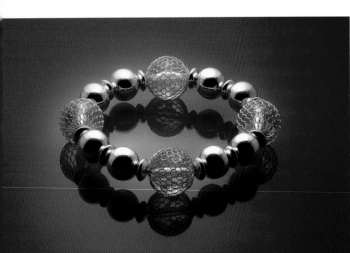

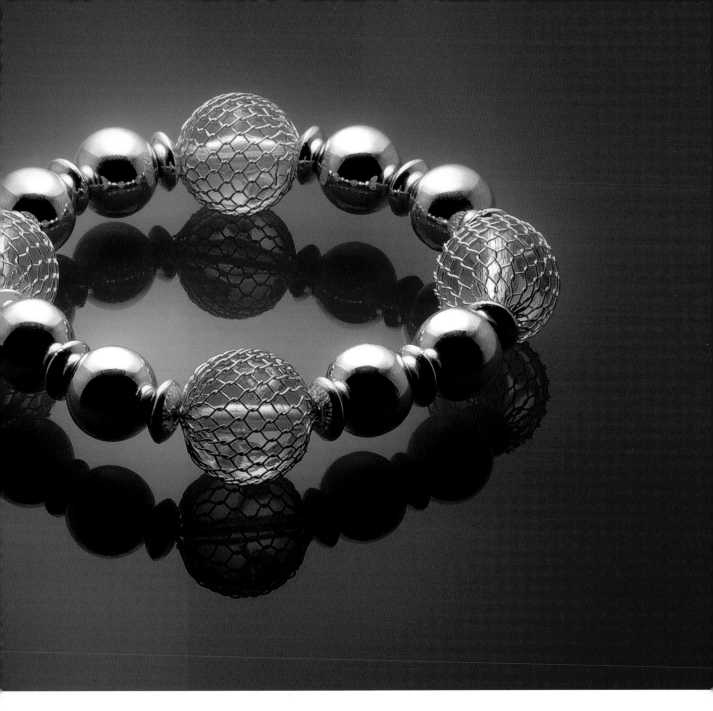

The cropped and processed result.

Canon EOS 5D Mark II · EF 50mm f/2.5 Compact
Macro @ f/20 · M mode · 1/160 second · ISO 250 ·
RAW · WB set to flash · Yongnuo YN-560 manual
flash mounted on a Manfrotto Magic Arm, fired
through Plexiglas · Image cropped in Photoshop

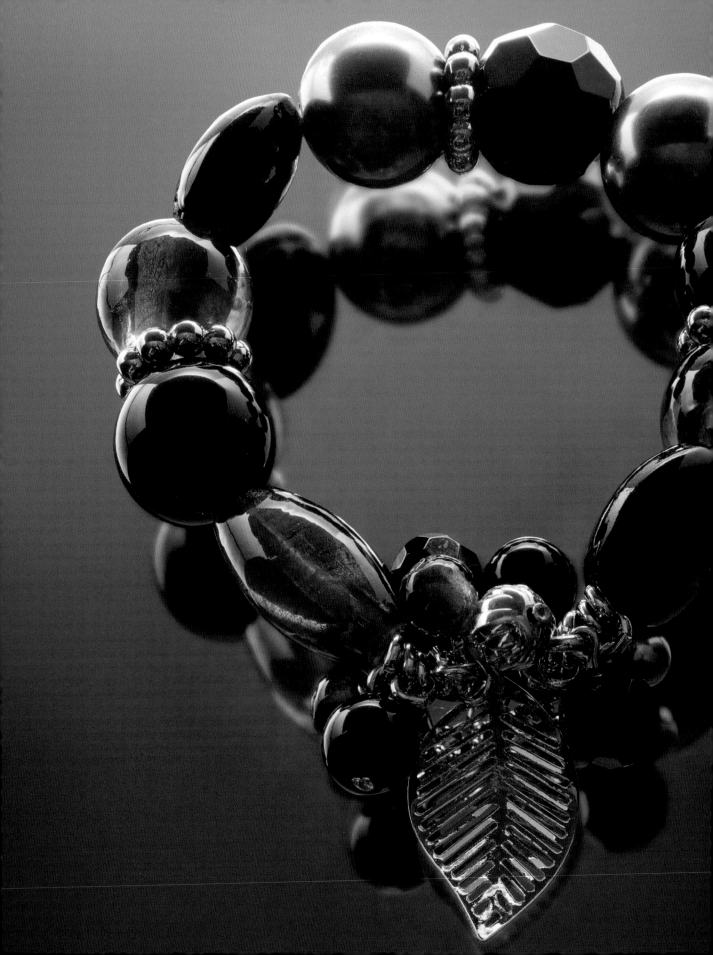

*A high-resolution jewelry shot with great depth
of field and a striking reflection—a simple shot
to capture if you know the right tricks.*

*Canon EOS 5D Mark III · EF 50mm f/2.5 Compact
Macro lens @ f/11 · M mode · 1/160 second ·
ISO 200 · JPEG · WB set to flash · Yongnuo YN-560
manual flash mounted on a Manfrotto Magic Arm
and fired through Translum sheeting · Stacked
from four source images*

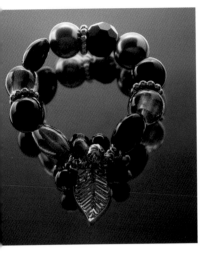

#14 Focus Stacking and Creating a Reflection

› Using focus stacking to increase depth of field

› Creating striking reflections

› Selecting complex objects

In the previous workshop, I used some simple tricks to work around the issue of insufficient depth of field, but these techniques only work if you don't want to capture the maximum possible resolution in your image. If, however, you have more exacting requirements, you have to use more sophisticated techniques. If you own a view camera or a bellows system like the Novoflex Castbal T/S series, you can adjust the plane of focus according to the Scheimpflug principle (check out "Scheimpflug principle" on Wikipedia for more details). Otherwise, as in the previous workshop, the most obvious solution is to use focus stacking.

If you also want to add a striking reflection, you have to delve even deeper into your photographer's bag of tricks.

Equipment and Lighting

I mounted my flash on a Manfrotto Magic Arm and fired it through a folded sheet of Translum. I placed two heavy books covered with copier paper to the right and left of the subject to provide bright accents, and placed a stiffened piece of black card above the subject to create the dark background tone. This setup prevented the shiny pearls in the bracelet from reflecting every detail of their surroundings. The setup left just a narrow slit through which the camera and the photographer were reflected. These reflections were, however, relatively simple to retouch.

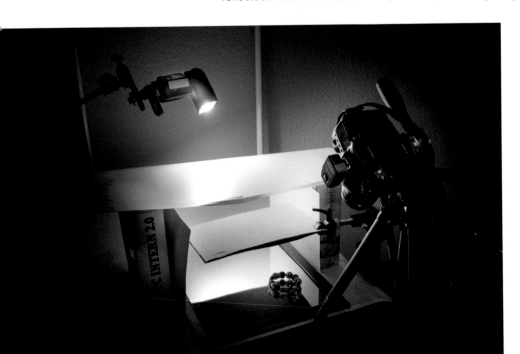

This setup consisted of a household mirror, two side walls that provided the reflected accents, a folded piece of Translum sheeting for the flash to fire through, and a stiff piece of black card positioned above the subject to provide the dark background.

I placed the bracelet on a simple household mirror to create the reflection. A mirror like this is not particularly suitable for this type of job because, when viewed at an angle, it produces one reflection in the reflective silver layer and another reflection in the uppermost surface of the glass. Although this issue can be solved using Photoshop, a better (but much more expensive) solution is to use a stainless steel mirror.

To make stacking easier, I mounted my camera on a tripod and focused using the zoomed-in live view image, altering focus from shot to shot using the lens. This approach worked very well here, but I recommend that you use a macro focusing rail to focus stack more complex subjects. You can read more about focus-stacking tests with a macro focusing rail at *www.tiny.cc/tz5nnx*. An inexpensive rail that I use can be acquired from *www.amzn.to/1FPns7B*.

The household mirror produced a strong reflection but, unfortunately, also created two separate reflected images—one in the reflective layer of the mirror and one in the upper surface of the glass.

Settings and Shooting

Once again, I used my EOS 5D Mark II and the highly capable 50mm f/2.5 Compact Macro lens. Diffraction blur isn't too obvious at f/11, so I only needed to capture four shots in my sequence. I set a shutter speed close to my camera's sync speed (1/200 second) to cut out the room lighting; I ended up selecting 1/160 second to give my wireless trigger time to work. I set a slightly higher ISO value of 200, which still prevents the ambient light from appearing in the final shot but also saves flash power. For shoots like this, I don't recommend setting the ISO higher than 400, simply because such values produce too much noise.

Post-Processing in Adobe Camera Raw and Photoshop

The first step involved the stacking process introduced earlier (see Workshop #11). I then gradually built a layer stack as follows:

1. Bottom layer: a clean, monochromatic gray background. To create this from my jewelry image I select the bracelet using the Polygonal Lasso tool and use the *Edit > Fill > Content-Aware* command. I then use the Gaussian Blur filter to clean up the result and add a little noise to give the layer a natural look.

2. Next layer up: a blurred mirror image of the bracelet.

3. Top layer: the isolated bracelet.

These screenshots demonstrate the individual processing steps. Once I had stacked the four source images, I used my professionally created selection path to build a stacked image from the background, the reflection, and the bracelet.

The screenshot shows my Photoshop layer stack. Selecting such a complex object using the Pen tool was too fiddly for me, so I got *clippingfactory.com* to do the job for me. The service cost me $5 and, six hours later, provided me with a perfect result. In this case, it was critical to communicate that I wanted the bracelet to be selected without its reflection.

If you look closely at the stack, you will see that Layer 2 appears as some sort of halo surrounding the pearls in Layer 3. To remove this effect, I masked the corresponding areas so that the background (Layer 1) showed through. To finish up, I removed dust and other imperfections using the Stamp and Patch tools.

Tips and Tricks: RAW or JPEG?

You have probably noticed that I usually use JPEG rather than RAW files for multi-shot techniques like panoramas, focus stacks, and flash composites. To avoid the large amounts of data involved with RAW processing and also to avoid having to convert my RAW images, I instead shoot JPEG and take special care when setting my exposure and white balance parameters.

But if you do decide to shoot RAW for multi-shot applications, proceed as follows:

1. Open your RAW source files in Adobe Camera Raw (ACR), develop one to your taste, and synchronize the rest to match.

2. Save your developed files to 16-bit TIFF or 16-bit PSD format.

3. Proceed as previously described for JPEG source images.

Same, but different! The camera, the lens, and the subject were the same for both images but the results are worlds apart. Careful lighting, focus stacking, and Photoshop processing make a huge difference.

The trick is that, if you use Photoshop for the next processing steps, you can simply prepare your images using ACR. ACR creates XMP sidecar files for the processed images, which are automatically loaded and used by Photoshop even if you use the *File > Scripts > Load Files into Stack* command instead of the standard file import.

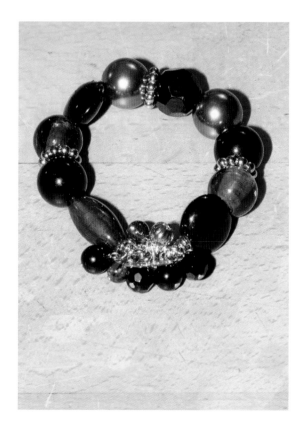

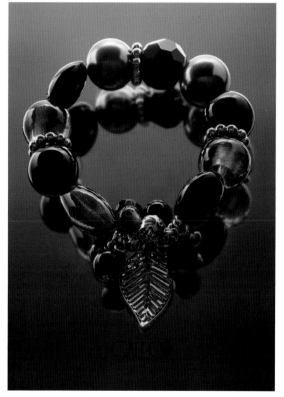

Simultaneously illuminating multiple precious stones is tricky business. However, you can still give each stone exactly the right level of sparkle using just one flash. In this case, the magic formula is "light painting."

Tripod-mounted Canon EOS 5D Mark III · EF 50mm f/2.5 Compact Macro lens @ f/16 · M mode · 10 seconds · ISO 200 · RAW · WB set to flash · Handheld Yongnuo YN-568 EX in Multi mode · Miniature snoot on the flash · Light painting

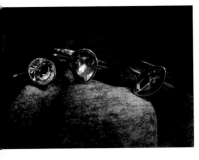

#15 Light Painting Jewelry Shoot

> › Illuminating multiple pieces of jewelry
> › Light painting with flash

Some complex subjects consist of so many surfaces at different angles that the only obvious way to illuminate them is to use multiple light sources. The three rings in the image on pages 148–149 demonstrate a scene that is tricky to light using conventional flash techniques. Not only does each ring require its own light, it is also extremely difficult to see if each has been properly lit, so setting the scene requires a large number of test shots. The most elegant way to light a scene like this is to set up your flash to provide continuous light and use it handheld.

"Light painting" has been around for a while but is usually performed using LED flashlights. Unfortunately, LEDs produce light of a single wavelength and manufacturers have to use tricks—such as adding red and yellow fluorescent particles to blue LEDs—to produce white light. The result is mixed-color light that is, technically speaking, not really white, as it does not contain all colors. The spectrum given off by a xenon flash tube is much better suited to our purposes but burns for only a very short time.

However, most modern speedlights have built-in technology that makes it possible to create the illusion of a continuous light source. To do this, switch to Multi (stroboscopic) mode and select the highest available frequency. If you now press the Test/Pilot button, the flash will emit a 1–2 second burst of seemingly continuous light.

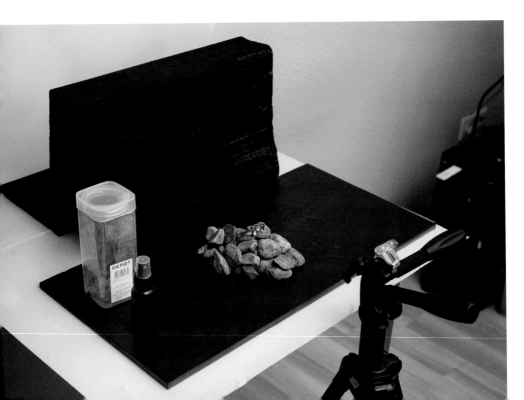

The simple setup consisted of some pebbles from a home furnishing store and the tripod-mounted camera. The room was darkened during the light painting process.

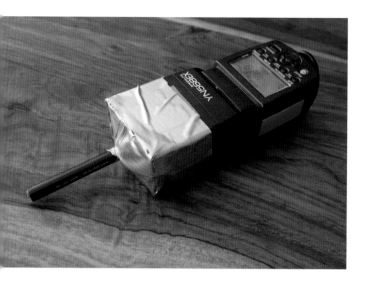 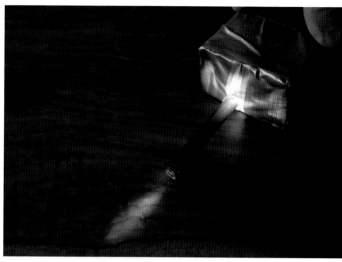

The Yongnuo YN-568 EX flash with the homemade mini snoot that helped me control the light I applied. The flash was set to Multi mode so that pressing the Test/Pilot button produced a continuous two-second burst of light.

Equipment and Lighting

For this image, I fitted my flash with a "mini snoot" made from a ballpoint pen, shot with my tripod-mounted EOS 5D Mark III and, once again, relied on my EF 50mm f/2.5 Compact Macro lens. You can, however, produce comparable results using a much less expensive crop-format camera and a standard 50mm lens with extension tubes.

Settings and Shooting

I selected an aperture of f/16 to provide plenty of depth of field and a long shutter speed of 10 seconds. Following a couple of test shots I settled for an ISO value of 200. The camera was tripod-mounted, and I focused using the zoomed-in live view monitor image. I set the flash to minimum output and Multi mode, and then darkened the room. Instead of using a cable release, I used a two-second self-timer to release the shutter.

When you are painting with light, it is essential to keep your light moving and to evaluate its effects from the camera's point of view rather than from above. And that's all there is to it. With a little practice, you will quickly learn to guess how much light to apply and where. If you use your camera's self-timer, you will be limited to a 30-second painting period, but you can always extend this by using bulb (B) mode and a cable release.

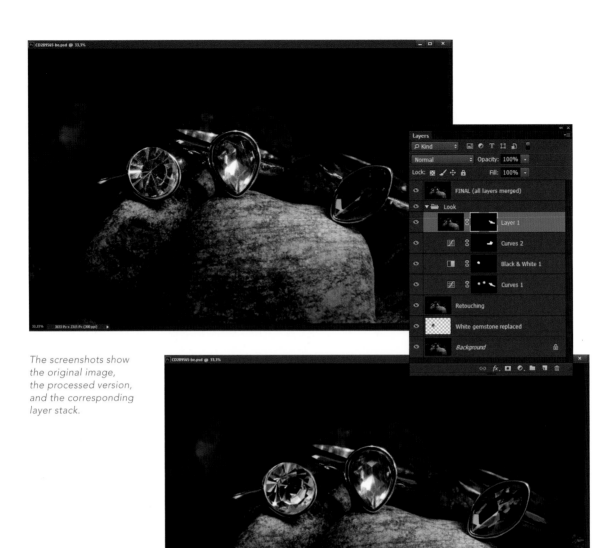

The screenshots show the original image, the processed version, and the corresponding layer stack.

Post-Processing in Adobe Camera Raw and Photoshop

The most serious processing step in this shoot involved copying the white precious stone from another shot and inserting it into the final image. I also retouched a number of dust spots and other imperfections, and I subtly tweaked the colors and contrast to taste.

Tips and Tricks

For this workshop, I used a not-so-cheap Yongnuo flash with TTL functionality, although you have probably noticed by now that I always try to use less-expensive alternative gear whenever I can. A recent addition to the Yongnuo lineup is the YN-560 III, which offers Multi (stroboscopic) mode but still costs less than half as much as the YN-568 EX. The newer model, too, can be fired manually off-camera using the Test/Pilot button—a feature that is not standard in flashes in this price range. Other models, such as the YN-468, can only be used in Multi mode when they are mounted on the camera's hot shoe.

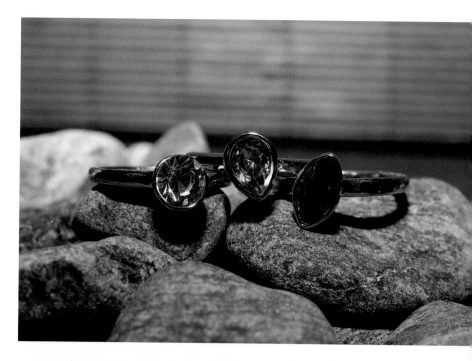

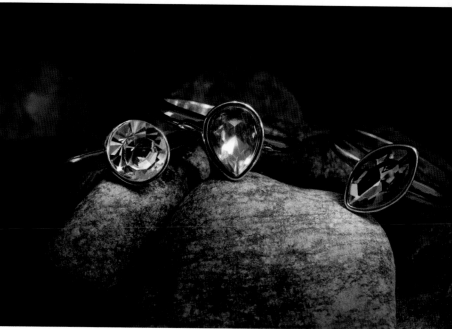

Same, but different! The camera, lens, flash, and subject were identical in both of these shots, but the results are very different indeed. The careful arrangement of the rings, the use of light painting to illuminate them, and some subtle Photoshop processing make a big difference.

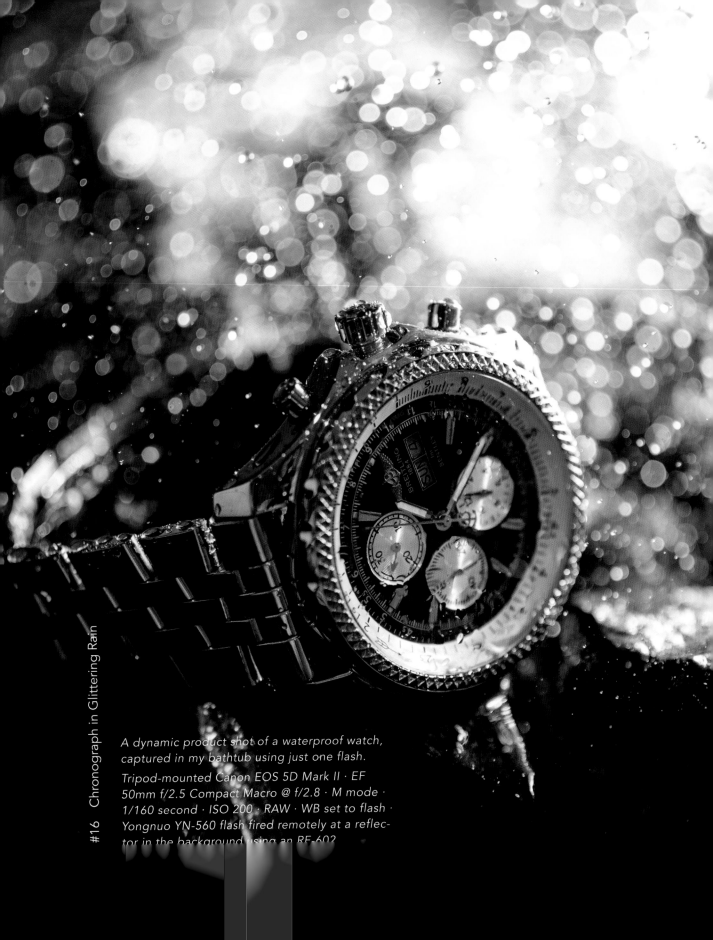

#16 Chronograph in Glittering Rain

A dynamic product shot of a waterproof watch, captured in my bathtub using just one flash.

Tripod-mounted Canon EOS 5D Mark II · EF 50mm f/2.5 Compact Macro @ f/2.8 · M mode · 1/160 second · ISO 200 · RAW · WB set to flash · Yongnuo YN-560 flash fired remotely at a reflector in the background using an RF-602.

#16 Chronograph in Glittering Rain

> › "Freezing" drops of water with flash

> › Creating an unusual setting for a watch

> › Double RAW development

Sometimes you can produce really impressive photos using simple tricks. For example, shooting with flash in the rain creates the impression of "freezing" the raindrops. If you shoot such a scene close up with backlight and a wide aperture, the bright "frozen" drops will be transformed into large circles of confusion. This is a great effect to use in shots designed to symbolize freshness or waterproofness.

Equipment and Lighting

The setup is simple. All you need is a watering can or shower and a waterproofed flash. For this shot, I packed my flash in a freezer bag and fired it at a piece of crumpled aluminum foil located in the background, with the foil acting as a backlight.

I used my Canon EOS 5D Mark II and the EF 50mm f/2.5 Compact Macro lens, but a crop-format camera such as the Nikon D5200 or Canon EOS Rebel fitted with a value 50mm lens and extension tubes would work just as well.

The setup, showing the flash aimed at the reflector in the background.

Settings and Shooting

Once again, I used settings that suppressed the ambient light. I selected a shutter speed close to my camera's sync speed and a wide aperture to produce the desired background blur. I then set the ISO value to take pressure off the flash but keep the ambient light out of the final shot. The flash was set to a relatively low output and, as I mentioned above, was aimed at a piece of aluminum foil located in the background. The corner of the room was decked out in black fabric to ensure that the circles of confusion created by the water droplets stood out well.

The setup as it looked in my bathroom, showing the granite blocks, the watch, the crumpled aluminum foil, and the flash aimed at it. The flash was protected from splashes by a freezer bag.

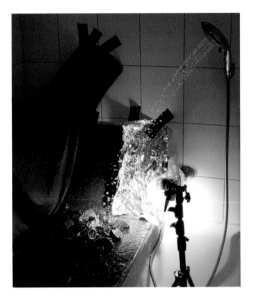

You need to be patient when shooting an image like this, as it can take some time to capture the right look. Some shots will have too much backlight and others too little. The sample shots above were overlit.

The secret to this kind of shot is to get up close to produce the shallow depth of field that creates the nice big bubbles you see in the final image. The effect is most striking if you shoot using a macro lens or a standard lens mounted on an extension tube.

It is also important to produce backlight to ensure that the bubbles stand out well against the background. You will simply have to experiment with the flash output and angles, as too much backlight produces extreme flares and ruins the effect, while too little backlight produces dull-looking results.

Post-Processing in Adobe Camera Raw and Photoshop

For this shot, I used two Photoshop tricks that go above and beyond my standard retouching steps. First, in spite of the splashing water, it is important for the product logo to be clearly legible, and this only works adequately if you capture it separately and insert it into the splash image later on.

The second trick concerns the warm foreground colors and the cool blue background. To achieve this effect, I processed two versions of the RAW image and merged them into one using a mask. This way, I was able to adjust the background color and increase its contrast without affecting the look of the watch. Additionally, I removed imperfections as usual using the Stamp tool, dodged and burned some areas, and removed fringing artifacts using the Lens Corrections tool.

Tips and Tricks: Protecting Your Gear Against Water

For this shot, I used a simple freezer bag to protect my flash from splashes and dried the lens with a kitchen towel. For real underwater shoots, though, I pack my camera in a Hama DiCAPac WP-DSLR case, which offers great value for the money and has so far kept my camera perfectly dry. For underwater shots, I don't use my expensive gear; instead I stick to using my older EOS Rebel T1i. Cheaper cases work for flash, too, and a large speedlight like the YN-560 III/IV might also fit in an underwater camcorder case from DiCAPac or Somikon.

If you want to shoot with your camera underwater and your flash in the open air, you will quickly discover that the range of a radio trigger is drastically reduced to about four inches when underwater. One solution is to use a more expensive underwater housing like those offered by ewa-marine (*www.ewa-marine.com*) (*fotomike. com*). The company even installs custom waterproof cable connectors in its products if you wish to use those connections underwater.

These screenshots show the "warm" and "cool" RAW images, the montage with the separately shot logo, the final image, and the corresponding layer stack.

A circuit board lit from behind and cap-
tured with a distinct focus gradient. Photos
like this are great for use in decorative
shots, banner ads, and magazines.
The circuit board was provided by Prof.
Volpe / University of Aschaffenburg.

Canon EOS 5D Mark II · EF 24–70mm f/2.8
@ f/3.2 with an extension tube · M mode ·
1/160 second · ISO 400 · RAW · WB set to
flash · Yongnuo YN-560 flash with a blue
gel, placed in a small, homemade
lightbox and fired using an RF-602

#17 Backlit Circuit Board

› Lighting a subject from below

› Creating decorative and themed images

Abstract decorative or themed images are often used in banner ads and magazines, and they can be used as a kind of "teaser" to emphasize headlines in daily newspapers. All three of the images shown below were shot using an off-camera flash fitted with a purple gel.

Most product shots are designed to make the subject recognizable, but there are also cases in which the overall graphic effect of the subject is more important than its recognizability. Photos in online or print banner ads are often used to symbolize concepts such as "technology" or "lifestyle" rather than portray a specific object. Such photos are known as decorative or themed images.

This type of shot gives the photographer a lot of stylistic freedom, although the resulting images still have to be interesting and arresting. For the cover of the annual report shown here, I decided to use a color filter gel for my main light and shoot close-ups that were lit using fairly extreme backlight and lateral "grazing" accents. The following sections explain how I created the shot of the circuit board.

Equipment and Lighting

I decided to light the circuit board from below to emphasize its semi-transparent nature and allow light to shine through the drill holes. Combined with shallow depth of field, this lighting setup produced circles of confusion of varying sizes. I built a lightbox out of a cardboard box covered with a sheet of white paper and a piece of black card with a rectangular hole cut in it. I set the flash to half power and extended the wide panel, then positioned the flash up to fire from diagonally beneath the hole in the card. I also attached a blue gel to the flash to give it a nice colored accent.

I shot with my Canon EOS 5D Mark II and my 24–70mm zoom mounted on a Kenko extension tube.

Settings and Shooting

I chose a shutter speed close to my camera's sync speed to suppress the ambient light. I then set a wide aperture and set my ISO to 400—again, making sure with a test shot that no ambient light would appear in the final shot. This ISO setting also saved flash power but didn't produce any visible noise.

Always shoot from a selection of angles and, for a shot like this, try shifting the subject so that some stray light escapes around its edges. Keep experimenting and don't give up too soon. To produce a cool effect like this, the circuit board has to have plenty of holes and not too many layers or components soldered onto its surface.

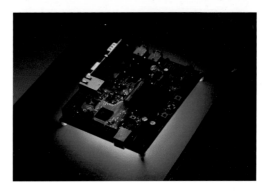

My homemade lightbox: a cardboard box, a sheet of paper, and a piece of black card with a hole cut in it. It takes about five minutes to build a setup like this.

Post-Processing in Photoshop

The focus trick and the color filter helped produce bright, high-contrast images straight out of the camera, so I didn't have to perform much processing at all. The

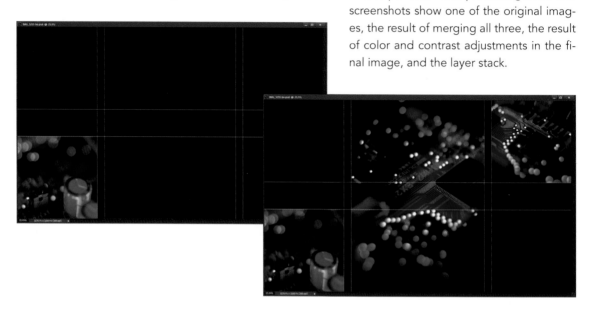

screenshots show one of the original images, the result of merging all three, the result of color and contrast adjustments in the final image, and the layer stack.

The screenshots show the process behind the creation of my "triptych" and the subtle color and contrast adjustments I made.

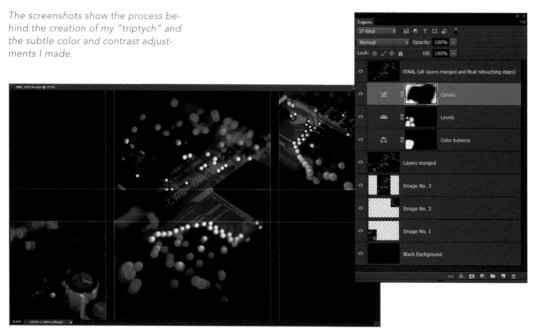

Tips and Tricks: Extension Tubes—Pros and Cons

There are advantages and disadvantages to using extension tubes, and you need to know about them before you decide to buy.

Extension tubes are small, light, and inexpensive, and they can be used to add macro functionality to just about any lens. Passive extension tubes cost $20–$30 for a set, while active models that transmit autofocus and aperture control signals between the camera and the lens cost $80–$150, but are worth the extra money if you can afford them.

One of the disadvantages of extension tubes is that you can no longer focus to infinity; instead, you can only focus within a relatively narrow range. This means you have to swap rings whenever you alter the subject distance, which is tedious. The other major drawback is that, with extension tubes, the lens is now used for object distances for which it was not constructed and optimized. This may sometimes lead to a reduction in image quality.

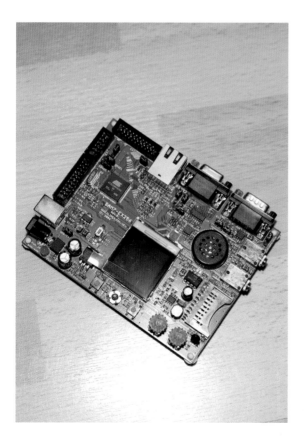 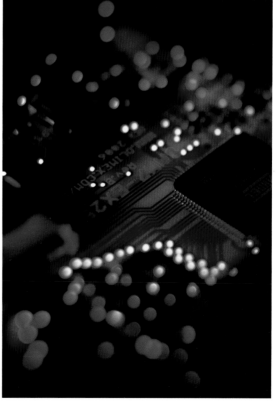

Same, but different! The subject, camera, lens, and flash were identical in both images, but the effect is completely different. Moving the flash off the camera, adding a color filter gel, and processing the results created a much more interesting image.

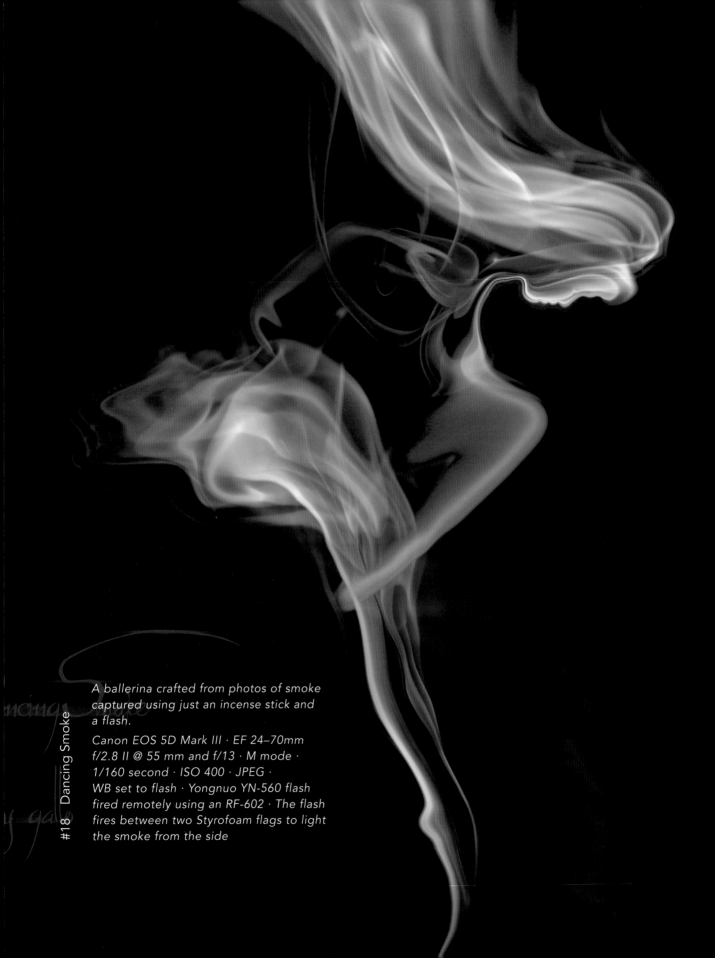

#18 Dancing Smoke

A ballerina crafted from photos of smoke
captured using just an incense stick and
a flash.

*Canon EOS 5D Mark III · EF 24–70mm
f/2.8 II @ 55 mm and f/13 · M mode ·
1/160 second · ISO 400 · JPEG ·
WB set to flash · Yongnuo YN-560 flash
fired remotely using an RF-602 · The flash
fires between two Styrofoam flags to light
the smoke from the side*

#18 Dancing Smoke

> › Using flash to "freeze" smoke patterns

> › Creating a smoke ballerina

Images of smoke figures are quite common, but most are created using Photoshop brush effects, which I find unrealistic. This workshop shows how easy it is to capture photos of real smoke and use them to create a convincing image of a dancer.

Equipment and Lighting

To capture photos of smoke, you need an incense stick, a bare off-camera flash, a dark background, and two flags to prevent stray light from entering the lens or affecting the background. If, like me, you use Styrofoam for your flags, you need to position them close together and cover the top with a piece of dark fabric folded over at the front. If you don't do this, reflections from the inside of the front edges of the flags will reduce contrast in the resulting images. Set up your scene as far as possible from the background to ensure that it ends up looking really black.

I used an EOS 5D Mark III with a 24–70mm lens, but a crop-format camera would work just as well. You don't need a tripod to capture shots like this.

This diagram shows the setup, which consists of a bare speedlight shaded by two Styrofoam flags.

The real scene, showing the manual YN-560 flash placed between two Styrofoam flags to light the smoke from the side. The camera was positioned to capture the smoke in front of a distant black background.

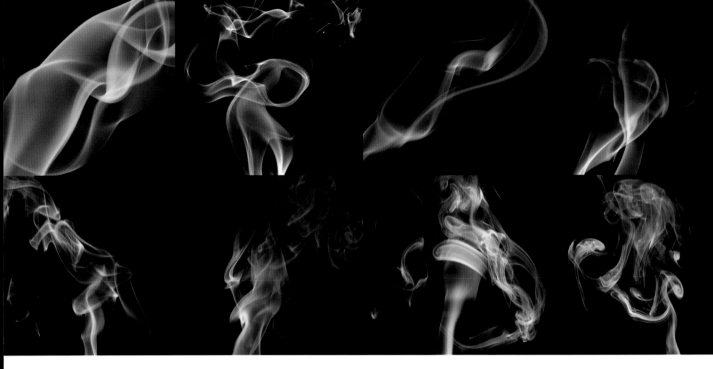

A selection of the smoke photos I used to create my ballerina.

Settings and Shooting

Once again, I suppressed the ambient light using a shutter speed of 1/160 second. The aperture value of f/13 is relatively small and ensures that the plumes of smoke are captured in sharp focus. I set the ISO to 400 to keep the ambient light out of the picture and reduce the amount of flash power required, while simultaneously avoiding any unnecessary reduction in image quality.

Post-Processing in Adobe Camera Raw and Photoshop

Once I captured my smoke shots, I downloaded a suitable ballerina image from Fotolia and inserted it into the background layer.

I then selected *Filter > Filter Gallery > Stylize > Glowing Edges* to produce an image of the most important contours in the ballerina image. This is the outline I used as a reference when patching together my smoke fragments.

I did some tests to see which smoke fragments best matched the outline and used the Liquify filter (*Filter > Liquify*) to adjust the shapes appropriately. When done, I hid the redundant parts of the smoke images using masks. Adjusting the smoke images using the Liquify filter is relatively easy if you adjust the opacity of the outline layer to around 50% to keep it visible while you work. The technique itself is simple but requires practice, and this image took me about two hours to complete.

I processed my JPEG smoke photos in 16-bit mode to prevent posterization from spoiling the effect. For monochromatic images like these, the results are much better if I apply Curves and Levels adjustments in 16-bit rather than in 8-bit mode.

The original ballerina image by Alexander Yakovlev @ Fotolia.

I neither rotated nor tilted the smoke images during processing, which allowed the lighting to stay consistent. I only transformed the images a little. The screenshots show the ballerina image, the inserted smoke patches, the merged layers, and the final result.

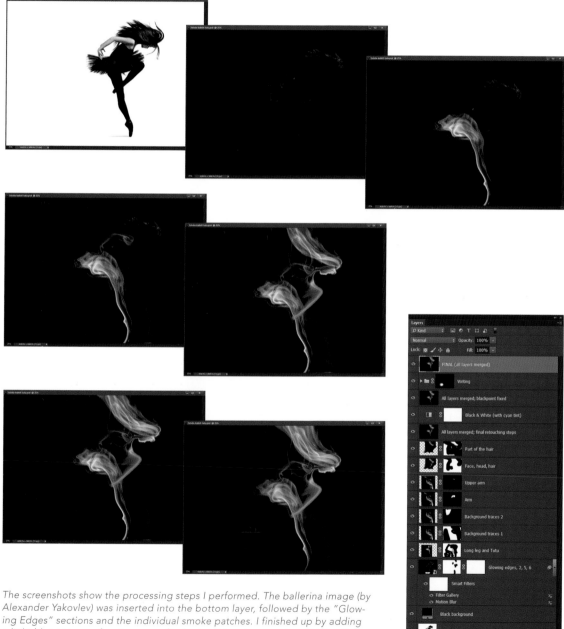

The screenshots show the processing steps I performed. The ballerina image (by Alexander Yakovlev) was inserted into the bottom layer, followed by the "Glowing Edges" sections and the individual smoke patches. I finished up by adding a light blue tone, performing some final retouching steps, and combining the image layers into a single layer.

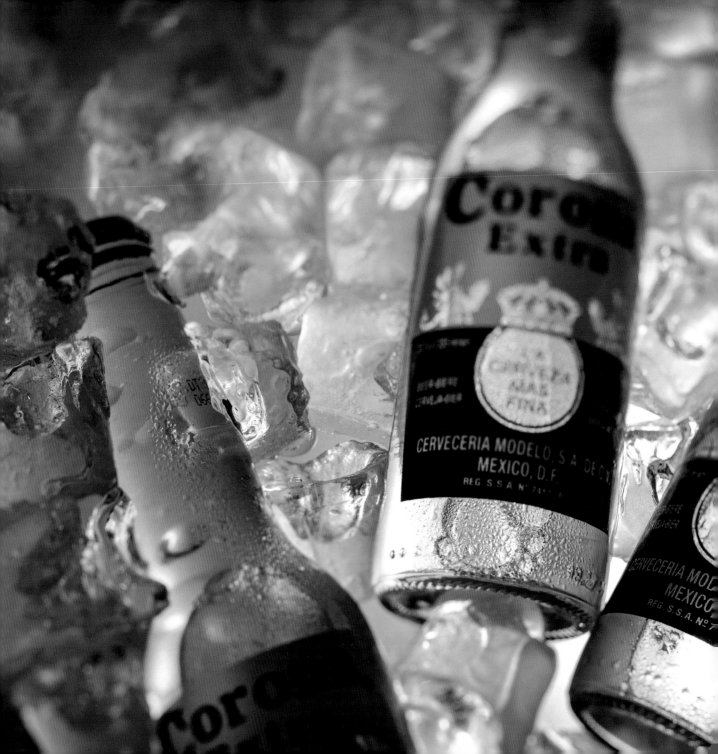

03

FOOD AND DRINK

Food, drink, and prepared dishes often look terrible in artificial light, providing yet another opportunity for flash to save the day. The white, almost continuous spectrum of flash light adds vitality to food shots and makes them look really appetizing. You can capture great food shots using sidelight, backlight, light painting, or "mystic light" effects. Believe it or not, you can even use on-camera flash.

If you're at work in the kitchen and you need to take a quick photo of a recipe for your food blog, bounce flash is the solution.

Canon EOS 5D Mark II · EF 24–105mm f/4 @ 105 mm and f/4 · M mode · 1/200 second · ISO 400 · JPEG · WB set to cloudy to produce warmer colors · On-camera Canon Speedlite 580EX II set to TTL, swiveled to the side and fitted with a BFT flag

#19　Quick Food Photos for Bloggers

› Creating quick and easy food photos, even while you are cooking

› Using flash exposure compensation, spot metering, and unusual white balance settings

A growing love of good food and the desire to cultivate an online community of like-minded people has seen an explosion in the number of food blogs in recent years, but it still takes good photos to give a food blog visual appeal and get people's juices flowing. Great food photos are relatively easy to shoot in daylight, but if you have a day job you might prefer to shoot in the evening. If you try to capture appetizing food photos in your kitchen's artificial light, you are sure to be disappointed with the results.

Once again, flash comes to the rescue, even if capturing images of food means you have to work fast. Let's face it, you want to cook while you shoot and then feast on the results, too!

Equipment and Lighting

The need for speed makes using cumbersome tripods and light modifiers impossible, so bounce flash is the answer. Prepare your camera, TTL flash, and flag before you start cooking to maximize your chances of capturing a great image on the fly.

For this shot, I used an EOS 5D Mark II with an EF 24–105mm f/4 lens, but a crop-format camera with a kit lens would work just as well. I used a Canon Speedlite 580EX II fitted with my current version of Niel van Niekerk's "black foamie thing" (BFT) that I described in detail in the first portrait workshop and the "Quick Product Shot Using Bounce Flash" workshop.

The camera, TTL flash, and "black foamie thing" (BFT).

An example of a bad food shot to spur you on to greater things! This shot was captured in Auto mode under ambient room light.

Once you have set your parameters in M mode, take a test shot without flash to confirm that the unfavorable room lighting has been suppressed. This shot shows that the settings were fine.

Settings and Shooting

An initial shot captured under the ambient room lighting serves as the "before" shot. In this case, neither the direction, the diffusion, nor the color temperature of the light was right, so the best solution was to cut it out altogether.

To suppress the room lighting, I set the shutter speed to my camera's sync speed and opened the aperture as wide as possible to ensure that the background in these close-up shots turned out nice and blurred. For this 24–105mm lens, f/4 is the widest aperture available. I set the ISO to 400 to keep the ambient light out of the picture and the required flash output to a minimum. Once everything was set up, I made a test shot without flash to make sure the ambient light was kept in check.

I then switched my flash to TTL mode and swiveled the head to the side. The BFT flag ensured that only soft, lateral light from the flash reached the subject. I tried bouncing the flash to the left and to the right, ultimately preferring the results from the right.

On food shoots, I often switch the white balance setting from **flash to cloudy** to produce a sunnier effect. Take care if you try this out for yourself, as the effect quickly looks overdone. If you shoot RAW, you can experiment more at the post-processing stage and adjust your white balance setting as necessary.

Now we add TTL flash, swiveled to the right and fitted with a BFT.
Canon EOS 5D Mark II · EF 24–105mm f/4 @ 32 mm and f/4 ·
M mode · 1/200 second · ISO 400 · JPEG · WB set to flash ·
On-camera Canon Speedlite 580EX II in TTL mode, fitted with a BFT

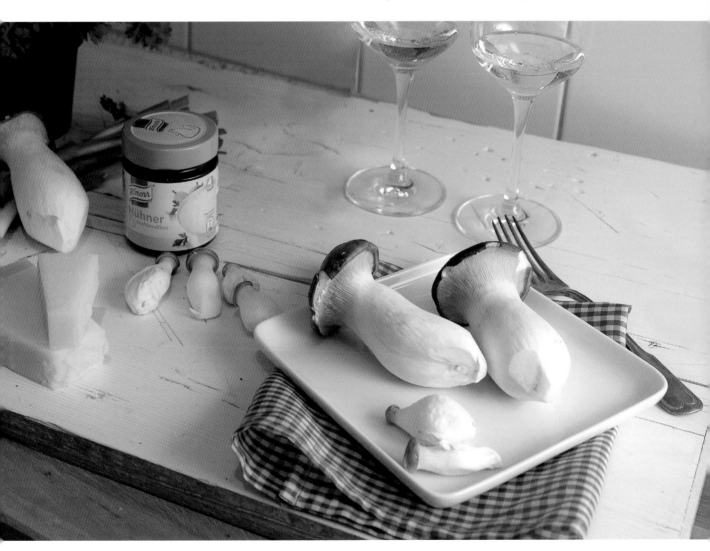

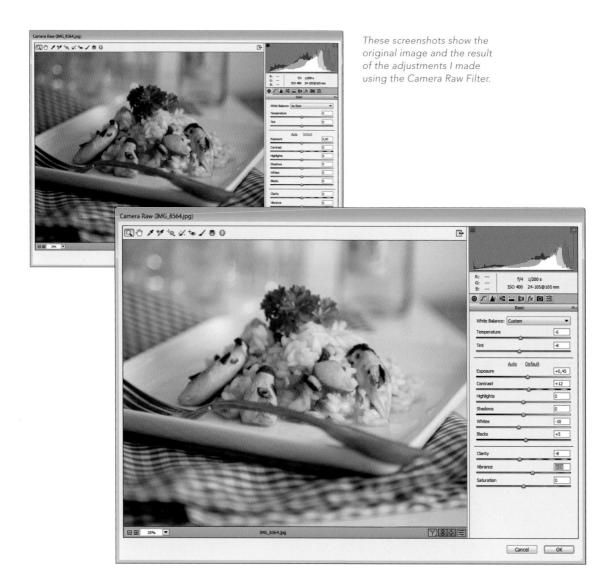

These screenshots show the original image and the result of the adjustments I made using the Camera Raw Filter.

Post-Processing in Adobe Camera Raw and Photoshop

To keep things simple, I developed the images shown here from the JPEG versions of the shots. JPEGs, too, can be adjusted using the tools built into Adobe Camera Raw using Photoshop CC's **Camera Raw Filter** tool. If you are using an older version of Photoshop, then use File > Open As... and select Camera Raw as the input. The size and dynamic range of the files and the range of available development options stay the same—in other words, JPEGs don't magically become RAW files!—but you can at least use the sliders you are used to.

In this example, I slightly adjusted the Exposure and increased the Vibrance setting. The screenshots show the original image, the settings I used, and the result.

Tips and Tricks

If you follow the steps described here, your photos should turn out perfectly right off the bat. If, however, your results are too dark or too bright, there are two ways to get things sorted out. For example, in the image shown here, if the rice appears too dark, set a flash exposure compensation (FEC) value between +0.3 and +1.0. If it's too bright, take the opposite approach.

If TTL metering doesn't work—either because the subject is too far from the center or doesn't fill enough of the frame—try using spot flash metering and locking in the result. Canon's version of this feature is called Flash Exposure Lock (FEL), while Nikon calls it Flash Value Lock (FV Lock).

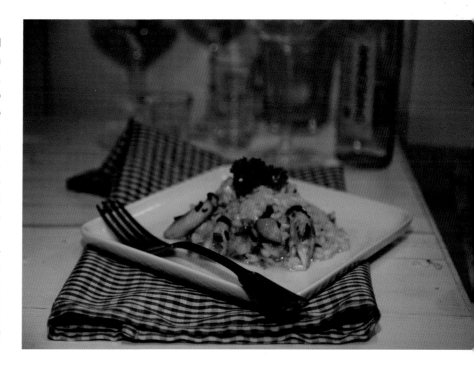

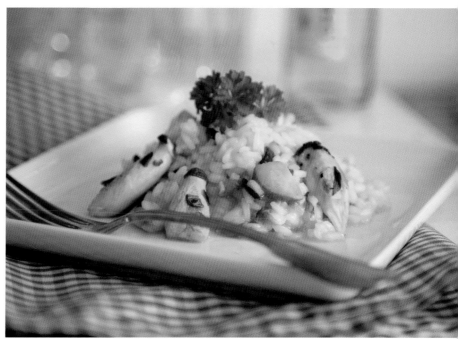

Same, but different! The flash, camera, and lens were identical for both shots, but the results are quite different. Switching from direct flash to indirect bounced flash definitely pays off.

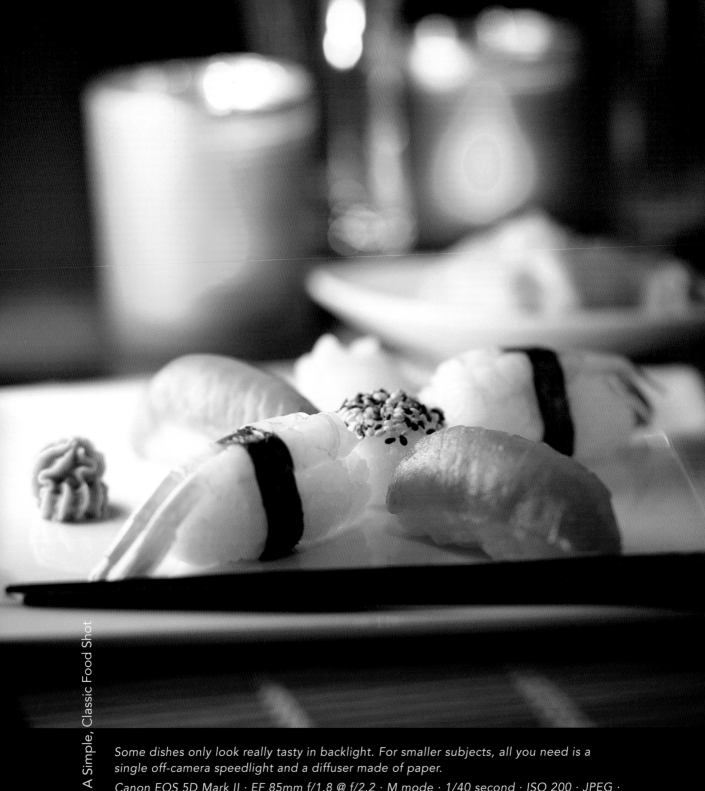

Some dishes only look really tasty in backlight. For smaller subjects, all you need is a single off-camera speedlight and a diffuser made of paper.

Canon EOS 5D Mark II · EF 85mm f/1.8 @ f/2.2 · M mode · 1/40 second · ISO 200 · JPEG · WB set to flash · Off-camera Canon Speedlite 430EX II in M mode, fired using an RF-602 from diagonally behind the subject using a paper diffuser and a paper fill-reflector.

#20 A Simple, Classic Food Shot

> › Improvising a softbox using paper

> › Shooting backlit food photos

The previous workshop showed what a difference switching from hard frontal light to soft lateral light can make. However, some dishes still require fairly extreme lighting. In this example, the sliced tuna only looks really fresh if you can see the reflection of a large light source in its surface, and the trout caviar only begins to look really tasty in backlight.

Equipment and Lighting

A classic food lighting setup consists of a main light positioned diagonally behind the subject and a fill light from the opposite side. You can construct such a setup using two softboxes, as long as you make sure that the backlight is brighter than the fill light. Interestingly, for small subjects you can produce the same look by using a sheet of folded paper placed in front of the flash and a second sheet placed opposite the main light as a fill reflector.

For this workshop, I used a Canon EOS 5D Mark II with an EF 85mm f/1.8 prime lens and a Speedlite 430EX II flash. I manually set the flash to 1/32 power.

My spartan "Zen" setup consisted of a single speedlight and two folded sheets of paper. The rear sheet acted as a diffuser and the one at the front as a fill reflector.

The setup in real life. An off-camera flash was fired through a sheet of paper from back left, while a second sheet at front right served as a fill reflector.

Settings and Shooting
I wanted the candles in the background to appear in the final image, so I set a relatively long shutter speed of 1/40 second. This strategy works because the in-focus elements are lit exclusively by the flash and thus appear perfectly still. To play it really safe, I could have used a higher ISO setting and a faster shutter speed (see the "Tips and Tricks" section on page 180). The photo on the left shows the test shot without flash.

This is my test shot without flash to check the look of the background. In this case, I wanted the candles to remain visible.
Canon EOS 5D Mark II · EF 85mm f/1.8 @ f/2.2 · M mode · 1/40 second · ISO 200 · JPEG · WB set to flash · Flash switched off

Then we add flash.
Canon EOS 5D Mark II · EF 85mm f/1.8 @ f/2.2 · M mode · 1/40 second · ISO 200 · JPEG · WB set to flash · Off-camera Speedlite 430EX II in M mode, fired remotely using an RF-602 from diagonally behind the subject using a paper diffuser, with a paper fill reflector positioned opposite the flash

Post-Processing in Adobe Camera Raw
The processing steps for this shot were limited to a square crop and the slight adjustments shown in the screenshots opposite.

The flash provides great-looking results straight out of the camera, so I only had to make slight adjustments in Adobe Camera Raw.

Tips and Tricks

You may be wondering how I managed to use the camera to separate the ambient and flash exposures and control each of them "remotely." Here are the details of how this is done.

If, as in this example, I want to deliberately include some of the ambient light in my composition without influencing the effect of the flash, all I have to do is increase the shutter speed. As long as the shutter speed is longer than my camera's sync speed, it has no further effect on the flash exposure.

If I need to change the effect of the flash remotely, I can do this by altering the ISO value, although I then have to compensate for this and adjust the shutter speed accordingly. For example, to get the flash to shine twice as brightly on the sushi, I can switch from 1/40 second and ISO 200 to 1/80 second and ISO 400. Conversely, to make it half as bright, I have to use 1/20 second and ISO 100. The overall exposure for the ambient light remains the same, but adjusting the ISO lets me dial up or down the flash's brightness right from the camera.

The limits of this particular trick lie between your camera's lowest ISO setting and the maximum acceptable ISO (e.g., ISO 100–800), as well as the range between the camera's sync speed and the slowest speed you can shoot handheld.

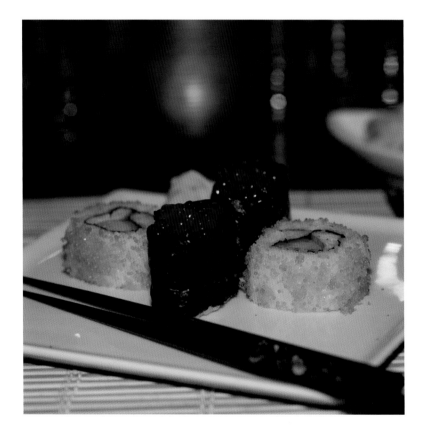

Same, but different! The photo on the left was captured using direct flash, while the one on the right was captured using my "Zen" setup with its two sheets of paper. The camera, lens, flash, and sushi were identical in both shots. These two images clearly demonstrate the benefits of using off-camera flash.

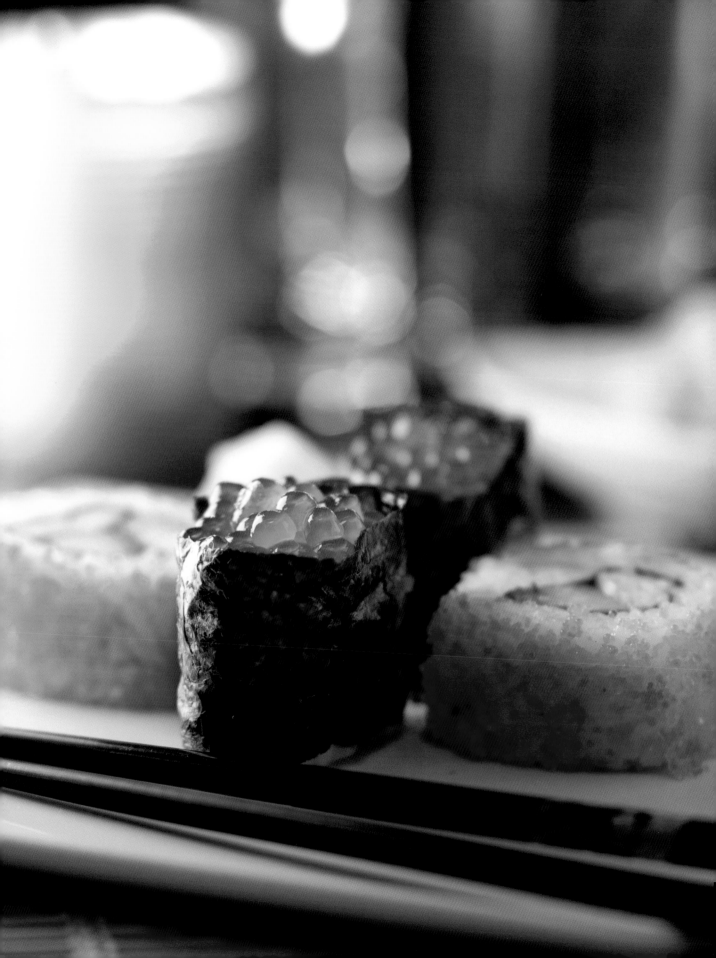

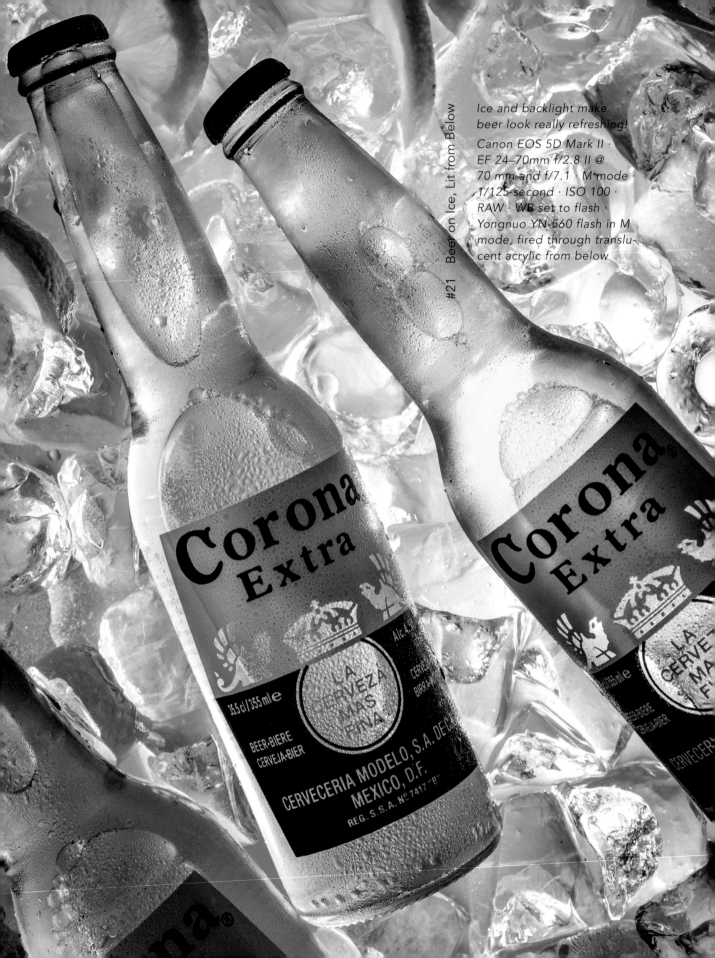

Ice and backlight make
beer look really refreshing!

Canon EOS 5D Mark II ·
EF 24–70mm f/2.8 II @
70 mm and f/7.1 · M mode ·
1/125 second · ISO 100 ·
RAW · WB set to flash ·
Yongnuo YN-560 flash in M
mode, fired through translu-
cent acrylic from below

#21 Beer on Ice, Lit from Below

#21 Beer on Ice, Lit from Below

> Giving beer bottles an iced look

> Building a backlit setup

> Applying multiple RAW development steps

Many subjects only look really good in backlight. The caviar in the previous example clearly shows that light coming from the camera's direction doesn't produce the desired effect; only backlight is what makes the brightly colored fish eggs recognizable and tasty-looking. The same is true for the beer bottles in this example, with the additional idea that beer tastes best when it is cold. This effect is easiest to produce using drops of moisture, which you can make last longer using a simple trick.

Equipment and Lighting

I used a manual YN-560 speedlight packed in a freezer bag and placed in the bathtub below the "stage" along with RF-602 triggers to fire the flash.

I extended the wide panel and tilted the flash head diagonally upward to fire through a sheet of translucent acrylic on which I artfully arranged the ice, some slices of lemon, and the bottles. Having the flash fire from the side prevented it from producing a hotspot in the resulting image.

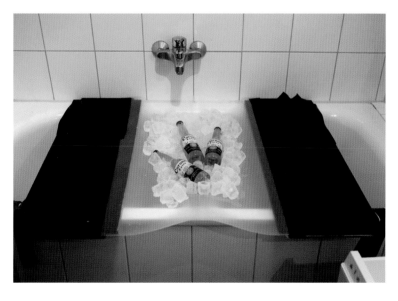

I used an acrylic sheet from a billboard as my stage.

The full setup, shown here under ambient room light, consisted of the acrylic sheet balanced on the bathtub, plenty of ice, and a flash aimed upward from below.

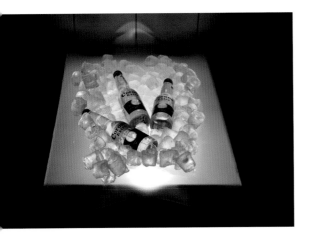

Above: This was how the setup looked when lit from below with flash.

Right: The trick with the shoe-waterproofing solution works! This shot shows an untreated bottle and one that I treated several hours prior to adding water droplets with a little perfume vaporizer filled with water.

The acrylic sheet rested on two planks of wood and was fastened in place using tape. I sprayed the beer bottles with a shoe-waterproofing solution the day before—a trick that made the condensation droplets last much longer while I shot. The photos show the setup captured with flash, untreated and treated bottles, and the setup captured in ambient light.

The test shot without flash shows that the ambient light was obviously completely suppressed!

Canon EOS 5D Mark II · EF 24–70mm f/2.8 II @ 70 mm and f/7.1 · M mode · 1/125 second · ISO 100 · RAW · Flash switched off

Settings and Shooting

The treated bottles kept their cold look much longer but the clock was nevertheless ticking from the moment I set up the bottles and covered them in droplets. For a shot like this, you need to set up the stage, the flash, and the props in advance, and only put a test bottle in place to determine your camera settings when everything is ready.

I set the camera to ISO 100, f/7.1, and 1/125 second, and I dialed in 1/8 power on the flash. A test shot without flash showed that the ambient light was completely suppressed.

Once everything was set up, I added the treated bottles, the ice, and the lemons, then sprayed the bottles using a perfume vaporizer. Thanks to the shoe-waterproofing coating, the water droplets stayed in place much longer and didn't run together.

In this type of situation, shoot from vertically above and make sure that the lighting is as even as possible. It helps to shoot with the flash positioned to the side and with the wide panel in place, and don't be afraid to try out different positions to see which works best.

Post-Processing in Photoshop

Processing for this shoot was quite complex, although the steps involved shouldn't take much more than a half hour once you've had some practice. The first step was to develop separate versions of the image that showed the bottles, the ice, and the lemons in the right light. Merging the three was then a simple case of using a soft brush to mask the superfluous parts of each layer. In this case, a precise selection wasn't necessary.

I repaired the overexposed area using a patch from elsewhere in the frame and produced the final look using two Color Lookup adjustment layers, a Curves adjustment layer, and the Camera Raw filter. The screenshots on this and the following pages show the original SOOC image, the three developed versions, and the final image.

The results of separate RAW processing for the bottles, the ice, and the lemons.

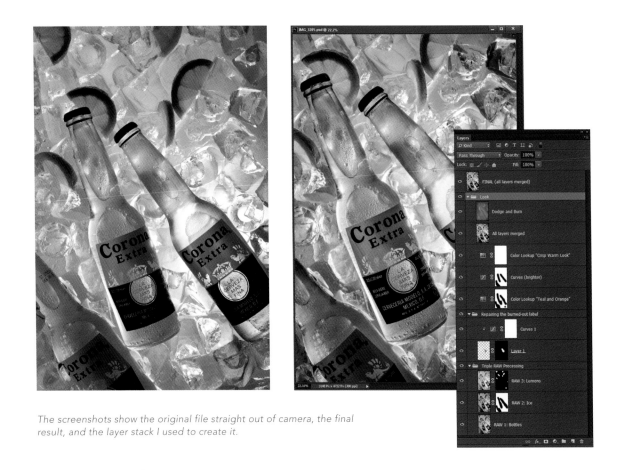

The screenshots show the original file straight out of camera, the final result, and the layer stack I used to create it.

Tips and Tricks: The Pros and Cons of Post-Processing

Post-processing played a more important role in this workshop than in most of the others, and you are probably asking yourself whether I could have saved some of the processing effort involved by taking more care during the shoot. The answer is "yes and no." It would have been extremely difficult to capture the cool look of the ice and the bright lemons simultaneously in one shot. I could have used a color filter gel on the flash to produce the overall look, but remember: it is much easier to recolor selected areas of an image (the ice and the lemons) and leave others neutral than it is to partially neutralize a global color cast. Repairing the over-exposed area, too, was simpler in Photoshop than it would have been to foresee and prevent during the shoot.

On the other hand, it was essential to set up the bottles, the ice, and the water droplets properly, and it was crucial to focus correctly right from the start. Retouching water droplets in Photoshop is possible but complicated, and artificial droplets simply look unrealistic. Incorrect focus cannot be repaired no matter how hard you try.

Exposure doesn't have to be perfect, but should be within a range that you can successfully fine-tune using ACR. The amount of processing flexibility available varies from camera to camera—for example, using my EOS 5D Mark II/III, I would never underexpose by more than –1 EV or overexpose by more than +0.66 EV.

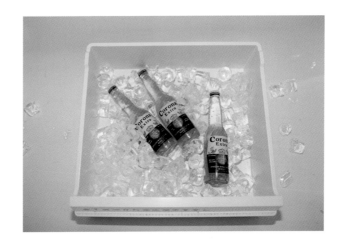

Same, but different! The camera, flash, and subject were once again the same for both images—the backlight and post-processing make all the difference. For the shot below, the unusual plane of focus was created using a Lensbaby Edge 80 tilt lens.

Canon EOS 5D Mark II · Lensbaby Edge 80 in a Lensbaby Composer @ f/4 · M mode · 1/160 second · ISO 100 · RAW · WB set to flash · Yongnuo YN-560 flash set to M mode and fired through translucent acrylic from below

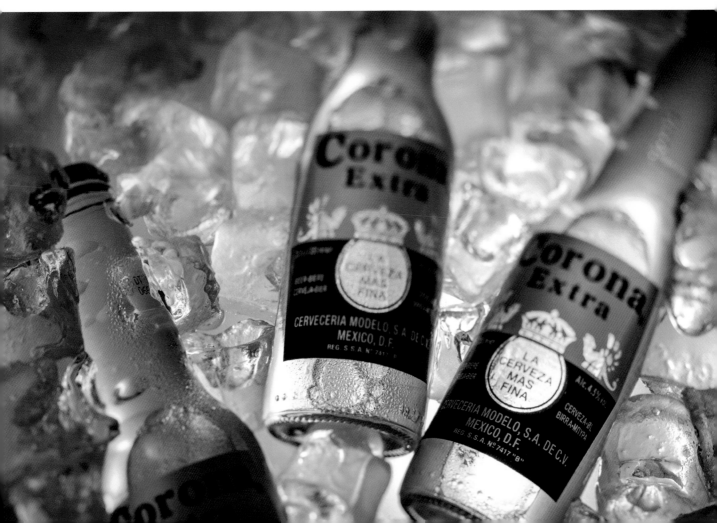

Pomegranate seeds and glasses of wine in atmospheric light, captured using a single flash.

Canon EOS 5D Mark III · EF 24–70mm f/2.8 II @ 70 mm and f/3.2 · M mode · 13 seconds · ISO 50 · RAW · WB set to flash · Handheld Yongnuo YN-568C flash in Multi (stroboscopic) mode · The flash is fitted with my homemade clone of the Fstoppers "Flash Disc" modifier

#22 Food in Mystic Light

> › Introducing the "mystic light" technique
> › Using light painting to bathe pomegranate seeds in mystic light
> › Building your own light modifier

The term "mystic light" was created by the StockFood agency and is currently a popular trend in food photography (see *www.tiny.cc/sxy8yx* for a video on the subject). This style is unusually cool and dark for food shots but is instantly recognizable. The simple setups usually involve just one or two lights and incorporate a lot of shadow. You can reproduce this look in the studio using a large softbox and strategically placed flags, but you can also create a similar look without the help of any conventional light modifiers.

Equipment and Lighting

As demonstrated earlier in the "Light Painting Jewelry Shoot" workshop, this shot uses a speedlight as a makeshift light painting tool. As previously discussed, the spectrum produced by xenon flash tubes is much better than that from LED flashlights, so it is worth making the extra effort involved in adapting your flash. I used a Yongnuo YN-568C speedlight that can be fired manually off-camera in Multi (stroboscopic) mode. In Multi mode, you have to set the number, strength, and frequency of the flash pulses. For this example, I set values of 70, 1/128, 9.

Pressing the Test/Pilot button then fires an apparently continuous stream of light with a duration of several seconds. I used a homemade "Flash Disc" light modifier, but any mini softbox designed for use with speedlights will do.

An overview of the setup, showing the pomegranate seeds that are in focus in the final image and the wine glasses that are blurred in the background. I used a slate tile as my stage and the black side of a large reflector for the background.

This shot shows how I moved the handheld flash during one of the long exposures.

Settings and Shooting

For a shot like this, you need to mount your camera on a tripod and darken the room. I set my camera to ISO 50, f/3.2, and 13 seconds, and I released the shutter using the self-timer. "Light painting" is relatively simple, and you just have to make sure you keep moving during the exposure and apply the light so that it comes from the side, behind, or above the subject, rather than from the camera's viewpoint. You can adjust the intensity of the light by altering the distance of the flash to the subject.

The photo on the left shows the movements I made with the flash during one of the long exposures.

Post-Processing in Adobe Camera Raw and Photoshop

The lighting is what makes these photos interesting, so I only had to straighten them, increase contrast a little, and shift the colors slightly to make them cooler.

These screenshots show the original image, the subtly processed version, and the corresponding layer stack.

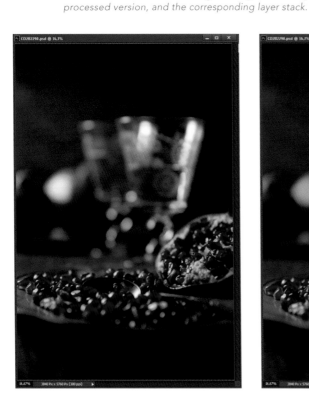

Tips and Tricks: My Homemade Flash Disc

I was really excited when the Fstoppers community (at fstoppers.com) introduced the cute little Flash Disc light modifier (see *www.tiny.cc/7qk8nx* for more details). Folded down, it fits into a pants pocket, and it pops up in one second flat. Mounted on a flash, it provides soft, flattering light for small-scale scenes and can be used to soften shadows in larger subjects, too. Fstoppers only delivers within the United States and, as I am based in Germany, I decided to get my favorite tailor to help me make my own. My "Clone Disc" is built using the diffusers from two mini reflectors and the silver skin from a larger reflector. The inner walls and back of my disc are covered in silver so that the light from the flash is all reflected to the front.

The Honl Traveller8 and the RoundFlash Dish are examples of other light modifiers that fold down small and produce similar effects.

If you are on the lookout for more DIY project ideas, check out Cyrill Harnischmacher's book *Low Budget Shooting*, which demonstrates how to build diffusers, reflectors, and softboxes at home using cheap, easily available materials.

My homemade mini modifier is made from two diffusers, a reflector skin on the inside, and some elastic. The light from a Flash Disc is most even if you use the catchlight and wide panels on your flash. Positioning the flash in the Clone Disc in such a way that the little white catchlight panel is at the side of the diffuser helps to prevent hotspots from forming.

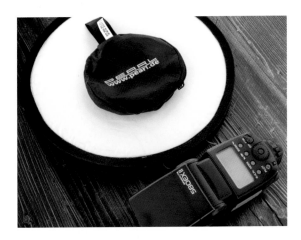

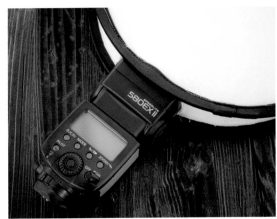

04

ADDITIONAL TECHNIQUES

This chapter explains some sophisticated additional shooting techniques, including bounced pop-up flash, stroboscopic flash that freezes sequential movements, homemade lens flares, and a guide to building your own bare-bulb flash. Prepare to be surprised!

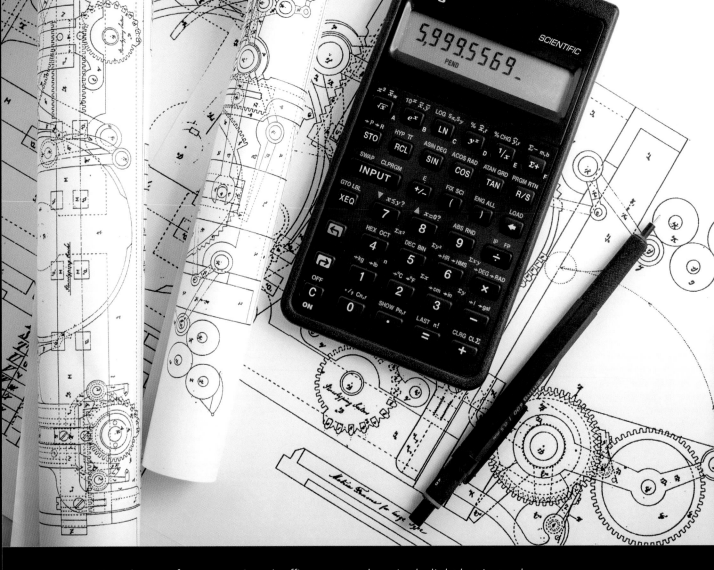

A scene from an engineer's office, captured not in daylight but instead using the pop-up flash built into an inexpensive DSLR. The soft, lateral light was created using sophisticated bounce flash techniques.

Canon EOS Rebel T1i · EF 24–70mm f/2.8L II @ 28 mm and f/5 · M mode · 1/160 second · ISO 400 · RAW · WB set to flash · Captured using pop-up flash and a Weinbrecht reflector

#23 Bounced Pop-Up Flash

› Using pop-up flash

› Using a Weinbrecht reflector to bounce flash

Imagine you are sitting in your hotel room and you need to capture a tabletop scene as a theme image for a magazine article. You set up the scene and begin to take a few test shots with your "travel" camera but, unfortunately, you left its matching speedlight at home. You quickly realize that the shots you capture using the camera's built-in flash look kind of cheap, just like the ones captured under the room lighting.

The solution is to bounce the light from the built-in flash off the wall. If you are shooting at relatively close distances, the only accessory you need is a mirror.

Equipment and Lighting

For this shot, I used a Canon EOS Rebel T1i with an EF 24–70mm f/2.8 lens and a Weinbrecht reflector (see *www.tiny.cc/u9dxyx* for more details). The walls in the room were green and therefore unsuitable for bouncing, so I set up one piece of Styrofoam as my main bounce surface and another as a fill reflector. If you had access to a white-painted corner of a room, you wouldn't even need the Styrofoam.

Once everything was set up, it was time to attach the Weinbrecht reflector to the camera's hot shoe. I positioned it so that the direct light path was blocked and only soft, lateral light reached the subject.

This is how a Weinbrecht reflector looks up close. This clever system enables you to position the mirror precisely and fix it firmly in place.

This is the scene as it looked in my hotel room. The setup consisted of the tabletop subject, a wall or Styrofoam sheet as a main bounce surface, and a second sheet of Styrofoam or a sheet of paper to act as a fill reflector.

My test shot without flash showed that the ambient light was sufficiently suppressed.

Settings and Shooting

Using bounce flash means keeping a certain distance between the bounce surface and the subject so that the angle of the reflected light reaching the subject suits the scene at hand. In this case, I had to get relatively close to the subject and set the focal length to 28 mm. I set the shutter speed to 1/160 second to suppress the unattractive room lighting and stay close to my camera's sync speed. An aperture of f/5 ensured sufficient depth of field, and an ISO of 400 took pressure off the relatively weak pop-up flash with its guide number of just 13. As usual, my first shot was a test exposure without flash to confirm that my settings cut out the ambient light.

These screenshots show the original SOOC image, the processed version, and the corresponding layer stack.

Post-Processing in Photoshop

I removed a few imperfections and added a "Dodge and Burn" layer. The screenshots show the original unprocessed image, the processed version, and the Photoshop layer stack.

Tips and Tricks

The Weinbrecht reflector is so small that you have no excuse for not carrying it with you all the time. In an emergency, even a piece of aluminum foil or a credit card can serve as a bounce mirror (thanks to Christian Konrad for the tip). These reflectors might take a little time to set up, but even these simple tools enable you to shoot with soft, lateral light.

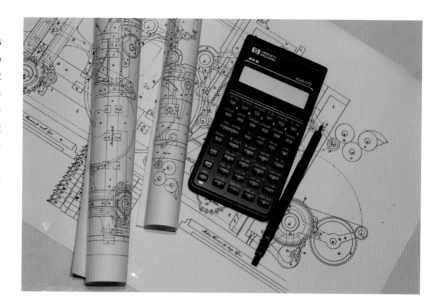

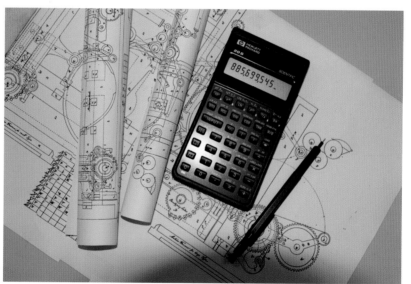

Same, but different! The same camera, lens, subject, and flash produced completely different results. The image at the top shows the scene captured under room lighting, the center image shows the result of using direct flash, and the bottom image shows the version captured using bounce flash.

Stroboscopic mode enables you to capture the full range of movements like this "robot ballet" in a single image.

Tripod-mounted Canon EOS 5D Mark III · EF 24–70mm II f/2.8 @ 38 mm and f/10 · M mode · 5 seconds · ISO 100 · RAW · WB set to flash · Yong-nuo YN-568C flash in Multi (stroboscopic) mode: 4 flashes per second, 20 flashes in total, 1/16 flash power · Honl Travel-ler8 mini softbox

#24 Stroboscopic Effects

> › Visualizing movements using stroboscopic flash

> › Learning to set the right parameters

Many modern speedlights have a Multi, or stroboscopic, mode that enables you to capture a series of movements in a single image. If you take the idea a step further and use your flash off-camera, you can capture intriguing photos of golfers or ballerinas that show a full range of motion.

To demonstrate the technique, I chose a model robot that I controlled manually using a chopstick taped to its gripper.

Equipment and Lighting

For this workshop, I used a Canon EOS 5D Mark III with an EF 24–70mm lens. I set a fairly small aperture of f/10 to ensure sufficient depth of field, and I set a shutter speed of five seconds. My flash was a Yongnuo YN-568C set to Multi mode.

I used my Honl Traveller8 mini softbox to soften the light and positioned a Styrofoam fill reflector behind the robot.

Settings and Shooting

Shots like these require no flash-free test shot as the room has to be completely dark anyway. I prefocused before switching autofocus off. I set the flash to 1/16 power, a total of 20 flashes, and 4 flashes per second, which equates to a five-second stroboscopic burst. The photo on the next page shows one of the five-second bursts I shot while moving the robot's arm with the chopstick. I fired the flash using RF-602 radio triggers.

The model robot was fixed to the wooden banister with tape. I moved its arm using a chopstick attached to its gripper.

This is a manually controlled sequence of movements captured using stroboscopic flash.

Post-Processing in Photoshop

The charm of these photos is the movement they depict and, apart from an appropriate crop, they require little or no processing. Of course, I retouched my hand and the chopstick out of the image, and I also optimized contrast and the black point. The screenshots opposite show one of the original images, the result of the processing steps, and the corresponding layer stack.

Tips and Tricks

This workshop shows you how to capture movements using stroboscopic flash effects in a darkened room. But what if your flash has no stroboscopic mode or you cannot easily darken the space you're working in?

You can simulate a stroboscopic effect by setting your flash to a low output and firing it continually by pressing the Test/Pilot button. If you cannot fire the flash fast enough, you can (just this once!) use a second flash in your other hand and double the frequency by firing the two flashes alternately.

If you don't darken the room during a long exposure you will capture the disruptive ambient room lighting along with your flash exposures. One way to work around this is to use your camera's burst shooting mode instead of using stroboscopic flash. If you set the shutter speed to the camera's sync speed, there shouldn't be any ambient light visible in the resulting photos. You can then use Photoshop to merge the results into a single image by generating a layer stack and setting the blend mode for each layer to **Lighten**. The downside of this approach is that you can't set the shooting frequency yourself; you have to stick to your camera's designated burst speed.

These screenshots show one of the original images, the processed version, and the simple layer stack that resulted.

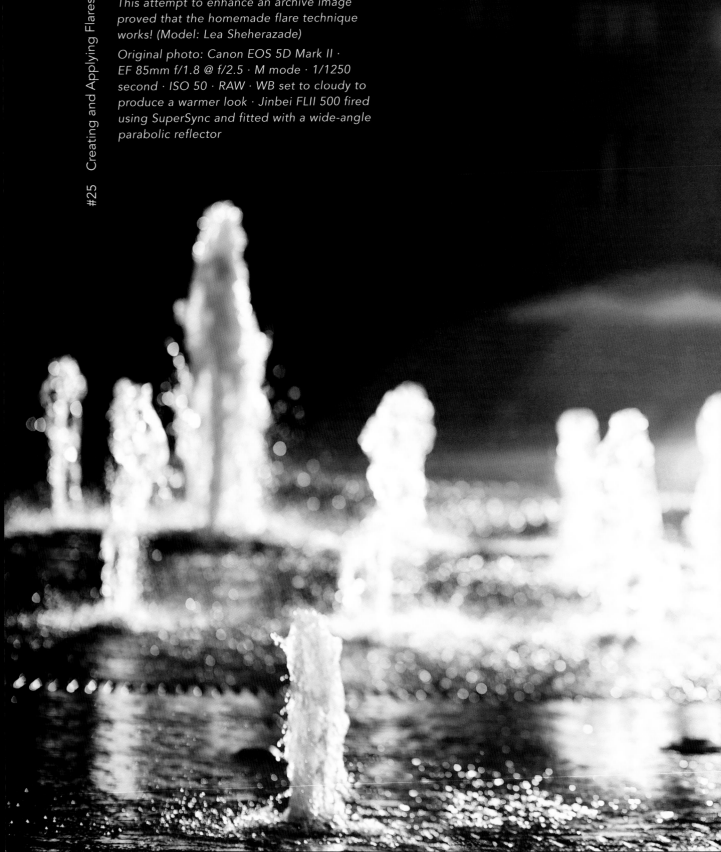

This attempt to enhance an archive image
proved that the homemade flare technique
works! (Model: Lea Sheherazade)

Original photo: Canon EOS 5D Mark II ·
EF 85mm f/1.8 @ f/2.5 · M mode · 1/1250
second · ISO 50 · RAW · WB set to cloudy to
produce a warmer look · Jinbei FLII 500 fired
using SuperSync and fitted with a wide-angle
parabolic reflector

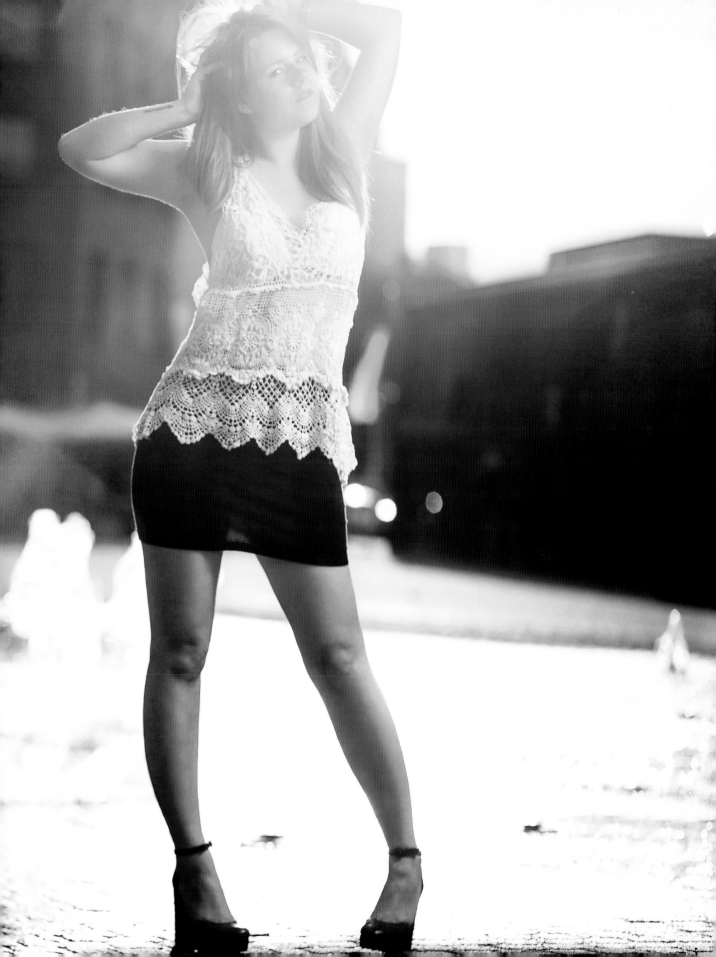

#25 Creating and Applying Flares

› Using a speedlight to create reusable flares

› Applying stock flares to other photos

Who needs technically perfect images? Not me! Noisy, overexposed images tweaked to look warm, golden, and sunny with streaks, flares, and leaks—these are great effects! But how can you purposefully get that flare look in your images? A couple of simple tricks is all it takes to produce flares on demand, which you can even reuse later as a kind of "flavor enhancer" to give other images a final polish.

Equipment and Lighting

Flares occur when you shoot into bright lights such as a low sun, an automobile headlight, or a photographic flash. The best way to deliberately create flares in your photograph is to use a telephoto lens without a lens hood. If you position your light source in a corner of the frame, the resulting flares will stretch from the bright point of the light to the center of the frame. And the best way to capture reusable flares is to shoot against a dark background, such as a night sky. To create my flares, I attached a flash mounted on a Manfrotto Magic Arm to the railing on my balcony and waited until dark to shoot directly into the flash as it fired.

My flare setup didn't look very promising in daylight, but shooting at night produced great flares that stood out perfectly against the dark sky.

Not bad for the first try. You can change the look of a flare by using Photoshop adjustment layers to shift the colors toward green or blue.

Canon EOS 5D Mark III · EF 24–70mm f/2.8 @ f/11 · M mode · 1/160 second · ISO 100 · RAW · WB set to flash · Canon Speedlite 580EX II set to M mode and fired using an RF-602 radio trigger

Settings and Shooting

Backlit photos will regularly exceed the limitations of a camera's normal dynamic range, so I always shoot in RAW for this type of shot so that I have the maximum possible post-processing capability. I set my exposure manually to prevent as much overexposure as possible, then use my RAW converter to repair any highlights and coax the last drop of detail out of the shadows. I shoot my flare shots with the light source in the corner of the frame to keep overexposure to a minimum and to fill the rest of the frame with large, intact flares.

The advantage of shooting your own reusable flares is that you get to know how they are created in the shot (in which direction and angle), enabling you to insert them into other images in a plausible fashion. Remember that flares only occur in backlit situations, so inserting them into a non-backlit scene produces unrealistic results. Flares always stretch from the light source to the center of the frame, so be sure to position your reusable flares this way when inserting them into other images.

Post-Processing in Photoshop

I selected a nearly flare-free backlit photo to test my homemade flares. I inserted one of my flare shots on a new layer, then rotated and transformed it until the position and direction of the artifacts matched those of the light in the original image. Using the Screen blend mode for the flares layer worked well. In this example, I had to hide some of the flare artifacts using a mask, as the model's upper body would otherwise have turned out too bright.

To fine-tune the results, you can use a Curves adjustment layer and a clipping mask to selectively adjust the brightness and overall effect of the flare layer, and use the Color Balance and Color Lookup tools to give it a nice color accent.

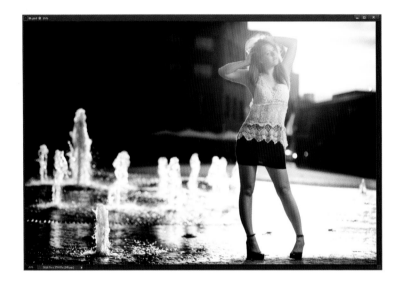

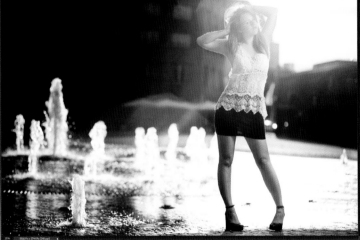

The screenshots show the original image, the version with the added homemade flare, and the corresponding layer stack.

You People Groups Explore Create Upload

Lens Flares
www.fotopraxis.net

40
Photos

View all albums **Photos**

If you don't want to shoot your own flares, you can use mine!
Navigate to www.tiny.cc/xkhgox for free access to my collection.

Tips and Tricks

If you want to experiment with flares but don't want to go to the trouble of shoot-ing your own, no problem! Simply navigate to *www.tiny.cc/xkhgox* and use some of mine.

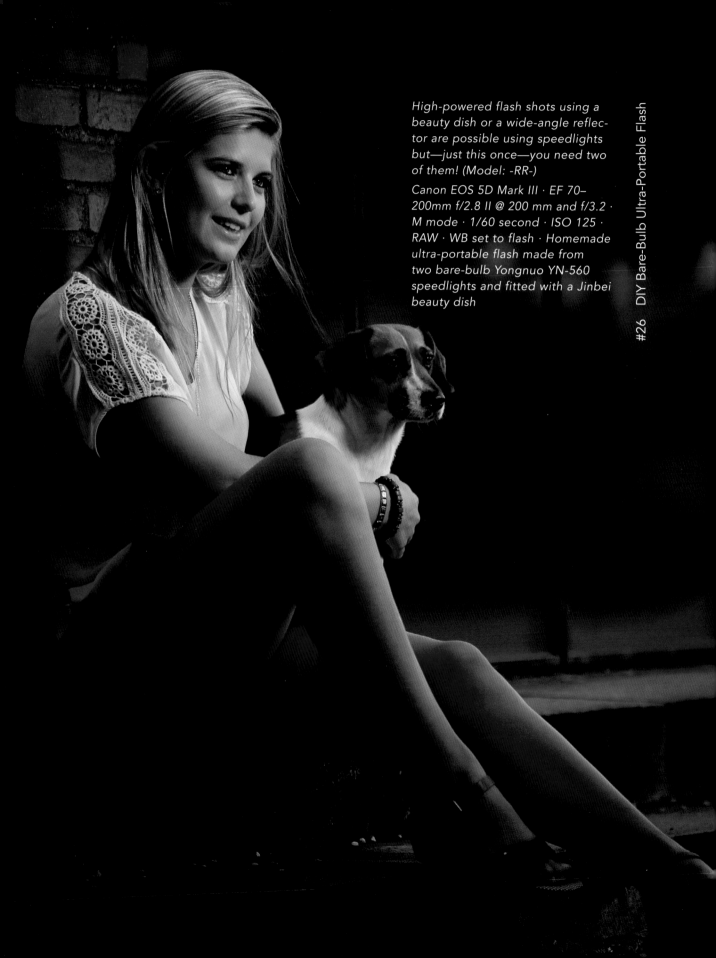

High-powered flash shots using a beauty dish or a wide-angle reflector are possible using speedlights but—just this once—you need two of them! (Model: -RR-)

Canon EOS 5D Mark III · EF 70–200mm f/2.8 II @ 200 mm and f/3.2 · M mode · 1/60 second · ISO 125 · RAW · WB set to flash · Homemade ultra-portable flash made from two bare-bulb Yongnuo YN-560 speedlights and fitted with a Jinbei beauty dish

#26 DIY Bare-Bulb Ultra-Portable Flash

› Modifying a speedlight to work in bare-bulb mode

› Building your own ultra-portable high-powered flash from
two speedlights

> **WARNING!** The voltage in a speedlight condenser is dangerously high!
> You should only attempt the hack described here if you are accustomed
> to dealing with high voltages.

Please let me explain: The idea behind this workshop was to construct an alternative to my rather cumbersome Jinbei portable flash unit based on inexpensive speedlights. To make this project a reality, I had to use two flashes instead of just *One Flash!* I hope you will let that pass in this final workshop. ☺

Speedlights are cool, compact, and versatile, and I love using them, but they are sometimes simply not powerful enough to achieve the effect I am looking for. If I need more power or I want to use a modifier such as a parabolic reflector or a beauty dish, a speedlight is not always the best option. In such situations, I need a flash with plenty of power that emits light in all directions. My dream flash has no cumbersome external battery pack and is ultra-light and ultra-cheap as well. Ultra-powerful (compared to a standard speedlight) wouldn't be a bad thing either, and ultra-flexible compatibility with my Bowens/Walimex VC light modifiers completes my wish list.

The Basic Concept

After some thought and a couple of initial experiments, I came up with the idea of using two speedlights wired in parallel with their flash tubes elevated. This design addresses several issues: 1) The ultra-portable flash provides twice as much light and opens up a whole world of new flash photo opportunities; 2) The hack pushes the flash tubes much further into the reflector so they can emit light in all directions and fill the reflector with light the way a studio flash does; 3) The construction features a Bowens/Walimex VC bayonet, so I can use all my existing studio light modifiers on that little flashhead; and 4) Because they are exposed to the air, the hacked flash tubes don't overheat as quickly as they normally do.

Parts and Construction

The table below lists the parts you need, and the photos show the individual steps involved in performing the hack. To build my ultra-portable flash, I carefully removed the flash tubes from two Yongnuo YN-560 speedlights, cut the three wires leading to the tubes, and added extension wires. I then inserted the flash tubes into tubular glass guitar slides and used Sugru to affix them to a small homemade aluminum bracket. I also used Sugru to fasten the flash tubes into the guitar slides and to mold the custom flash mounts on the aluminum bracket.

Once you have bare-bulbed the flashes, performing the rest of the mod is child's play. All you have to do is mount the two flashes on the hand-formed aluminum bracket, attach the resulting unit to the Aurora bracket, and mount the reflector. The modded flash tubes now protrude far enough to fill most beauty dishes, softboxes, and PAR reflectors with light.

The list of parts for my homemade ultra-portable flash unit.

Quantity	Item Description	Availability
1	Aurora Flash Bracket or a Jinbei ET-1	eBay or amazon.com
4	Black and white Sugru self-setting silicone	sugru.com or amazon.com
2	Dunlop 202 Pyrex glass guitar slides	eBay or amazon.com
1	40mm × 3mm aluminum bar for the main flash bracket	Hardware store
1	25mm × 2mm aluminum bar for elevating the flash tubes	Hardware store
1	Roll of black tape	Hardware store
1	Roll of chrome tape for the flash tube holder	Hardware store
1 handful	Wire and heat-shrink tubing off-cuts for re-attaching the amputated flash tubes; screws	Electronics supply mail order, amazon.com

Comparing the Ultra-Portable with the Commercial Competition

Once my ultra-portable flash was finished, I compared it with my stock Jinbei FLII 500 using a beauty dish. Regarding the quality of light and its directional characteristics, I couldn't tell the difference between the two. I will spare you the details of all the measurements I made, but the most important results are as follows.

At full power, the 400-Ws Jinbei delivers about 2½ stops more light than a single bare-bulb YN-560 (now with comparable light dispersion characteristics). This is close to the energy values of 60–75 Ws that are quoted for many speedlights in online forums. Using two bare-bulb flashes in parallel, I measured a one-stop increase

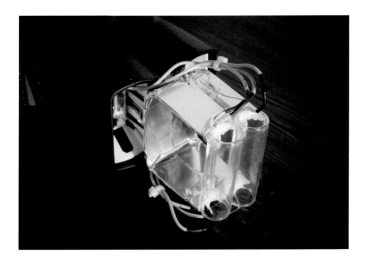

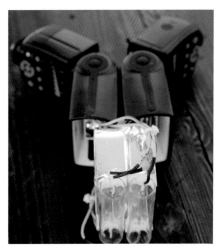

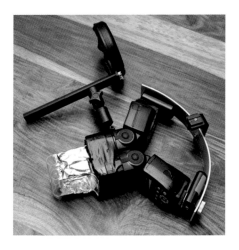

The steps involved in my flash mod. Taping the two flashes together and attaching them to a custom aluminum bracket creates a small, portable, 150-joule flash head. A Bowens adapter enables me to attach a standard beauty dish, and you can clearly see how far into the dish the modified flash tubes extend.

in light. If, like me, you normally set the Jinbei's flash power to 3 or 4, then two bare-bulb YN-560s provide just as much light. In comparison, two standard YN-560s without raised flash tubes cannot adequately fill the reflector and produce an amount of light similar to a setting of 2 or 3 on the Jinbei.

My custom flash head in use with a gridded beauty dish.

The First Test Shoot

The image on page 208 shows one of the images that came from my first test shoot with my new ultra-portable flash. The shoot went well and presented no major problems. The flash didn't complain once and even survived a fall. Even though I didn't always need all the power it can provide, the short recycle times were a real boon.

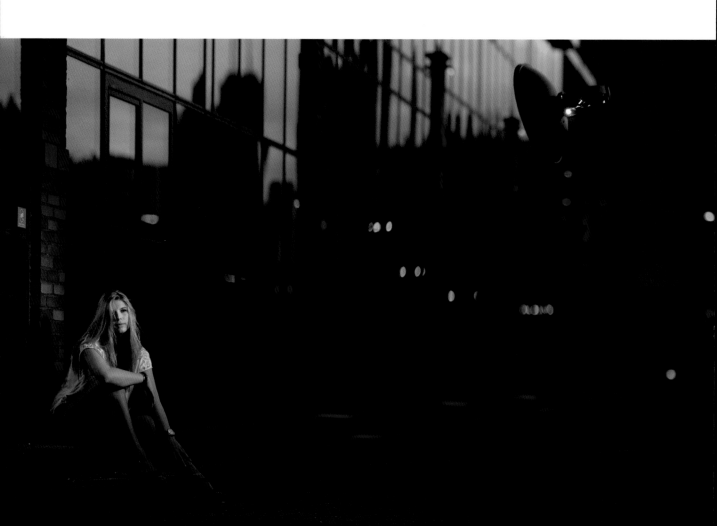

If you want to use a flash like this in brighter surroundings, try swapping the beauty dish for a standard reflector. The light will be harder, but you will have about two more stops of light to play with, enabling you to shoot even in bright sunlight, with the sun as a backlight.

Conclusions

To me, the mod was a success. With just 1½ stops less power than a Jinbei FLII 500, it gives me a versatile, portable flash with power that normal speedlights can't even begin to compete with. Thanks to the built-in Bowens/Walimex VC bayonet, I can use it with all my existing light modifiers.

Theoretically, even SuperSync should work with the YN-560 speedlights, although their actual flash duration is so short that the light they yield is not bright enough. If I want to shoot in the sun at wide apertures using my ultra-portable, I simply resort to using my good old neutral density filter.

Another shot captured on our first trip out with the homemade ultra-portable flash.
Canon EOS 5D Mark III · EF 70–200mm f/2.8 II @ 170 mm and f/3.2 · M mode · 1/60 second · ISO 125 · RAW · WB set to flash · Homemade ultra-portable flash unit made from two bare-bulb Yongnuo YN-560 speedlights · Jinbei beauty dish

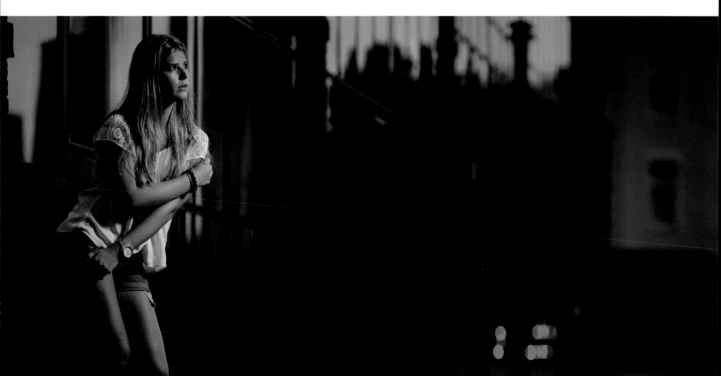

APPENDICES

ONLINE RESOURCES

Whether it's technical tips, product tests, hacks, or behind-the-scenes info you're after, the Web offers a wealth of useful resources. The following pages list some my favorites.

Zack Arias

As well as his commercial material, Zack offers an interesting blog and a Q&A Tumblr archive for free:

www.zackarias.com/blog

www.zarias.tumblr.com

www.dedpxl.com

Fstoppers

Day in and day out, the Fstoppers team puts together an interesting and entertaining potpourri of photography-related stuff, including Lightroom tricks, lighting tips, and product reviews. The site is free, although some content requires registration:

www.fstoppers.com

Strobist

David Hobby, the Strobist himself, started the *www.strobist.com* website (originally *strobist.blogspot.com*) in 2006 and quit his job as a photojournalist at the *Baltimore Sun* in 2007 to concentrate full-time on his blog. David has been instrumental in popularizing the strobist ethos and has now copyrighted the "strobist" label. A strobist is a photographer who uses off-camera flash the way others use studio flash.

The Strobist website includes the *Lighting 101* and *Lighting 102* series that provide an easy-to-understand introduction for anyone interested in pursuing flash photography. The Strobist Flickr pool and Strobist Facebook group offer further opportunities to talk shop:

www.strobist.com

www.strobist.blogspot.com/2006/03/lighting-101.html

www.strobist.blogspot.com/2007/06/lighting-102-introduction.html

Fotopraxis

This is my own blog, for those of you who read German (though, of course, you can use Google Translate to keep up in English!). The weekly entries are mostly about flash photography and Photoshop techniques. My "Light Primer" article introduces the basics of exposure calculation, flash exposure, sync speeds, the inverse square law, and much more. It is also available for download in English:

www.fotopraxis.net

www.tiny.cc/a5fxyx

Photigy

This is where Alex Koloskov publishes his Web content and his blog. Alex is a product photographer specializing in high-quality jewelry and splash shots. The workshops here are interesting and educational, and some of them are free:

www.photigy.com

www.youtube.com/user/Photigy

David Ziser

Wedding photographer David Ziser offers a wide range of free online videos covering themes as diverse as flash sync tricks and optimizing image composition. David also knows his way around Photoshop and Lightroom, and his videos are a lot of fun to watch:

www.vimeo.com/user468120

Neil van Niekerk

New York wedding and portrait photographer Neil van Niekerk produces unrivaled natural-looking lighting scenarios using both off-camera and on-camera flash. Neil has published four books and continues to write his acclaimed *Tangents* blog:

www.neilvn.com/tangents

Sylights

Sylights offers the ideal tool for creating diagrams of your own lighting setups. The diagrams in this book were all created using the Sylights editor. The company website includes sample diagrams, photos by Sylights users, and detailed information on usage and publishing rights:

www.sylights.com

> Many thanks to Olivier and the entire Sylights team for their kind support and the use of their great product for this book – Sylights rulez! ☺

Lightware Direct

This site sells popular photo gear from Manfrotto and other manufacturers, as well as its own FourSquare multi-flash mounts. The Lightware YouTube channel features videos showing the potential of many of their products:

www.lightwaredirect.com
www.youtube.com/user/LightwareDirect/videos

elixxier

Set.a.light 3D STUDIO from German software manufacturer elixxier enables you to create 3D studio setups and simulate the lighting effects they produce. The tool is also great for demonstrations at lighting workshops and for documenting your studio work:

www.elixxier.com

Setting viewed from the side – rendered

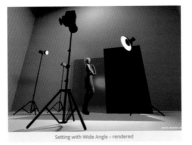

Setting with Wide Angle – rendered

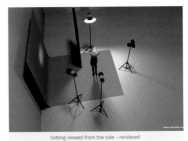

Setting viewed from the side – rendered

B&H

The Manhattan-based dealer's Event Space offers a wide range of free seminars and inspirational lectures by talented pros from around the world. These are filmed and posted for free viewing on YouTube:

www.youtube.com/user/BHPhotoVideoProAudio/videos

Michael Zelbel

Michael Zelbel uses speedlights to conjure soft and flattering light in his tasteful beauty and nude portrait photos. His YouTube channel offers a cross section of his free tutorials. His paid tutorials, which also cover erotic photography, are available via his website:

www.youtube.com/user/FreePhotographyTips/videos
www.zelbel.de

Lighting Rumours

This site keeps you up to date by publishing weekly news and product reviews covering the latest speedlights, portable flashes, and flash triggers:

www.lightingrumours.com

RECOMMENDED READING AND DVDS

If you are on the lookout for print or DVD material to accompany the online resources listed on the previous pages, read on. DVDs are sometimes more current than books and give you the opportunity to look over the shoulders of the pros as they work.

Neil van Niekerk

I can thoroughly recommend all four of Neil's Amherst Media titles: *On-Camera Flash*, *Off-Camera Flash*, *Direction and Quality of Light*, and *Lighting and Design for Portrait Photography*.

Zack Arias

Zack's *OneLight* DVD is essential viewing but is unfortunately now only available secondhand. You can purchase his newer *OneLight 2.0* from *www.dedpxl.com/onelight-v-2-0-the-new-video/*.

Zack has published his Q&A Tumblr blog as a book. His self-published book *One Light Field Guide* is also a great read and is available here: *www.tiny.cc/pgatjx*.

Joe McNally

Joe McNally has worked for the National Geographic Society since 1987 and, over the years, has had countless images published in *National Geographic* and other well-known magazines. McNally recognized the potential of off-camera flash early on and continues to share his skill and experience via workshops, DVDs, and books. His advanced techniques aren't always easy for beginners to grasp or execute, but the wealth of background information and fantastic images that accompany them are a lot of fun to read. See the Store section at *portfolio.joemcnally.com* for more information.

David Ziser

In his book *Captured by the Light* (New Riders), David Ziser offers a wealth of useful information not only for wedding photographers but also for anyone interested in improving their flash photography, composition, and portrait lighting skills.

Tilo Gockel

One Flash is my second book about flash photography that has been translated into English. If you want to peek at the first book, visit publisher Rocky Nook's website (*www.rockynook.com*) and have a look at the reading sample of *Creative Flash Photography*. Also, the freely available "Light Primer" excerpt from that book contains a lot of examples of how to calculate exposures:

www.tiny.cc/3jexyx.

Dustin Diaz

Dustin Diaz came to fame through his 365-day Flickr project and has since cemented his reputation with his unique nighttime bokeh photos and the film-like scenes he captures using speedlights. He shares important portions of his knowledge in his book *This Is Strobist Info* (Peachpit Press).

Paul Fuqua, Steven Biver, and Fil Hunter

These three are the authors of *Light Science & Magic: An Introduction to Photographic Lighting*, now in its fifth edition. The book contains an abundance of essential information on object and product photography.

Dennis Savini

Dennis Savini is a professional photographer who specializes in high-end product photos captured in his studio using medium- and large-format cameras. His book *Materclass: Professional Studio Photography* (Rocky Nook) is full of great ideas that you can use for your own flash experiments.

GLOSSARY

Throughout the book I discuss a number of well-known terms, but you are sure to have noticed some more exotic-sounding expressions and abbreviations, as well. Not everyone is familiar with acronyms like SOOC, CTO, and others; the following glossary covers most of the everyday strobist terms that you'll encounter in the course of your flash photo workflow.

Term	Explanation
2nd Curtain	See second curtain
35mm image format	See full-frame
accessory flash	See speedlight
ACR	Adobe Camera Raw. Adobe's in-house RAW converter with functionality very similar to that of Lightroom.
AF	Autofocus
APS-C	Advanced Photo System "Classic" negative format. Canon's term for sensors that measure 22.2 mm × 14.8 mm.
AWB	Automatic White Balance
back-button focus	Focus mode that separates autofocus and shutter release. Instead of pressing the shutter button halfway to focus, autofocus is initiated by pressing a separate button (usually AE lock or AF-ON).
bare-bulb flash	Speedlight modification that bares the flash tube and allows it to emit light omnidirectionally without restriction by its reflector. See *www.tiny.cc/c32zmx* for details and a sample mod.
bare flash	Flash without any light modifier
beauty dish	Large, flat, circular light modifier made of metal with a parabolic cross section and a built-in reflector. Produces softer light than a PAR reflector but higher-contrast light than an umbrella or a softbox.
BFT	See black foamie thing

Term	Explanation
black foamie thing	Flag/shade mounted on a flash to prevent light from directly illuminating the subject. Invented by Neil van Niekerk (see *www.tiny.cc/p72zmx* for details).
blinkies	Slang for the highlight warning system built into many modern cameras
bokeh	English spelling of a Japanese word that means blurry or fuzzy. Used to describe the blur effects (and the aesthetic qualities thereof) that occur around out-of-focus points of light in photographic images, also known as bokeh bubbles.
bokeh bubbles	See bokeh
boom-stick	Slang for a handheld monopod light stand
bounce flash	Flash technique that "bounces" light off a nearby surface (typically a ceiling or a wall, but can also be a deliberately placed reflector) instead of aiming the flash directly at the subject
broad lighting	Portrait lighting pattern. If the subject's nose doesn't point precisely along the camera's optical axis, the image will contain a broader side that faces toward the camera and a narrower side that faces away from the camera. Lighting that illuminates the broader side is called "broad lighting" (see also short lighting).
brolly	Slang for umbrella
brolly box	A combination silver-coated reflector/diffuser umbrella that functions like a circular softbox
closed loop lighting	Portrait lighting pattern in which the nose shadow and the cheek shadow merge, leaving a bright triangle beneath the subject's eye (also known as "Rembrandt lighting")
cold shoe	Flash shoe with no built-in electrical contacts
composite	Image made from multiple source images (see flash composite)
critical aperture	The aperture that provides the best compromise between optical aberrations and diffraction blur. Often lies two or three stops below the maximum aperture. Values for a range of popular lenses can be found at www.slrgear.com.

Term	Explanation
crop	Refers either to the removal of unwanted (usually peripheral) image areas, or the format of a camera sensor that is smaller than full-frame
cross lighting	Lighting pattern with two lights that cross at the subject—for example, one from front right and one from back left. A symmetrical cross-lighting setup is sometimes called a "double kicker" (see kicker light).
CTB	Color Temperature Blue
CTO	Color Temperature Orange
dodge and burn	Photoshop tools that produce effects like the classic darkroom processes used for selectively darkening or brightening parts of the frame. The effect is similar to "painting with light."
DSLR	Digital Single Lens Reflex camera
DX	Nikon proprietary term for sensors of approximately the same dimensions as APS-C
EC	Exposure Compensation
E-TTL	Canon proprietary TTL flash metering technology that incorporates distance data and detects disruptive reflections (now in its E-TTL II iteration)
EV	Exposure Value (1 EV is equivalent to 1 f-stop). An adjustment of 1 EV halves or double the amount of light reaching the image sensor.
FEB	Flash Exposure Bracketing. A shooting mode that automatically captures a sequence of images with varying flash power.
FEC	Flash Exposure Compensation
FEL	See Flash Exposure Lock
flag	Light modifiying accessory used to block light
flares	Artifacts caused in backlit scenes by (usually) unwanted light scatter within the lens

Term	Explanation
flash composite	The result of combining multiple flash images in which the position or angle of the flash is altered between shots. The images are merged so that only the brightly lit parts of each source image contribute to the resulting image (use the Lighter Color Photoshop layer blend mode).
Flash Exposure Lock	Canon's term for spot metering with flash. Pressing the FEL button fires the pre-flash and then locks in the flash exposure.
flash synchronization	In a DSLR with a two-curtain focal-plane shutter, standard flash synchronization is only possible when the sensor is completely exposed. If the shutter speed is shorter than the sync speed, the sensor is no longer completely exposed during the flash exposure and the edge of the shutter curtains crossing its surface become visible. Using flash under such circumstances produces an image with a black stripe across the frame.
flash trigger	Any device that fires a flash. Usually this term refers to RF modules.
Flash Value Lock	Nikon proprietary term for Flash Exposure Lock
focus and recompose	Focusing technique that involves locking focus (usually by pressing the shutter button halfway) and then reframing to shoot
focus stacking	Photographic technique that takes multiple images shot with different focus or varying object distance and merges them in post-processing to form a single image with enhanced depth of field
FP Sync	Focal-Plane Sync. Nikon proprietary term for HSS (High Speed Sync).
full-frame	Camera sensor format with the same dimensions as a 35mm film frame (i.e., 36 mm × 24 mm)
FV Lock	See Flash Value Lock
gaffer tape	Universally useful strong black or gray cloth tape, originally from the theater and event sectors
gang light	A light source made up of multiple speedlights, typically used to compensate for the loss of flash power that results from using HSS (High Speed Sync)

Term	Explanation
gel filter	Plastic sheet filter for use with flash or other light sources (used to be made of gelatin, hence the name)
GN	See guide number
gobo	Stands for "go between." A shade/flag positioned between the light source and the subject. The term is also used to describe slides made of metal or etched onto glass that are used to project patterns.
gray filter	See neutral density filter
guide number	The maximum distance at which a flash can illuminate a subject at given ISO and aperture settings. This range is equal to the product of the flash-to-subject distance and the aperture required to expose the subject correctly at that distance.
hair light	Portrait light from above and behind the subject that is used to give the subject's hair additional luster, as well as separate it from the background and add dimension
highlight warning	Indicates areas of overexposure in the camera monitor image
hot shoe	Flash mounting shoe with electrical contacts
HSS	High Speed Sync. Flash mode that allows photographers to use flash at shutter speeds shorter than the camera's designated flash sync speed. HSS flash consists of a pulsed sequence of very short flashes (at 30–50 kHz) that give the impression of continuous light.
HyperSync	Proprietary term used by PocketWizard for SuperSync
inverse square law	The inverse square law states that the illuminance provided by a point light source is proportional to the inverse of the square of the distance to the source—in other words, if the illuminance at a distance of one meter from the subject is 100%, it will be reduced to 25% at a distance of two meters
IR	Infrared
IS	Image Stabilization

Term	Explanation
ISO	International Organization for Standardization, used in this case to denote the standardized value for the signal amplification as output by the image sensor, comparable with legacy ASA film sensitivity values
i-TTL	Nikon proprietary TTL flash metering technology that now incorporates distance data and detects disruptive reflections
J	See joule
joule	SI unit of energy, equivalent to watt-second
kicker light	A light located to the side of, or diagonally behind, a subject that accentuates cheekbones and temples
loop lighting	Also known as open loop lighting. Portrait lighting pattern that produces a subtle "loop" shadow beneath the subject's nose but doesn't merge with the cheek shadow (as opposed to closed loop lighting).
LR	Lightroom. An Adobe digital darkroom product.
master flash	The transmitter in a group of wirelessly controlled flashes. It transmits signals that control slaves.
meter and recompose	Technique that involves locking a light meter reading before adjusting framing and releasing the shutter
modeling flash	Light provided by high-end speedlights for evaluating the effects of a flash in advance of shooting. Consists of a short sequence of flashes that appear as continuous light.
modeling light	Additional continuous light source in a studio flash that enables the photographer to evaluate the effect of a lighting setup in advance of shooting (usually halogen lamps, sometimes LEDs)
neutral density filter	Optical filter used to enable wide-aperture flash photography in sunlight without using shutter speeds shorter than the camera's sync speed
ND filter	See neutral density filter
ODS	See Overdrive Sync

Term	Explanation
off-camera flash	Flash located off the camera and triggered using either a cable or infrared/radio-based wireless controller
on location	Outdoor shoot
optical slave	Optical flash trigger
optimum aperture	The aperture that provides the best compromise between depth of field and diffraction blur
Overdrive Sync	Phottix proprietary term for SuperSync
PAR reflector	Reflector with a parabolic cross section
PC sync socket	Prontor-Compur standardized connector socket for flash devices
pop-up flash	Flash built into the camera body that pops up when needed
Porty	Hensel proprietary term for a powerful, battery-driven portable flash. In some circles, the word has come to be used as a generic term for similar devices.
Porty look	The look produced using a Porty, which enables you to shoot using strong underexposure for the ambient light, thus producing especially dark blue skies
pseudo HSS	See SuperSync
RAW	Digital image capture format that retains the maximum amount of visual data. In contrast to a processed JPEG image, which is compressed and stored to an 8-bit RGB format.
Rembrandt lighting	See closed loop lighting
RF	Radio Frequency
rim light	Light from behind the subject that accentuates the subject's outline
second curtain	Rear shutter curtain, or the last moment at which the sensor is completely exposed before the shutter curtain closes. This is the last possible moment at which you can make a flash exposure.

Term	Explanation
short lighting	Portrait lighting pattern. If the subject's nose doesn't point precisely along the camera's optical axis, the image will contain a broader side that faces toward the camera and a narrower side that faces away from the camera. Lighting that accents the narrower side is called "short lighting" (see also broad lighting).
shutter, focal plane shutter	Camera shutter, two-curtain shutter
slave	In a setup that consists of multiple wirelessly controlled flashes, a slave is a flash that receives firing instructions from a master
slave flash trigger	Device that usually consists of a hot shoe and a photoreceptor (or photodiode) that detects the signals transmitted by a master and uses them to fire a slave
SLR	Single Lens Reflex camera
SOOC	Straight Out Of the Camera. An unprocessed image, usually JPEG or a JPEG preview of a RAW image.
Speedlight	Nikon proprietary term for a system flash. The term is also often used generically to describe on-camera flash units from other manufacturers.
Speedlite	Canon proprietary term for a speedlight
spigot	Standard adapter bolt (usually brass) for connecting various light stands and adapters
split lighting	Portrait lighting pattern that splits the subject's face into a brightly lit half and a half that remains in shadow
strobe	Flash unit, or stroboscope
strobist	Term for photographers who use speedlights the way others use studio flash—i.e., off-camera, triggered wirelessly and equipped with studio-style light modifiers such as softboxes.
stroboscopic flash	Flash mode that emits a sequence of short flashes, producing an effect similar to that found in many dance clubs
Sugru	Patented moldable silicone with a small degree of shrinkage

Term	Explanation
SuperSync	Flash technique that utilizes powerful, slow-burning flash units to produce continuous light. This technique requires an unusual early firing of the flash, before the shutter curtain starts to move. One way to accomplish this is to fire the flash simultaneous with the first HSS light pulse of a HSS-capable system flash.
sync speed	Camera-dependent shortest shutter speed at which standard flash synchronization can take place
system flash	An accessory flash (typically made by the same manufacturer as the camera) usually equipped with features such as HSS, TTL, FEC, FEL, and stroboscopic flash.
tail-sync hack	See SuperSync
Translum sheeting	Flexible, semitransparent diffuser material that is available in sheets and rolls from Manfrotto and other manufacturers
TTL	Through the Lens metering. Uses a preflash to measure subject distance and brightness, and uses the returned signal (received through the lens) to calculate exposure parameters. Much more accurate than the photoreceptors used in legacy "computer" flashguns. Called E-TTL by Canon and i-TTL by Nikon.
watt-second	Unit of energy, equivalent to joule
WB	white balance
Ws	watt-second
X-Sync	See sync speed. The "X" stands for Xenon (as in xenon flash).
zebras	See blinkies
zoom reflector	Reflector with a parabolic cross section built into a speedlight. The xenon flash tubes in these flashes can be shifted using a motor to provide varying zoom settings. This way, the speedlight can be adjusted to suit the focal length of the lens.

INDEX